10th Anniversary Edition

How to Draw
Cool Stuff

A
Drawing
Guide for
Teachers
and
Students

Written and
Illustrated by

Catherine V. Holmes

Published by:
Library Tales Publishing
www.LibraryTalesPublishing.com
www.Facebook.com/LibraryTalesPublishing

For general information on our other products and services, please contact our Customer Care Department at 1-800-754-5016, or fax 917-463-0892. For technical support, please visit www.LibraryTalesPublishing.com

Library Tales Publishing also publishes its books in a variety of electronic formats. Every content that appears in print is available in electronic books. Library of Congress Control Number: 2017944834

ISBN-13
978-1956769715

How to Draw Cool Stuff

This is the one-stop shop for creating beautiful and engaging artwork!

Inside, you'll find over 100 how-to, step-by-step drawing guides that are easy to follow and fun to do.

For Artists: Organized into chapters, "How to Draw Cool Stuff" covers elements of design, human facial features, perspective, holidays, animals, creatures, and more. It offers hundreds of drawings demonstrating how simple shapes can be combined to create detailed artwork. Artists will learn to identify basic shapes in objects and transform them into intricate works of art through a few simple steps. These practical exercises enhance drawing skills and inspire the creation of unique artwork.

For Teachers: If you are working with a limited budget, time constraints, scarce resources, or have students who enjoy drawing, this book is ideal for you! Inside, you will find numerous lessons that are portable and suitable for teaching art to students of all levels. Each lesson includes easy-to-follow instructions, with the entire process illustrated through a sequence of drawings and minimal text. Additionally, each art project is accompanied by a chart that outlines the basic skills and concepts students will learn, along with final assessment tasks for them to complete. The best part is that this book includes subjects that kids are eager to draw.

All you need are a pencil and paper, and you're ready to start drawing cool stuff!

TABLE OF CONTENTS

Chapter 2
Human Face

Chapter 3
Perspective

Chapter 4
Holidays and Seasons

Chapter 5
Animals and Creatures

Chapter 6
Cool Stuff

About the Author

Catherine V. Holmes is a mother, teacher, artist, youth advocate, and author/illustrator of the "How to Draw Cool Stuff" series.

Holmes was formally trained at Boston University School for the Arts and is currently independently learning and exploring different techniques for creating art. She is not very particular about what she makes, as long as she is making something.

Recently, Holmes has turned her attention to incorporating graffiti text into her work along with pop art techniques.

Holmes believes that everyone deserves art. Art does not have to be created to be appreciated. Art is all around us and can be enjoyed whether we draw it, sing it, write it, read about it, or simply view it.

AUTHOR'S FOREWORD

Dear Artists and Educators,

It has been a remarkable decade since this journey began – a decade of inspiring creativity, fostering artistic skills, and, most importantly, bringing the joy of drawing to countless individuals across the globe. "How to Draw Cool Stuff", which has proudly maintained its bestseller status since its release, started as a seed of an idea, a desire to make the art of drawing accessible and enjoyable for everyone. Today, it stands as a vibrant community of learners, teachers, and creators, each contributing uniquely to this ever-expanding canvas.

The essence of "How to Draw Cool Stuff" lies in its simplicity and profound understanding of the artistic process. Through step-by-step illustrations and easy-to-follow guidelines, it demystifies drawing, transforming complex concepts into accessible and enjoyable experiences for both budding and seasoned artists.

From its original foundation, the series has blossomed into seven books, each addressing different facets of drawing, including shading, textures, speed-drawing, and specific guides for kids, adults, and holiday-themed artwork. This expansion reflects our evolving artistic community's needs and interests, continuing our legacy of making art accessible and a source of endless inspiration.

In this 2024 edition, we honor the past while embracing the future. Maintaining the beloved essence of the original, this edition integrates fresh perspectives and updated techniques, aligning with the evolving artistic landscape.

To our devoted readers, both longstanding and new, your support and feedback have been invaluable. Your artistic journeys inspire us to continually improve and expand. Whether you are picking up a pencil for the first time or seeking to refine your skills, this book is here to guide and inspire your creative potential.

To the dedicated educators shaping the next generation of artists, your adaptability, creativity, and commitment, particularly in resource-limited situations, have been nothing short of inspirational. "How to Draw Cool Stuff" has served as a teaching tool and a bridge to connect with and guide your students in their creative pursuits.

As "How to Draw Cool Stuff" enters this new era, I am excited to see how it continues to shape and be shaped by the wonderful community that has grown around it. Your creativity, feedback, and passion are the true forces that drive this book forward. Together, let's keep nurturing this space where art is not just a skill but a shared language of expression, connection, and joy. Thank you for being an integral part of this remarkable journey.

Art, in its many forms, is a powerful tool for expression, communication, and understanding. It transcends language, culture, and time. Through "How to Draw Cool Stuff", we aim to make this tool accessible to everyone, encouraging you to see the world through the eyes of an artist and to express your unique vision. Our hope is that "How to Draw Cool Stuff" continues to be your trusted companion in your artistic journey, helping you unlock your creative potential and explore the endless possibilities that art has to offer.

Here's to another decade of drawing, learning, and creating cool stuff!

Catherine V. Holmes
Author, Illustrator
How to Draw Cool Stuff

INTRODUCTION

This book evolved out of necessity. After exploring art catalogs and libraries and wading through the "how to draw" section of bookstores, I found a few good resources but none that had all the qualities I was looking for in a drawing book. Some ideas were too basic and often insulting to my older, more artistically inclined students. Other materials seemed to serve as a showcase for beautiful artwork but lacked any concrete instruction.

As a "traveling" art teacher working with a limited budget and preparation time, I needed a single, easily transportable resource capable of teaching students across various levels—from middle school to high school and beyond. This book was created to fill that specific need, and I am eager to share it with teachers and artists facing similar challenges.

The projects within these pages are designed to provide engaging and informative lessons with clear objectives, fostering achievement without the necessity for expensive or multidimensional supplies. A simple pencil and eraser are all that is needed (sometimes a ruler or fine pen). There's no need for fancy art pencils, expensive paper, or kneaded erasers to complete them. All the activities and lessons have been student-tested and approved.

The Book Details:

Inside, you will find specific exercises that offer step-by-step guidelines for drawing a variety of subjects. Each lesson begins with an easy-to-draw shape, forming the basic structure of the drawing. Subsequent steps add elements to this structure, allowing the artist to build upon their creation and make a more detailed image.

Every art project is accompanied by a chart. This chart includes information that artists should **KNOW** (facts, basic skills), **UNDERSTAND** (big ideas, concepts, essential questions), and be able to **DO** (final assessment, performance, measurements of objectives) by the end of the lesson.

This additional information gives these pages more power than just 'art for art's sake' - not that it's needed - because art is important enough on its own! Artists are learning about themselves as expressive souls through the process of creating beautiful and interesting work.

The best part is, this is stuff that artists *want* to draw.

Information for Teachers Using This Book:

Teachers can be confident that this guide utilizes instructional time in ways that significantly benefit their students. Each lesson includes easy-to-follow instructions, with the entire process illustrated through a sequence of detailed drawings. These can be connected to historical contexts, aligned with curriculum learning standards, or adapted into arts integration lessons. The intensity of each project is at the teacher's discretion.

The projects can be differentiated to respond to students' diverse learning styles, through a mixture of visuals and text.

For the Best Results, Here Are a Few Tips:

- Lessons are provided on a single page for easy reproduction. If possible, copy them using the photo setting on your school's copy machine to ensure that the shaded areas retain their best quality.

- Display the "Know, Understand, Do" sheet prominently on the board so students can clearly see the lesson objectives.

- Encourage your students not to skip any of the steps. Teachers may find that many students want instant gratification and often try to skip to the last step without following the process. There are a few art students who have a "talent" for drawing or have prior experience with drawing complex forms and do not need the steps, however, most do need to follow the sequence in order to achieve their best result. For greater success, they must follow the steps! By doing so, students are training their brains to see shapes within an object instead of the object as a whole. This will simplify the drawing process.

- Tell students to draw lightly. Once they have a basic outline and a few details, then students can make their lines darker and more permanent. Getting heavy-handed artists to draw lightly can be a constant battle but the struggle is worth it once they see the benefits. Erasing becomes easier and fewer papers are crumpled up and thrown away.

- Every student will find a different level of success with these drawing guides. Encourage students to make their work different from the exercises in the book by adding "extras" and more details. This makes each work of art unique and personal.

- These simple steps can be adapted to any level - the student can put as much or as little effort into their work as their comfort level allows. NOTE: As a great art teacher, always push your students for more - going beyond the comfort zone is how we learn!

- The techniques and processes presented in this book are well within the reach of what your student can do. On occasion, some students may get frustrated and want to give up. Sometimes a student will declare defeat before even attempting the work. That is unacceptable! Remind them that creating art is a process. In cases like this, encourage your student to try just the first step. They will see that first step is quite easy and may be encouraged to try the next step, etc.

- If all attempts at drawing seem to be preventing your student from achieving success, you may want to allow that student to trace. The drawings on these pages are presented on a smaller scale in order to discourage tracing, however, it is better to allow tracing as opposed to your student doing nothing at all. Modifications for assignments can include tracing if need be, just have the student add their own unique twist by shading or adding "extras" that are not seen in the examples provided.

- This book is great for substitutes. Copy a bunch of these lessons, put them in your sub folder and take your sick day without worry.

With enough practice, eventually students won't need a "how-to" book. A shift in the brain will occur and your students will be able to mentally break down the simpler image behind the complex one without assistance. That is when they will become Super Smart Artists!

Information for Artists using this Book:

Following these exercises is a great way to practice your craft and start seeing things in terms of simple shapes within a complex object. Professional art pencils and paper can offer a variety of results, however, the techniques discussed in this book can be successful by using everyday supplies.

This book is intuitive but you may come across a few challenging steps. Follow the tips below for best results.

- Try blocking out the information you don't need. When you begin drawing one of the artworks in this book, cover all of the steps shown with a blank piece of paper except for the first one. Draw just the first step that is exposed. After that step is finished, uncover the next step and work on it. By blocking out the steps you are not working on, the artwork becomes less challenging to attempt. Continue uncovering each step one by one and adding to your artwork until it is complete. It is a simple tactic but it works by getting you to focus on just one action at a time.

- Patience is necessary. Don't rush, take your time and practice patience. Don't crumple up your paper in frustration every time you make a mistake. Look at your artwork and figure out the lines that work and the lines that don't. Change them as needed.

This is easier when you:

- Draw lightly. Start with a light, sketchy outline and add more detail as the drawing progresses. Once all the lines look good to you, then they can be drawn darker and more permanent.

- Don't be too concerned with trying to make your drawing look just like the one in the book or spend a lot of time trying to get both sides of a supposed symmetrical object the same. Even our faces are not perfectly symmetrical. Your unique (and sometimes imperfect) approach is what will make the artwork engaging and beautiful. If your drawing doesn't look "perfect," that's OK!

- Want your artwork to look even more professional? Draw your object large then shrink it on the copier using the photo setting. The details and lines appear finer and your work looks more detailed. A great trick to try!

- Finally, don't worry about what your neighbor's artwork looks like. Remember: everyone can draw, but no one can draw just like *you*. That is what makes art so special. If we all drew exactly the same way, art would be boring and there would be no point to it. Look at the way your artwork comes out after you finish and compare it to your own previous work. You will probably be impressed with yourself!

Tips for Shading:

- "The Basics" chapter displays several different shading techniques Using heavy pressure with your pencil will leave dark lines, while light pressure will produce light marks. A combination of both with a gradual transition from one to the other is one approach to realistic shading. Practice using different pencil pressures to create a variety of tones.

- Be careful if you choose to smudge your artwork to create shading effects. The technique of smudging an artwork with a finger to create shadows can blur some intricately drawn lines and ruin a beautiful drawing. However, when done properly, smudging can be a quick and effective way to add depth to an artwork. This can be an acceptable practice, just beware of making mud! Rubbing too much will cause all of those fine lines and contrasting shades to become the same muddled, flat gray tone. This takes the depth away from a drawing and makes the work appear less detailed. For best results when shading with the finger rub technique, just smudge a little.

- You will see some examples in this book where hatching and cross-hatching are used. This technique offers a unique alternative to smudging or varying pencil pressure for creating shading effects. Try them all and see which one works best for you.

Why We Need Art

Drawing makes you smarter! Believe it or not, artists are not just mindlessly copying what they see when following the activities in this book. By completing these projects, artists enhance their creativity and artistic confidence while gaining powerful tools for understanding what goes in to creating visual works. Students are actually re-training their brains to see in a different way. This allows them to express themselves and become competent, savvy, literate, imaginative, creative and perceptive in art and in life. Let your students, co-workers and the world know that ART IS IMPORTANT!

Chapter 1

Elements of Design

ELEMENTS OF DESIGN

KNOW:
Elements of Design: Color, value, line, shape, form, texture and space.

UNDERSTAND:
• The basic components used by artists when producing works of art.
• How these components are utilized.
• The difference between shape (length and width) and form (length, width and depth).

DO:
Practice hatching, pointillism, texture, line, shape, form, and space using a fine black pen in the space provided next to the examples. Copy what you see or create your own designs. Use the area in box number 7 to craft an original design incorporating at least 4 of the Elements of Design practiced in the boxes above.

EXTRA: Create an original artwork on a separate piece of paper using at least 6 of the 7 Elements of Design. Fill the paper from edge to edge with your design.

VOCABULARY:

Color: Light reflected by an object.

Elements of Design: Color, value, line, shape, form, texture, and space. The basic components used by the artist when producing art. The elements of art are the parts used to create subject matter in an artwork.

Form: A space that is three dimensional and encloses volume including height, width and depth.

Line: A point moving in space.

Line Drawing (Line Art): Any image that is made with straight or curved lines on a background (usually plain), without gradations in shade.

Shape: A two dimensional space.

Space: Refers to the areas around, between and within an artwork. It can also refer to a feeling of depth of 3 dimensions.

Texture: Visual and tactile characteristics added to a work of art.

Value: Lightness or darkness of a color.

For reproduction purposes, enlarge the information sheet to 115%

The Elements of Design
The basic components used by an artist when creating art
Color, Value, Line, Shape, Form, Texture and Space
Create examples of each in the spaces provided
Use a sharp pencil or fine black pen to complete the exercises below (we will skip color for now)

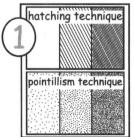

VALUE - the lightness or darkness of a color.
In this box you will show value using lines or dots.

TEXTURE - the way an object looks like it feels.
In this box, draw what you see or create your own texture.

LINE - a mark showing length and direction.
In this box, draw what you see or create your own line art.

SHAPE - an enclosed space showing length and width.
In this box, draw at least 4 different shapes.

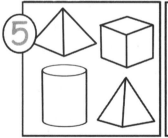

FORM - an enclosed space showing height, width & depth.
In this box, draw the forms seen at left.

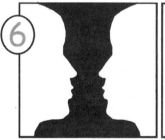

SPACE - distance or area between, around or within things.
In this box, draw the positive and negative space seen on left.

USE THIS AREA to create an original design using at least 4 of the Elements of Design practiced above.

SHADING SHAPES

KNOW:
Blending, Shading, Shadows, and Value.

UNDERSTAND:
• Adding value to a two-dimensional (2D) shape can create the illusion of a three-dimensional (3D) form in drawing.
• The lightness or darkness of a value indicates a light source on an object.

DO:
• Recreate the 9 examples provided in "Shading Shapes," starting with the Value Scale.
• Shade each object in accordance with the value scale.
• Blend the values to ensure smooth transitions.

VOCABULARY:
Blend: To merge (or blend) tones applied to a surface so that there is no distinct line indicating beginning or end of one tone. Using a blending tool such as a shading stump, tissues, or even fingers to blend the graphite will help to achieve a smooth look. Begin with the darkest tones and gradually work toward lighter areas.

Shading: Showing change from light to dark or dark to light in a picture.

Shadow: A dark area cast by an object illuminated on the opposite side.

Shade: A color to which black or white has been added to make it darker or lighter.

Value: An element of art that refers to the lightness or darkness of a color.

Tone: Lightness or darkness of colors used. Another word for value.

Value Scale: A system of organized values, usually consisting of squares that range from white to black with several shades of gray in between.

Notes about shading: Realistic shading is done with a series of tones ranging from light to dark. The more pressure used, the darker the mark. When shading the value scale and forms, practice pencil pressure control to create a variety of tones.

Shading Shapes

1. Value Scale

Make a rectangle with 5 squares

Number them: 1 2 3 4 5

Shade the squares

leave white	light gray	medium gray	dark gray	black
1	2	3	4	5

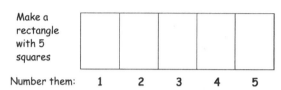

2. Flat shading - CUBE

The light source is coming from the right. The darkest tones and shadows are on the left.

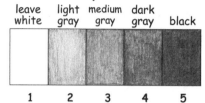

angle bottom

3. Round shading - SPHERE

Add 3 more circles

highlight
midtone
shadow
reflected light

Shade

Blend

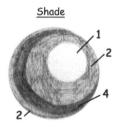
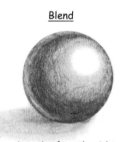

4. Banner Shading

The light source is coming from the right. The darkest tones and shadows are on the left

Shade darkest inside folds

2 3 4 5

Use a tool to gently smooth the tones into one another.

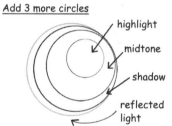
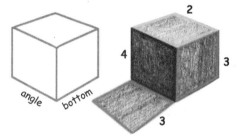

The banner appears darkest inside the folds while the outer curves are light. Gently blend the light and dark tones into one another for a smooth finish.

5. Pyramid Shading

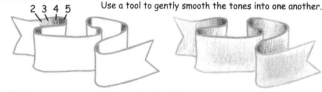
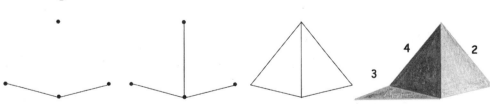

The light source is coming from the right. The darkest tones and shadows are on the left

Shading Shapes 2

6. Coin

A coin is a short cylinder.

Guide points

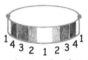

Shade **Blend**

The light source is front and center, therefore, the darkest tone will be close to the left and the right. The top should be dark toward the front and lighter toward the back of the ellipse

7. Cone

1.

2.

3.

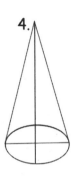

4.

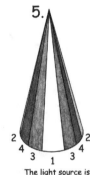

5. **Shade**

6. **Blend**

The light source is front and center, therefore, the darkest tone will be close to the left and right.

8. Top View of Cone

Shade

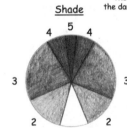

Blend

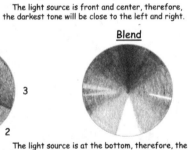

The light source is at the bottom, therefore, the darkest tone will be at the top. A few reflection lines of light can be seen on the sides.

9. Layered Pyramid

Angle sides

The light source is coming from the left, therefore, the darkest tone will be on the right. Leave the inside layers of the pyramid light for a glowing effect.

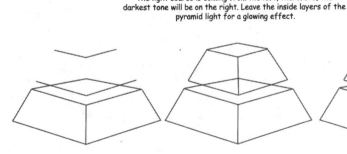
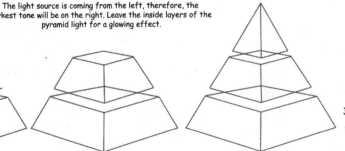
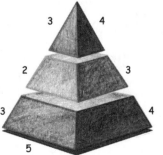

28

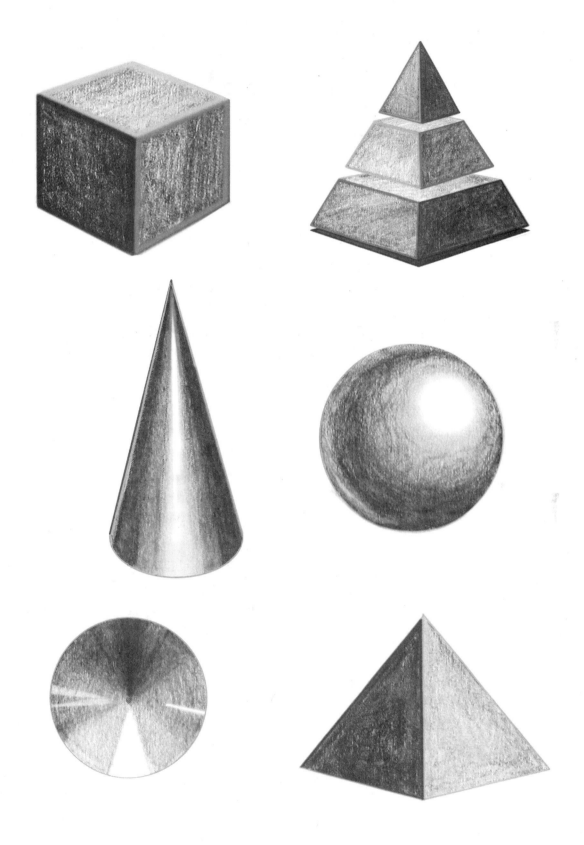

GETTING READY TO DRAW

KNOW:
Cross-Hatching, Hatching, Texture, Value Scale.

UNDERSTAND:
• Texture is used by artists to show how something might feel or what it is made of.
• Value added to a shape (2D) when drawing creates form (3D).
• The lightness or darkness of a value indicates a light source on an object.

DO:
To practice different types of shading, complete the value scale, hatching, and cross-hatching exercises in the area provided. On a separate piece of paper, draw a tree (or other object) that includes the types of shading practiced.

VOCABULARY:

Hatching: Creating tonal or shading effects with closely spaced parallel lines. When more such lines are placed at an angle across the first, it is called cross-hatching.

Shading: Showing change from light to dark or dark to light in a picture by darkening areas that would be shadowed and leaving other areas light.

Texture: The surface quality or "feel" of an object, characterized by its smoothness, roughness, softness, or any other tactile sensation.

Value: An element of art that refers to the lightness or darkness of a color.

Value Scale: A system of organized values, usually consisting of squares that range from white to black with several shades of gray in between.

TIP: A typical value scale includes around 9 squares of various tones. For simplicity, we will create a value scale using only 4 tones.

Getting Ready to Draw

Create Your Own **Value Scale**

leave white

light gray

dark gray

black

Sample of a birch tree with values, hatching and cross-hatching

Draw at least 4 examples of
Hatching

Draw at least 4 examples of
Cross-Hatching

Assignment: On a separate piece of paper, draw a tree (or other object) that shows hatching, cross hatching and value scale.

LINE QUALITY (DOVE)

KNOW:

Lines are tools used for communication.

UNDERSTAND:

• Various types of line in an artwork add depth and interest, imply space, movement, light, and/or thickness.
• Range in line quality heightens the descriptive potential in an artwork (textures, movement, light, space, etc.).

DO:

Create an original image using detailed line art that focuses on line quality. Experiment by drawing the artwork of the dove provided, and add line weight in the contour areas highlighted. Next, apply this technique to an item of your choosing, making sure to vary line weight so that some lines appear to advance (thicker) and others to recede (thinner).

VOCABULARY:

Line Quality (Line Weight): The unique character of a drawn line as it changes in lightness/darkness, direction, curvature, or width; the thin and thick lines in an artwork that create the illusion of form and shadow.

Recede: To move back or go further away from a previous position.

Line quality describes the appearance of a line - its look, not its direction (i.e., thick, thin, light, dark, solid, broken, etc.).

Line Quality

The olive branch and dove are symbols of peace

Line Quality describes the appearance of a line (thick, thin, light, dark, solid, broken, etc)

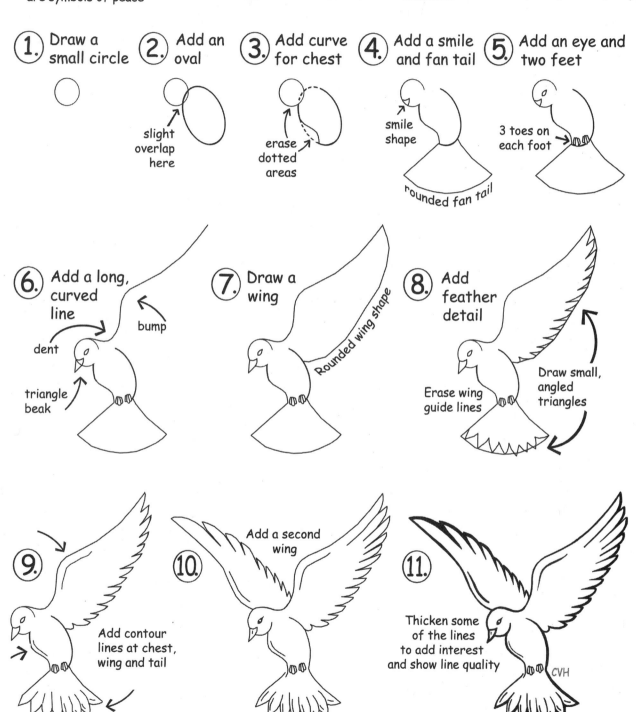

① Draw a small circle

② Add an oval

slight overlap here

③ Add curve for chest

erase dotted areas

④ Add a smile and fan tail

smile shape

rounded fan tail

⑤ Add an eye and two feet

3 toes on each foot

⑥ Add a long, curved line

bump

dent

triangle beak

⑦ Draw a wing

Rounded wing shape

⑧ Add feather detail

Erase wing guide lines

Draw small, angled triangles

⑨ Add contour lines at chest, wing and tail

⑩ Add a second wing

⑪ Thicken some of the lines to add interest and show line quality

CVH

33

These objects DO NOT HAVE . . .

Line Quality

. . . yet

Choose one of the following or create your own line drawing. Add Line Quality.

Butterfly

1.

2. Erase dotted areas. Add curves.

3. Add scalloped edges. Follow the contour of the wing edges to outline.

4. Draw "vein" lines

5. Add "Y" shapes to the vein lines

6. Add antenae and "tails". **Add line quality.**

CVH

Fishy

1. Start with 4 ovals

↑ connect here

2. Add fin details

erase dotted areas

3. Add scales, eyes, & fin lines

CVH

Ginny's Mini

1. Start with 3 shapes

trapezoid

rectangle

upside down trapeziod

2. Add rounded detail

erase dotted areas

3. Add extra's

GINNY'S MINI

CVH

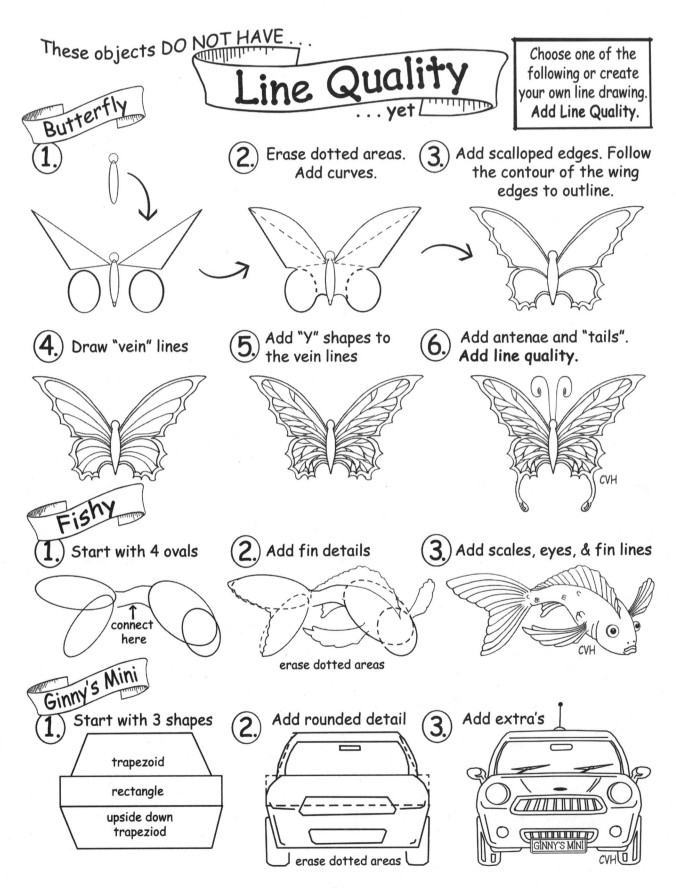

Line Quality

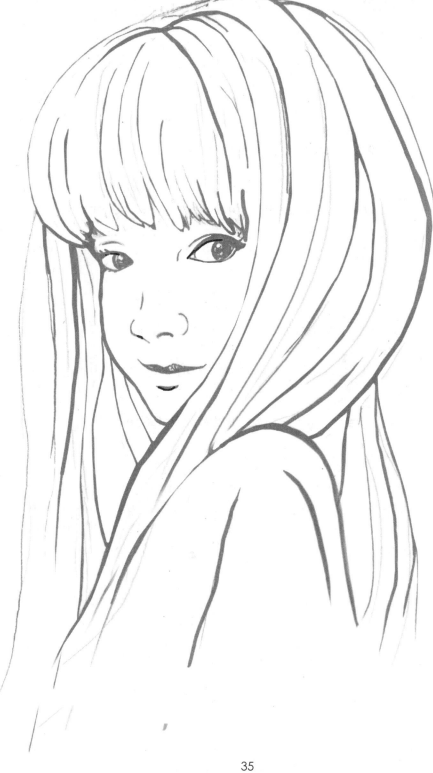

FORESHORTENING

KNOW:
• Simple steps to turn shapes into forms.
• How to create the illusion of 3D.

UNDERSTAND:
• Foreshortening is a way of representing an object so that it conveys the illusion of depth (3D).
• Foreshortening is when an object appears to thrust forward or go back into space.

DO:
• Practice foreshortening by recreating the 7 mini drawings. Use hatching and cross-hatching techniques to add shade.
• Create an original drawing on a separate piece of paper that show foreshortening.

TIP: These objects display a light source on their right side.

VOCABULARY:

Foreshortening: A way of representing an object so that it conveys the illusion of depth, seeming to thrust forward or go back into space. Foreshortening refers to the technique of drawing an object in a picture so it creates an illusion of projection or extension in space.

Foreshortening

1. Easy Cake

guide points

curve the bottom

2. Magic Hat

ring is thinner in back

thicker in front

curve the bottom

CVH

3. Simple Gift

Longer in Center

angle bottom

4. Stick of Butter

5. Open Box

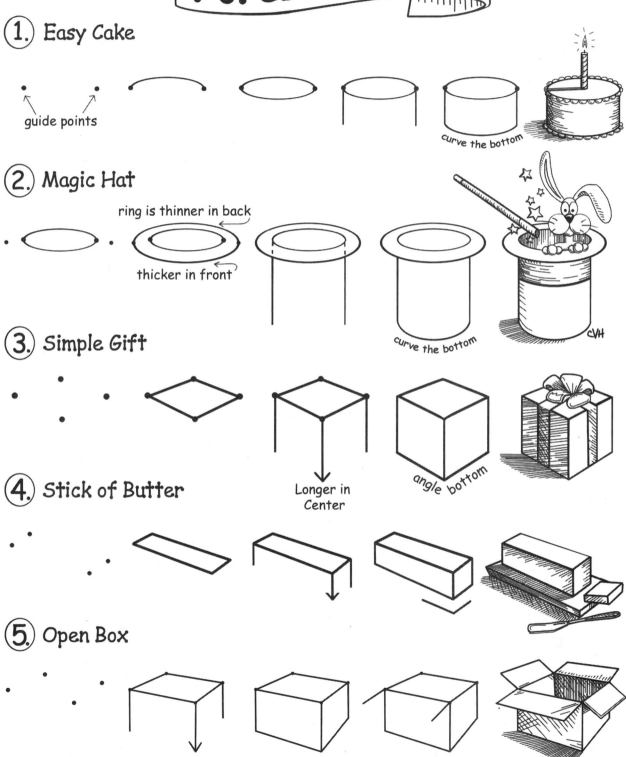

Foreshortening

① Layer Cake

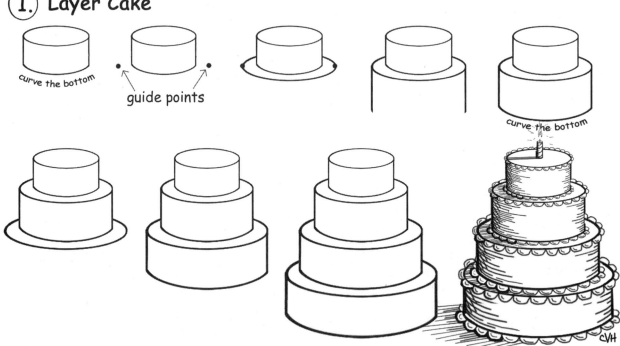

curve the bottom

guide points

curve the bottom

② Box in a box in a box in a box

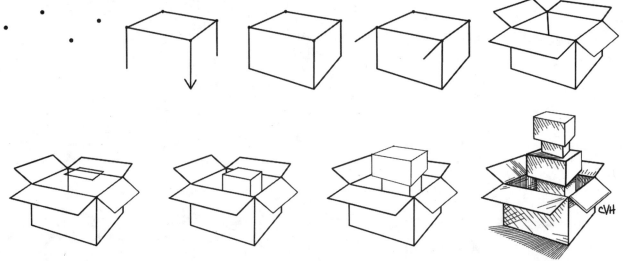

Question: I have 3 boxes. Inside those 3 boxes I have 3 boxes. Inside those 3 boxes I have 3 boxes. **How many boxes do I have?**

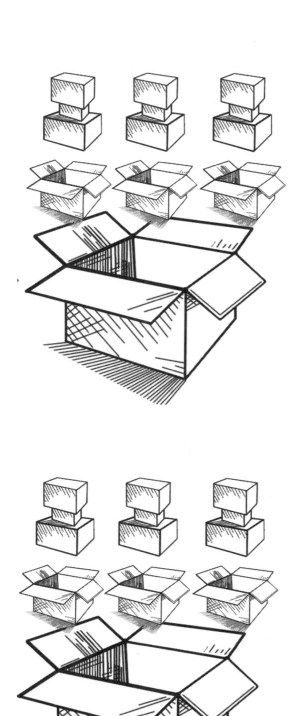

FORESHORTENED PERSON

KNOW:
Point of view.

UNDERSTAND:
Perspective in which the sizes of near and far parts of a subject contrast greatly. Near parts are larger and farther parts are much smaller.

DO:
Practice foreshortening by creating a version of your own foreshortened person as viewed from above. Make sure the head of your character is much larger than the feet to give the appearance of foreshortening.

VOCABULARY:

Foreshortening: A way of representing an object so that it conveys the illusion of depth, seeming to thrust forward or recede into space. The success of foreshortening often depends on a point of view or perspective where the sizes of near and far parts of a subject contrast greatly.

Perspective: The technique artists use to project an illusion of the three-dimensional world onto a two-dimensional surface, creating a sense of depth or receding space.

Point of View: The position or angle from which something is observed or considered, determining the direction of the viewer's gaze.

SHADING TIP:
Apply more pencil pressure when shading areas of darkness, such as fabric folds, recessed sections, and underneath protruding elements.

Foreshortened Person

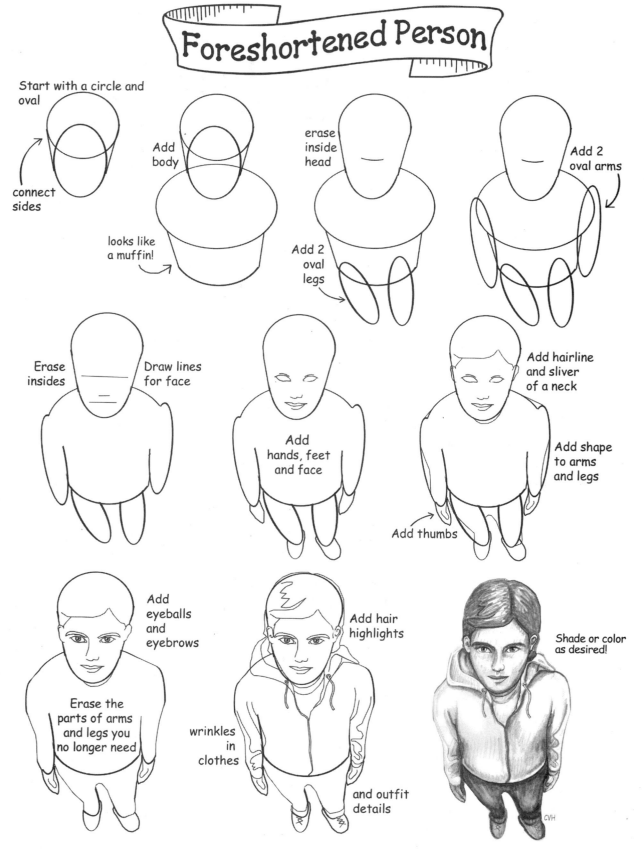

Start with a circle and oval

connect sides

Add body

looks like a muffin!

erase inside head

Add 2 oval legs

Add 2 oval arms

Erase insides

Draw lines for face

Add hands, feet and face

Add hairline and sliver of a neck

Add shape to arms and legs

Add thumbs

Add eyeballs and eyebrows

Erase the parts of arms and legs you no longer need

Add hair highlights

wrinkles in clothes

and outfit details

Shade or color as desired!

CVH

41

CONTOUR LINES AND TUBES

KNOW:
Contour lines surround and define the edges of an object.

UNDERSTAND:
Adding hatch marks to the inside of an outlined object gives it shape and volume.

DO:
• On a separate piece of paper, recreate the 5 mini-drawings shown on the next page.
• Draw your own original work focusing on the use of contour lines.
 Include: at least 5 bending tubes, 4 stacked round shapes, 3 cubes, 2 "furry" objects, and 1 "extra" object.
• Don't forget shadows!

VOCABULARY:

Contour: The outline and other visible edges of an object.

Contour Lines: Lines that surround and define the edges of a subject, giving it shape and volume.

Hatch Marks / Hatching: An artistic technique used to create tonal or shading effects by drawing closely spaced parallel lines.

Tube: A hollow cylinder.

Volume: The space within a form.

Contour Lines and Tubes

Try all 5 drawings and the exercise at the bottom

A simple tube

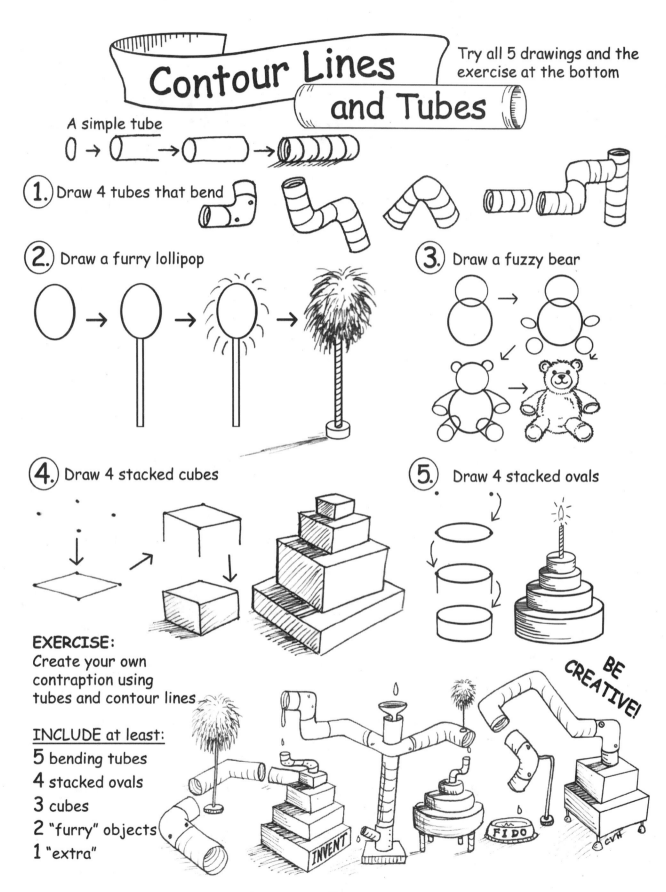

1. Draw 4 tubes that bend

2. Draw a furry lollipop

3. Draw a fuzzy bear

4. Draw 4 stacked cubes

5. Draw 4 stacked ovals

EXERCISE:
Create your own contraption using tubes and contour lines

INCLUDE at least:
5 bending tubes
4 stacked ovals
3 cubes
2 "furry" objects
1 "extra"

BE CREATIVE!

INVENT

FIDO

SHAPES TO FORMS

KNOW:
• Basic cylinder construction in drawing.
• Shape and form are 2 of the 7 elements of art.

UNDERSTAND:
• The difference between shape (2D) and form (3D).
• Depth: The perceived distance from the observer.
• 2D: Two-dimensional, having height and width.
• 3D: Three-dimensional, having height, width, and depth.

DO:
Look at the 2D images of shapes provided and use learned techniques to redraw them as 3D forms.

ASSIGNMENT:
Draw a glass of clear liquid with ice cubes and a straw. Don't forget - ice cubes float!

VOCABULARY:

2D: Two-dimensional artwork has the dimensions of length and width but lacks depth.

3D: Three-dimensional refers to objects or artworks that possess the spatial dimensions of length, width, and depth.

Depth: The perceived distance between the background and the foreground of an object or within a composition, making a two dimensional image seem three dimensional.

Form: A three-dimensional shape (height, width, and depth) that encloses volume.

Shape: An enclosed space defined by its boundary.

Volume: The space within a form.

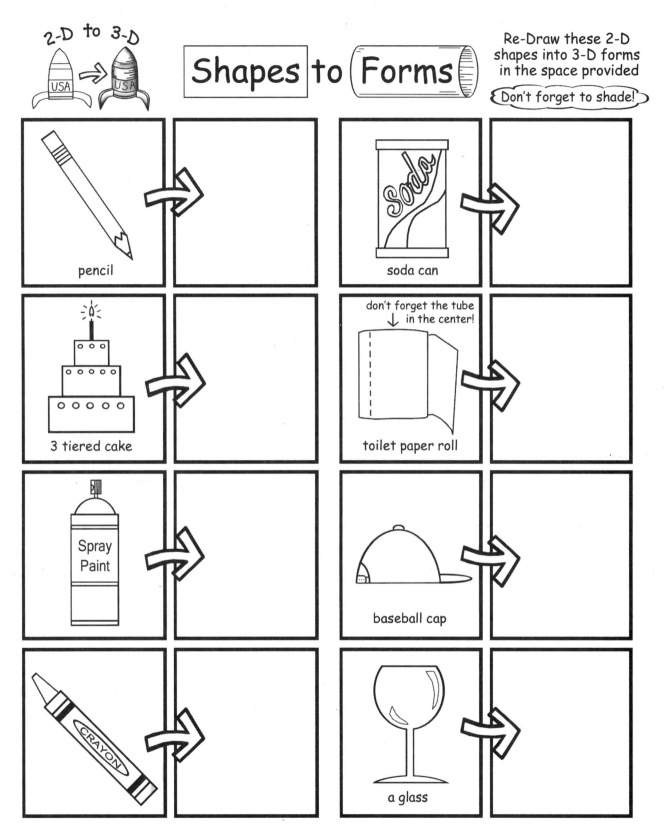

Shapes to Forms

2-D to 3-D

Re-Draw these 2-D shapes into 3-D forms in the space provided

Don't forget to shade!

pencil

soda can

3 tiered cake

don't forget the tube in the center!

toilet paper roll

Spray Paint

baseball cap

CRAYON

a glass

Assignment: On a separate piece of paper, draw a glass of water (cylinder) with ice (cubes) and a straw (tube). Remember, ice cubes float!

45

CYLINDERS AND DISKS

KNOW:
Many objects, both man-made and natural, are based on the cylinder.

UNDERSTAND:
• Cylinders in art give the appearance of a 3D circular tube.
• Disks are short cylinders.
• A variety of everyday objects can be drawn by starting with tubes, cylinders and disks.

DO:
• Practice drawing cylinders by completing the 7 drawings provided.
• On a separate piece of paper, trace the outline of your hand and turn it into a series of segmented cylinders.

VOCABULARY:

Cylinder: A three-dimensional shape resembling a tube.

Disk: A flat, circular region bounded by a circumference (also spelled "disc").

Plane: A flat, two-dimensional surface.

Tube: A hollow, elongated cylinder.

Practice **Drawing Cylinders** AND **Disks**

Draw the 3-D objects below

1. A Disk is a short cylinder . .

Start with 2 dots → • •
← guide points

Connect them at top → •⌒⌒•

Connect the bottom → ⬭

Make another → ⬭

Connect with parallel lines →

Shade →

or →

2. Mug O' Joe

2-D → 3-D

3.

BATTERY BATTERY

#2 Pencil

roll of tape

4.

Draw 3 cylinders showing 3 different angles

5. "Tree of Cylinders"

6. Create your own "tube" animal!

tube cat

Dexter

7. or

fancy tire

GoodYear

8. On a separate piece of paper, trace your hand and turn it into a series of segmented cylinders

47

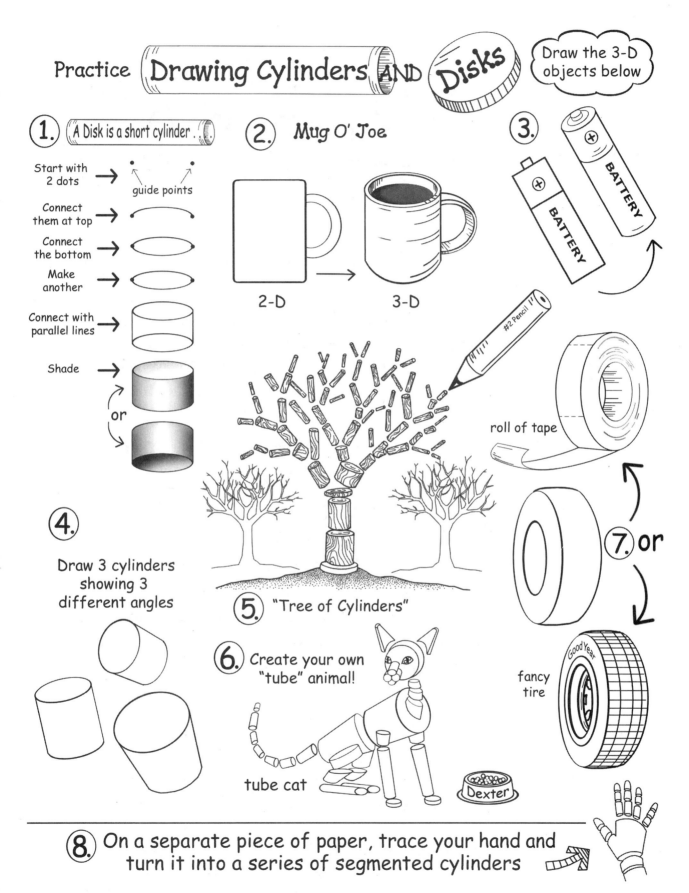

TIERED CAKE

KNOW:
Stacking and layering cylinders can create a unique structure.

UNDERSTAND:
• Indicating both the top and bottom ellipse on a tube drawing, and then erasing the area that is not seen, can aid in creating a proportionate cylinder.
• Cylinders are one of the four basic forms that help an artwork appear three-dimensional.

DO:
• Start at the top of your paper and begin practicing by creating short cylinders layered on top of one another.
• Try to stack as many "cakes" as you can until the page is filled. Add unique decorations to each layer for variety. Some ideas include candles, candies, swirly frosting, flowers, etc.

VOCABULARY:

Cylinder: A three-dimensional shape resembling a tube.

Disk: A flat, circular region bounded by a circumference. (Also spelled "disc")

Ellipse: A circle viewed at an angle, typically drawn as an oval.

Layer: An item that lies over or under another item, creating depth.

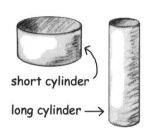

short cylinder

long cylinder →

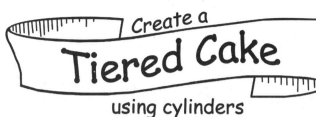

Create a
Tiered Cake
using cylinders

Cylinders are one of the four basic forms that help an artwork appear 3-Dimensional (the others are **cube**, **sphere** and **cone**)

①. Start with two points

point ↓ •

point ↓ •

②. Connect the points with rounded lines to make a thin oval

point ↓

point ↓

③. Add 2 vertical lines directed straight down from both points

point ↓

point ↓

④. Connect the base with a curved line and add two more points at sides

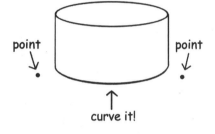

point ↓ •

point ↓ •

↑ curve it!

⑤. Repeat steps 2 and 3 with your new points

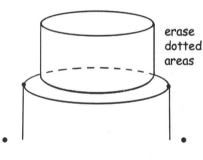

erase dotted areas

⑥. Repeat again for the third tier

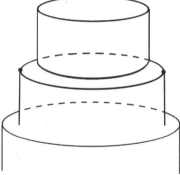

⑦.

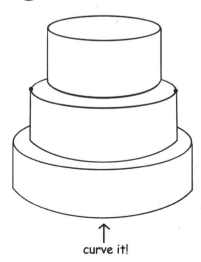

↑ curve it!

⑧. Shade and Decorate

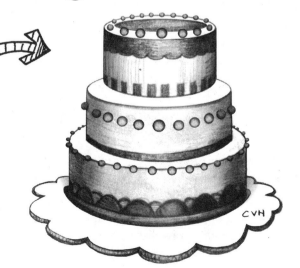

CVH

PIECE OF CAKE

KNOW:
• The techniques used to transform a shape into a form.
• Scumbling.

UNDERSTAND:
• The difference between shape and form.
• Parallel lines indicate both direction and the edges of an object.
• Small additions can become significant details in realistic drawings.

DO:
• Follow the provided steps to create a slice of cake in the form of a triangular prism.
• Enhance your artwork with details, shading, and extra elements to make it unique.
• Try using scumbling to create the cake's texture.

In Step 9:
Lighten the lines around the plate so they are not as dark. Use gentle pencil pressure to add subtle curves to the cake frosting. Apply more pressure in areas of shadow, such as on the right side of the cake and the strawberry. Remember, the fork also casts a small shadow.

Note: "Extra's" are small details that the artist imagines and creates.

VOCABULARY:

Form: A three-dimensional shape (height, width, and depth) that encloses volume.

Shape: An enclosed space defined by its boundaries.

Triangular Prism: A three sided prism (polyhedron)

Volume: Refers to the space contained within a form.

Scumbling

Scumbling: An art technique involving layering small, over-lapping strokes to create texture and depth. It employs light, circular motions to build up layers, resulting in a soft, textured appearance ideal for depicting objects like clouds or foliage with a realistic touch.

Piece of Cake

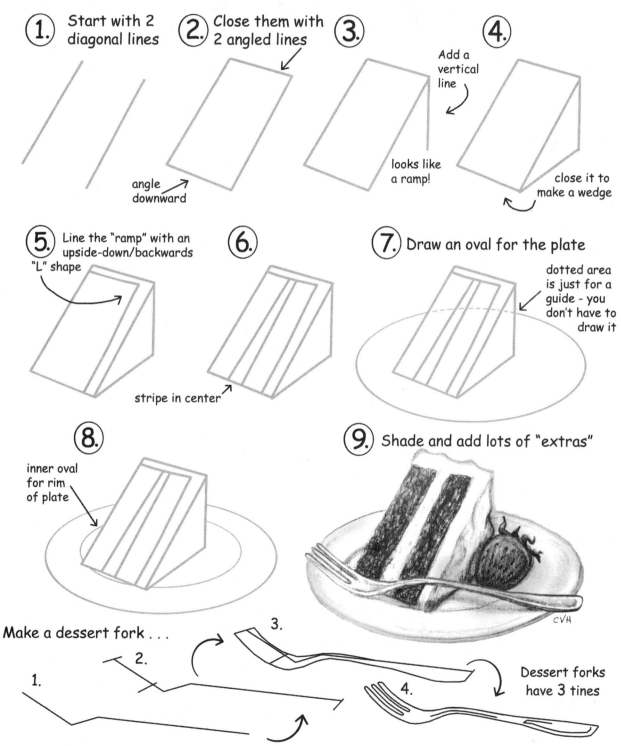

1. Start with 2 diagonal lines

2. Close them with 2 angled lines
 angle downward

3. Add a vertical line
 looks like a ramp!

4. close it to make a wedge

5. Line the "ramp" with an upside-down/backwards "L" shape

6. stripe in center

7. Draw an oval for the plate
 dotted area is just for a guide - you don't have to draw it

8. inner oval for rim of plate

9. Shade and add lots of "extras"

CVH

Make a dessert fork . . .

1.

2.

3.

4.

Dessert forks have 3 tines

RIBBONS, SCROLLS AND BANNERS

KNOW:
Overlapping, Receding Lines.

UNDERSTAND:
• Conveying an illusion of depth.
• Varying sizes and placement on a receding plane.
• Overlapping and shading give the appearance of 3D.

DO:
Practice overlapping and shading by creating a unique version of the banners, scrolls and ribbons seen in the following pages using the provided techniques.

VOCABULARY:

Overlap: The placement of one thing over or partly covering something else.

Perspective: The technique artists use to project the illusion of three-dimensionality onto a two-dimensional surface, creating a sense of depth or receding space.

Plane: A flat surface.

Receding Line: Any line that appears to go back into space.

SHADING TIP:
The banners appear darkest inside the folds, with outer curves appearing lighter. Gently blend the light and dark tones into one another to achieve a smooth finish.

 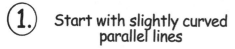

Ribbons and Banners

1. Start with slightly curved parallel lines

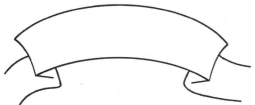

2. Add 4 angled vertical lines as seen below

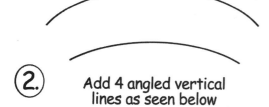

3. Add the bottom edge of the ribbon and curved lines seen here

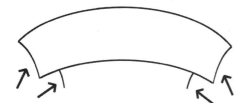

4. Close the ribbon ends and add "cracks" for an aged apperance

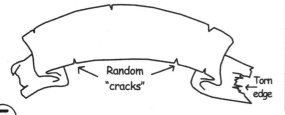

Random "cracks" Torn edge

1. Start with one long, curvy line

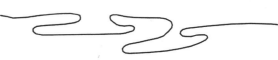

2. Add a short vertical line coming down from each curved edge

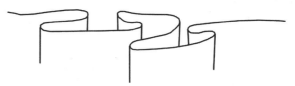

3. Close the bottom of the ribbon with curved lines

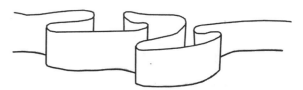

4. Close both ribbon ends with a "<" shape

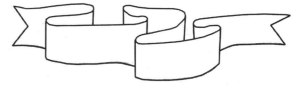

5. Finish with words and shading

53

How to Draw Scrolls

1. Start with a curved line like this

2. Add swirls to each end

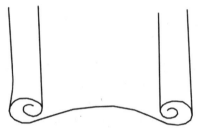

3. Add 4 vertical lines. These will be the ends of the scroll.

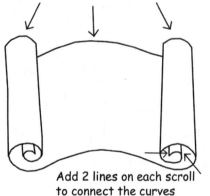

4. Connect tops with 3 rounded lines

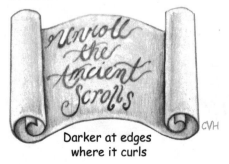

Add 2 lines on each scroll to connect the curves

5. Shade

Darker at edges where it curls

CVH

1. Start with a backwards "S" **2.** Add swirls to each end

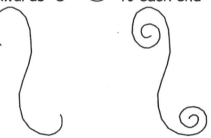

3. Add three horizontal lines

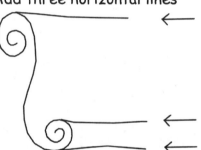

4. Connect swirls with vertical lines

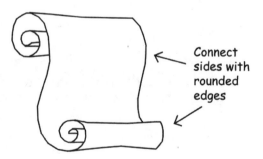

Connect sides with rounded edges

5.

TREASURE MAP

CVH

Rolling Scrolls

Double Roll

1. Start with 2 slightly curved parallel lines

2. Add 2 vertical lines at each end (closer at the center, wider at ends)

3. Add opposite facing swirls
< like this > as seen below

connect with curves

4. Shade darker at the overlapping/ folded areas

Single Roll

1. Start with 2 slightly curved parallel lines. The bottom is longer and "L" shaped

round edge

2. Create a mirror image of the vertical portion of the "L" shape

end banner with jagged edges →

3. Add swirl as seen below. Connect "rolled" portion with a round top

add "fold" details

4. Shade darker at folded areas

Opposite Roll

1.

2.

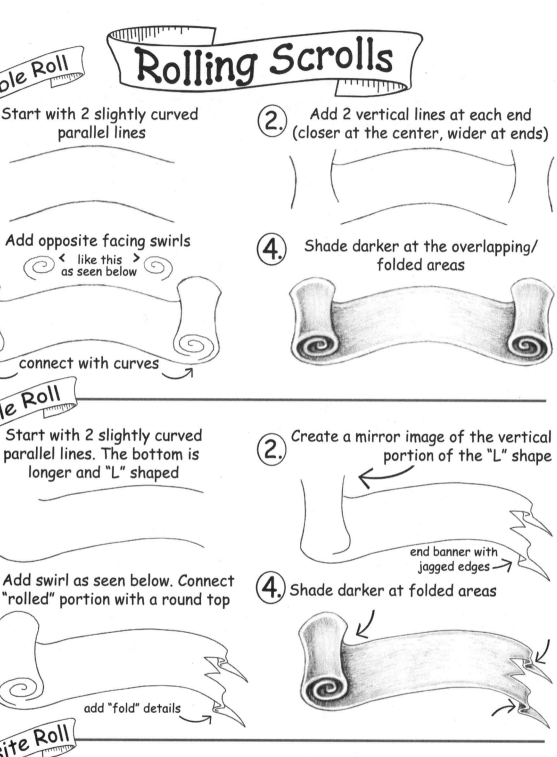

WAVING BANNERS

KNOW:
Curve, Overlapping, Perspective, Receding Lines, Using Guidelines.

UNDERSTAND:
• Any 3D form can be created using a simple line as a guide.
• Conveying an illusion of depth.
• Overlapping and shading give the appearance of 3D.

DO:
• Draw your own Banner/Ribbon/Scroll using the provided techniques.
• Incorporate at least 2 folds to add dimension and interest.

VOCABULARY:

Curve: A line or edge that smoothly deviates from straightness.

Overlap: The placement of one element over or partially covering another.

Perspective: The technique used to project the illusion of three-dimensionality onto a two-dimensional surface, creating a sense of depth.

Receding Line: Any line that gives the appearance of moving back into space.

Guideline: A lightly drawn line used as a reference for the positioning of elements in a drawing.

Note: The dotted lines in "Waving Banners" serve as guidelines and should be erased eventually.

SHADING TIP
Start by adding deep tone inside the folds and along the edges of the banner, where shadows are darkest. The banner's outer curves should be lighter. For a seamless transition, gently blend the light and dark tones.

Waving Banners

1. Start with a backwards "S" shape
(Draw lightly as this line will eventually be erased)

2. Surround the top and bottom of the backwards "S" shape with lines

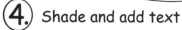

3. Add detail at the folds and ends

erase dotted areas

4. Shade and add text

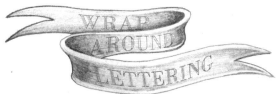

WRAP AROUND LETTERING

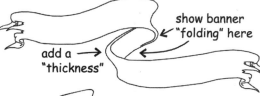
Try Another

1. The backwards "S" shape is coiled loosley

2. Draw lines on both sides

Erase original guideline (shown as broken line)

3. Finish ends

show banner "folding" here

add a → "thickness"

4. Shade and add a message

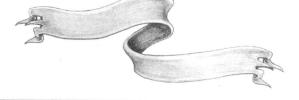

A Simple Banner

1. Draw 2 arching lines

2. Close each end with jagged lines

Try adding text that extends beyond the banner

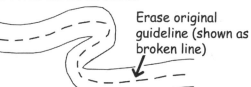

add random cracks to show age

More Waving Banners

1.

2.

The Dex-Meister

1.

2.

1.

2.

1.

2.

AMERICA'S FLAG

KNOW:

A simple repetition of overlapping shapes can create the appearance of a waving flag.

UNDERSTAND:

• Conveying an illusion of folds.
• Drawing stripes or patterns along the curves of a surface helps to indicate realism and depth.

DO:

• Create a waving version of the U.S. flag using the provided tips and techniques.
• Include 13 stripes to represent the original 13 colonies.
• Add 50 stars to represent the 50 states.

VOCABULARY:

Overlap: The placement of one element over or partially covering another.

Repetition: Repeating a single element multiple times in a design.

Contrast: The difference in luminance or color that makes an object distinguishable.

SHADING TIP

When shading the flag, the inner folds should be the darkest, while the outer curves should be lighter. Use small, side-to-side pencil movements to fill in medium and darker tones. Enhance the darkest areas with additional layers and increased pressure for greater contrast.

For a smoother appearance, vary the length of the pencil strokes to avoid uniformity. Consistently shade in the direction that follows the contour of the stripes or shapes.

1. Start with an angled rectangle

2 parallel lines

2 angled lines

2. Repeat the same shape as seen in step 1

slightly lower

3. Repeat again

even lower

4. Add 2 letter "V" shapes

5. erase dotted areas

Connect triangle to rectangle

6. It will look like this . . .

7. Round the points

round these 3

round these 4

8. Add stripes and area where stars will go

6 of the stripes shoule be below the star area

9. Shade

blue

Add 50 white stars (or keep it simple and just add a bunch of white circles)

red

white

CVH

Add a total of 13 stripes to represent the original 13 colonies

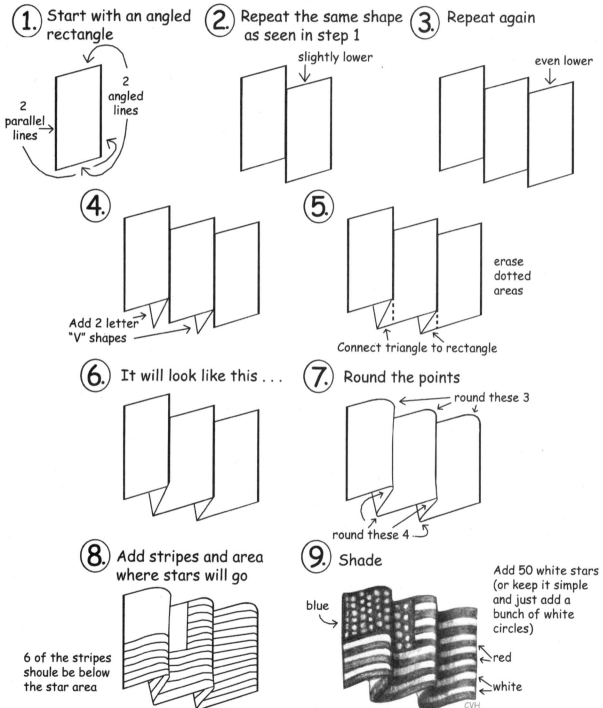

Chapter 2

Human Face Parts

THE HUMAN EYE

KNOW:
Visible parts of the eye: iris, pupil, sclera.

UNDERSTAND:
• A generic human eye can be realistically drawn using a few simple lines and shapes.
• The human eye is spherical.
• The average human eye's width is approximately the distance between the eyes (one eye width apart).

DO:
• Draw a basic human eye using the proposed techniques, beginning with a circle for the iris, a smaller circle for the pupil, and simple arched lines for the eye shape.
• Add eyelashes last.
• Apply shading, then erase areas as needed for highlights and corrections.

VOCABULARY:
Iris: The colored portion of the eye surrounding the pupil.

Pupil: The central, darkest appearing part of the eye located within the iris.

Sclera: The white part of the eyeball surrounding the iris.

Sphere: A three-dimensional, ball-like shape, not a flat circle.

Draw a Human Eye

1. Start with a circle. This will be the iris.

Tip: try and find a circle you can trace!

2. Add a small circle in the center.

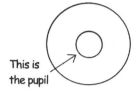

This is the pupil

3. Draw an arch over the larger circle

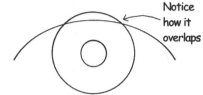

Notice how it overlaps

4. Add bottom lid area

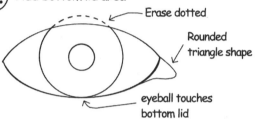

Erase dotted

Rounded triangle shape

eyeball touches bottom lid

5.

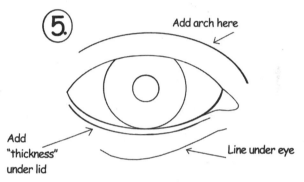

Add arch here

Add "thickness" under lid

Line under eye

6. Start by shading the pupil as dark as you can.

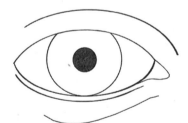

7.

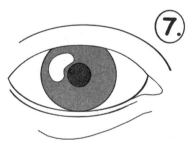

Shade the iris with a light layer of tone. Leave a small area within the iris unshaded to serve as a shiny highlight spot.

8.

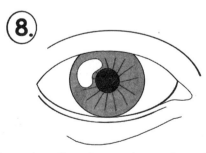

Next, draw faint lines radiating from the center of the pupil, similar to spokes on a bicycle wheel or sun rays. Avoid equal spacing; instead, create a random appearance by varying the thickness and length of each line.

9.

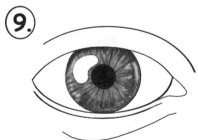

Shade around the rim of the iris to enhance its definition. Gradually lighten each stroke towards the center of the iris to create a feathered effect.

Shading the Eye

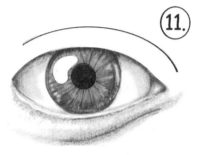

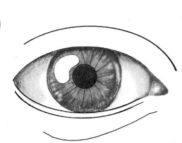

Next, shade the sclera, remembering it's not pure white. Apply a light layer of tone throughout, increasing pressure at the sides and beneath the upper eyelid area. Don't forget to shade the inner corner of the eye as well.

Next, shade the skin around the eye. For the lower lid, which resembles a small ledge, use very light or scumbled lines to avoid hard, straight lines that may appear unnatural. Lightly shade from the inner corner of the eye down into the fold to create a subtle eye pouch. This shading should form a curve extending toward the opposite corner of the eye.

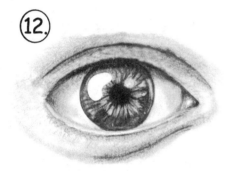

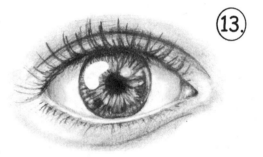

The upper eyelid requires shading in the crease. If desired, use a blending tool to achieve a smooth effect. Enhance the contrast to ensure that the darkest parts of the eye include the iris, the area under the upper lid, and the pupil.

Next, add the eyelashes, doing so later in the shading process to prevent them from being obscured during tone blending. Eyelashes grow in various directions: those on the left mostly point leftward (with a few exceptions), central lashes extend somewhat straight out, and right-side lashes angle toward the right. This pattern applies to both the upper and lower lashes.

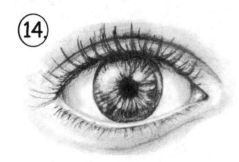

Use a kneaded eraser to gently lift graphite from the lightest areas of the iris, enhancing detail. Ensure the highlight on the eye has softly blurred edges rather than being perfectly sharp, to achieve a more natural appearance.

EYEBALL

KNOW:
Iris, Pupil, Sclera, Sphere, Layering.

UNDERSTAND:
• The distinction between shape (length and width) and form (which includes depth).
• How to create a realistic eyeball using a series of circles of varying sizes.
• Achieving the illusion of depth by layering shapes and varying their sizes.
• How shading adds volume (three-dimensionality) to a drawing, enhancing its believability.

DO:
• Follow the provided steps to create an original eyeball drawing, focusing on shading and blending tones.

VOCABULARY:

Iris: The colored portion of the eye.

Pupil: The darkest part of the eye, located in the center of the iris.

Sclera: The white part of the eyeball.

Layer: The act of drawing one object or shape over another.

Three-dimensionality: The quality of having depth or varying distances, giving the appearance of being three-dimensional.

Mid Tones: The range of tones in an image that are neither very dark nor very light.

Eyeball

1. Start with a circle.

TIP: try and find a circle you can trace!

2. Add a small circle in the center. This will be the iris.

3. Add the last smaller circle in the center of the iris.

This is the pupil

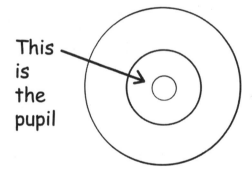

4. Shade the pupil black. Draw "spokes" around the pupil.

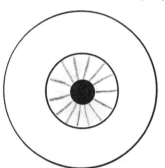

5. Darken edges of iris. Add more "spokes".

Smudge/shade the outer eyeball rim to darken it

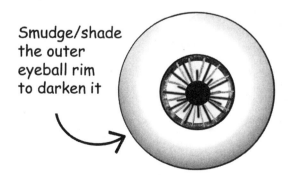

6. Shade entire iris. Add more spokes as needed.

Erase some areas on iris to indicate "shine"

Add a few thin lines for veins

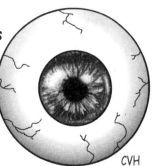

CVH

THE HUMAN NOSE

KNOW:
A generic human nose can be drawn realistically with a few simple lines and shapes.

UNDERSTAND:
• The base of the average human nose is as wide as the distance between the eyes
• The nose protrudes and is usually lighter in the center and darker on the sides (depending on light source)
• A human nose is thin at the point between the eyes and gets wider as it moves down the face

DO:
Practice drawing a generic human nose using the proposed techniques. Shade with pencil and focus on shadows and blending tones.

Tip: Don't make the nostrils too dark as they will draw attention from the rest of the face and look too "piggy."

VOCABULARY:

Shading: The blending of one value into another. Showing change from light to dark or dark to light in an artwork by darkening areas that would be shadowed and leaving other areas light. Shading is used to produce illusions of dimension and depth.

Draw a Human Nose

A Simple Nose

1. Start with a "U" shape

2. Add 2 small "U" shapes to sides

3. Lightly draw sides of nose

4. Shade one side darker

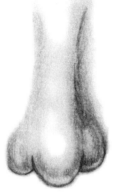

nose is always thinner at top and wider at base

More Advanced

1. Start with a wide "U" and curl the ends

2. Add a "parenthesis" shape to sides

3. Lightly draw sides of nose

4. Shade one side darker

TIP: sides of nose are not lines, they are shaded

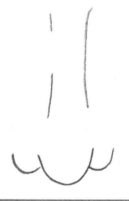
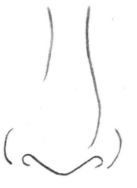
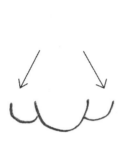

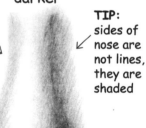

Another

TIPS:

Pick a side to be in the shadows

other side is lighter

erase some spots for highlights

Pick a Nose

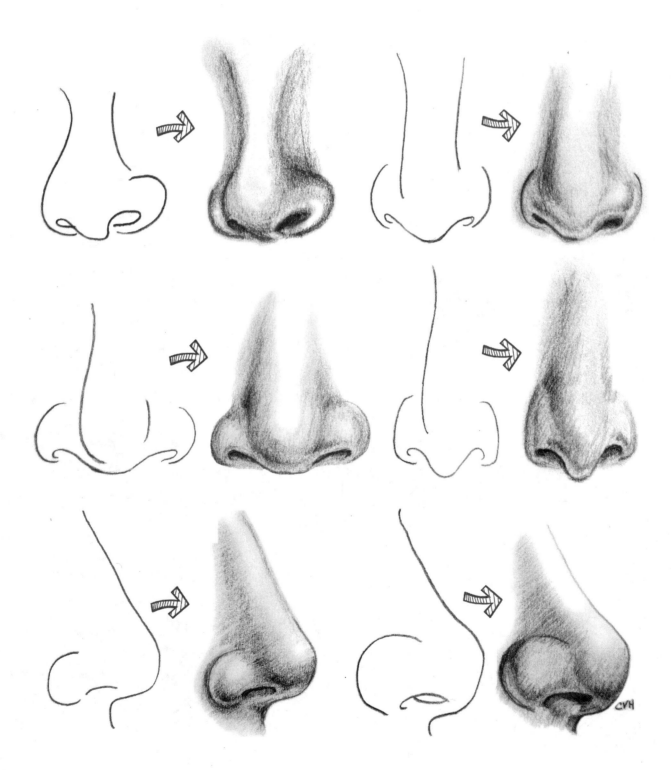

Tips for Shading a Nose

1. Start with a light contour nose drawing.

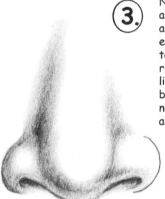

2. Shade the darkest areas, primarily focusing on the nostrils and the base of the nose, especially on the left side to account for a light source from the right. You may need to revisit the nostrils, applying more pressure to deepen the contrast and achieve darker tones.

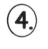

3. Next, introduce the mid-tones, applying a lighter layer of shading adjacent to the darker areas to ensure a smooth transition from dark to light. As you shade toward the right along the bridge, gradually lighten your pencil strokes. Since the bridge will be the lightest part of the nose, refrain from shading in that area.

4. Proceed by applying the lightest tones, ensuring strokes gradually become lighter as they extend toward the right. Introduce a subtle shadow along the bridge of the nose to add depth.

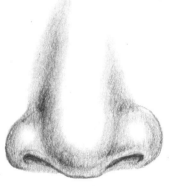

5.

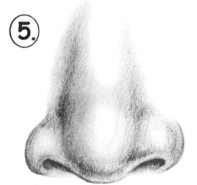

Darken the very bottom of the nose. Round off the tip to prevent the nose from appearing blocky.

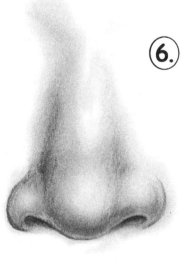

6. Use a blending tool to smooth out the tones, working in sections to prevent smudging. Create highlights by carefully erasing areas such as the tip, the top of the nose bridge, the side of the nose, and a narrow strip beneath the nostril.

THE HUMAN MOUTH

KNOW:
A generic human mouth can be drawn realistically with a few simple lines and shapes.

UNDERSTAND:
• Contour lines can enhance detail and volume by following the shape's natural curves.
• The average human bottom lip is fuller and larger than the top lip for most people.
• Mid-tones help to create depth and dimension in the drawing.
• Drawing with lines that follow the cross contours of a shape shows detail and helps to define volume.

DO:
• Practice drawing a basic human mouth using the proposed techniques.
• Apply shading, focusing on creating the darkest value at the line where the lips meet.
• Erase some spots on the center of the bottom lip to create a natural shine effect.

VOCABULARY:

Cross contour: A method of drawing that creates the illusion of 3D form. These are the drawings that outline and highlight the figurative shape of an object or objects in a drawing.

Draw a Human Mouth

1. Start with a "sunset" shape

2. Make rounded indent at center

Erase dotted area

3. Make 2 more rounded indents (this time at bottom)

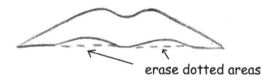

erase dotted areas

4. Add a short line to indicate the location of the bottom lip

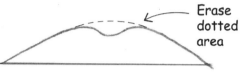

MOST people have a bigger bottom lip than upper

5. Connect the bottom lip with curving lines

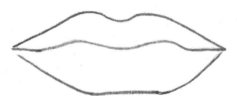

6. Add lip lines

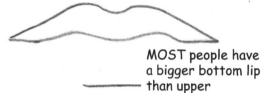

Curved lines show the cross contours of the lip shape

shadow line

7. Darken the line between the lips and the area just beneath the lower lip for added definition

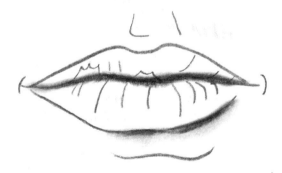

Fill in the shapes outlined in step 6 and smooth out the shadow beneath the lip

8.

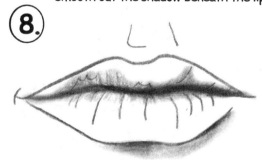

9.

Apply the mid-tones with a medium layer of hue adjacent to the darker areas. Introduce subtle shadows to define the cupid's bow above the lip. Leave areas on the lower lip unshaded where the light naturally hits. Shading along the lip's contour lines will enhance volume and realism.

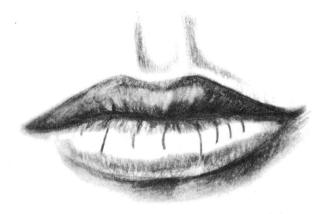

10.

Continue to add lines to define the lip's volume, gradually incorporating the lightest tones.

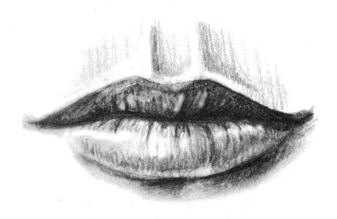

11.

Use a blending tool to smooth out the shading. Restore highlights that may have been obscured during blending by carefully erasing with a kneaded eraser.

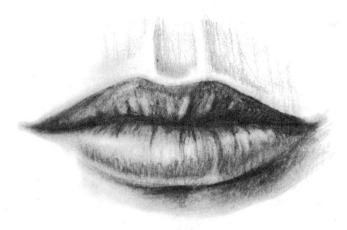

THE HUMAN EAR

KNOW:
• The ear is an organ that detects sound and aids in balance and body positioning.
• Human ears are symmetrically placed on opposite sides of the head.

UNDERSTAND:
• A basic human ear can be realistically drawn with just a few simple lines and shapes.
• Employing a value scale for shading will result in a more realistic depiction.

DO:
• Practice drawing a basic human ear using the suggested techniques.
• Apply the darkest value within the inner curve and beneath the top rounded area.
• Erase certain areas on the lobe to create a natural highlight effect.

VOCABULARY:

Symmetry: Having balanced proportions and identical forms on both sides.

Proportions: The comparative relationship between elements in terms of size, quantity, or degree.

TIP:

When drawing ears on a face, ensure proper proportion by aligning the top of the ear with the eye line and the bottom with the nose line.

Draw a Human Ear

1. Start with 2 overlapping circles on a diagonal

larger circle →

smaller circle →

2. Erase parts shown with dash lines

connect with a line here

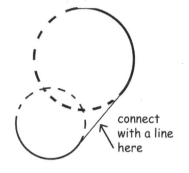

3. Draw the top of a question mark shape

"?" without the bottom dot →

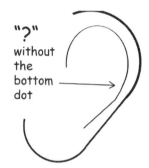

4. Add a small circle

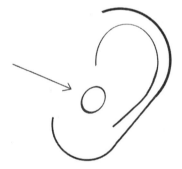

5. Add more as seen below . . .

Add a small triangle →

another curved line →

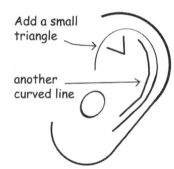

6. Add a few more details

Add 2 more lines here

curve this line upward and inward →

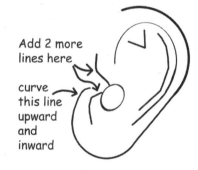

7. Make these 2 shapes and shade them in

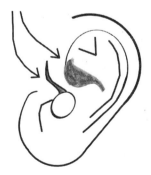

8. Fill in the areas as seen below

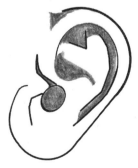

9. Darken areas where ear curves inward.

Blend over and soften any harsh outlines.

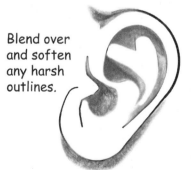

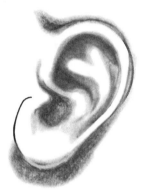

 11.

Add the mid-tones with a medium layer of hue, blending smoothly into the darker tones. Enhance the area below the earlobe with more tone to emphasize its protrusion.

12.

Introduce the lightest tones. Erase any overly prominent dark outlines, as real-life objects don't have outlines.

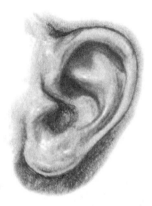

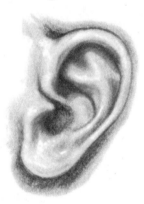

13.

Smooth the shading with a blending tool. Use a kneaded eraser to restore any highlights that might have been diminished during the blending process.

THE HUMAN HEAD

KNOW:
The simple steps to create a human face.

UNDERSTAND:
• The use of proportion in creating a believable human head with accurately placed facial features.
• Subtle differences in the shape and size of specific features make us look unique.
• Protruding objects like the nose and lips cast shadows.
• A basic human head can be realistically drawn using standard guidelines and measurements.

DO:
• Practice drawing a generic human face/head using the proposed techniques.
• Start with guidelines, position the features accurately, and then apply shading.

VOCABULARY:
Proportion: The comparative relationship in size and placement between one part and another.

EXTENSION TO ACTIVITY
Self-Portraits: Start with basic guidelines and use a mirror to see the unique shapes and sizes of your individual features. Focus on identity and individuality; it's those small deviations from the generic face that make us look unique!

SHADING THE HUMAN HEAD

BEFORE SHADING:
• Erase any remaining guidelines.
• Enhance the eyebrows and add a hairstyle, ensuring the hair extends slightly above and beyond the scalp to avoid the appearance of it being plastered to the head.

HAIR:
• Hair typically appears darker than skin. On your drawing, the darkest elements should usually be the hair, irises/pupils, and eyebrows, though exceptions exist.
• Draw hair strands following their natural growth direction.

FACE:
Apply a light tone under the eyebrows, nose, lower lip, between the lips, under the chin, and along the cheekbones, depending on the light source.

LIPS:
• The upper lip is generally smaller and slightly darker than the lower lip on most people.
• Erase a small area on the lower lip to simulate a shine.
• Use rounded, contour lines around the lips to suggest form.
• Erase a thin line above the upper lip to add a highlight.

EYES
• Shade the pupil in black, with the iris being lighter.
• Draw radial lines from the pupil to detail the iris.
• Include a white highlight in the iris.
• The area along the upper lash line should be darker than the lower.
• Eyelashes shorten as they approach the center of the face.

NOSE
• Shade the sides and the area beneath the nose; avoid harsh outlines.
• Use caution when shading nostrils to avoid an unnatural appearance. Lightly erase a line at the nose's base to suggest reflected light.
• Draw two lines from the nostrils to the upper lip to define the cupid's bow and add subtle shading to indicate shadows.

TIP
When drawing your own face, hold the mirror directly in front of you. Looking down into the mirror can result in an unflattering angle, particularly of the nose, leading to a less favorable self-portrait.

A Basic Human Face

1.

Start with an oval or "upside down" egg shape. The top part should be slightly fuller.

2.

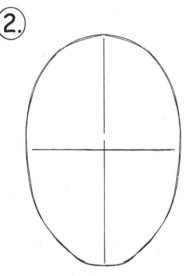

Make a lower case letter "t" in the center of the face.

3.

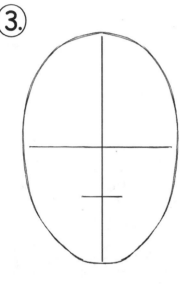

Put your finger in the center of the "t" and your other finger on the chin. Find the center and draw a line there. This will be the bottom of the nose.

4.

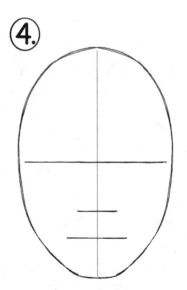

Put your finger in the center of the line you just made and your other finger on the chin. Find the middle, make one last line. This will be the mouth.

5.

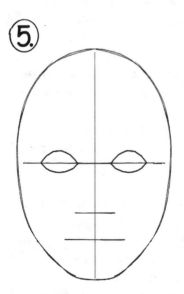

On the top line, draw 2 almond/football shapes for the eyes.
TIP: The distance between your eyes is about the width of one eye.

6.

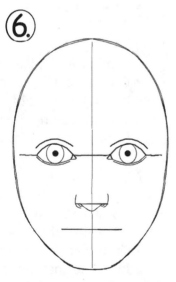

Add the iris, pupil, eye lids, etc. On the second line, draw the bottom of the nose.

TIP: The width of the bottom of the nose is about the same as the width between the eyes.

A Basic Human Face
... continued

7.

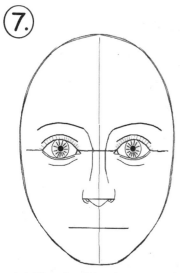

Add "spokes" in the iris and lines for the brows and sides of the nose. TIP #1: The sides of your nose are connected to your brows! TIP #2: The fattest part of the nose is the base, the thinnest part is between the brows. (think triangle shaped)

8.

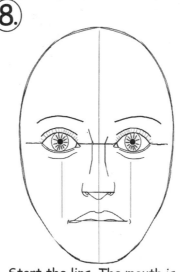

Start the lips. The mouth is usually as wide as the distance between the pupils.

TIP: Don't forget to add the "Cupid's Bow": the little divit at the top of the upper lip.

9.

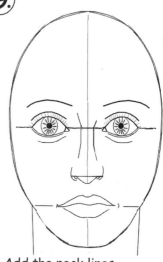

Add the neck lines.
TIP: The neck is about as wide as the edges of the mouth lines.
Add the bottom lip.
TIP: The bottom is usually fuller than the upper on MOST people.

10

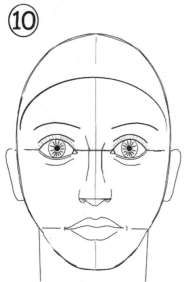

Add the hairline (looks like a swim cap). Add the ears.
TIP: The top of the ear lines up with the eye line, the bottom of the ear lines up with the bottom of the nose.

11

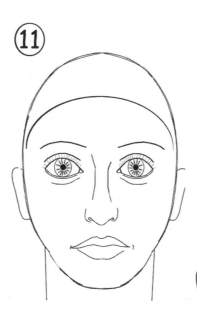

Erase the guidelines

12

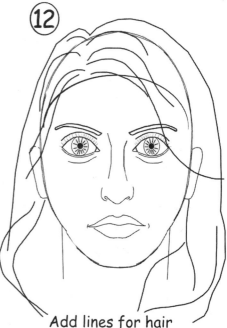

Add lines for hair

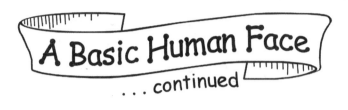

(13)

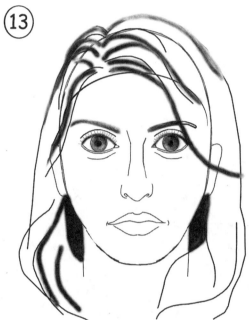

Add the darkest tones

(14)

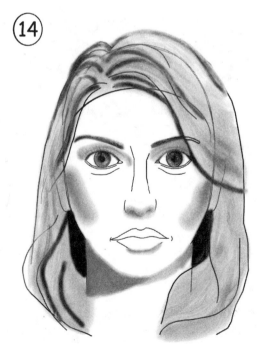

Add the mid-tones

(15)

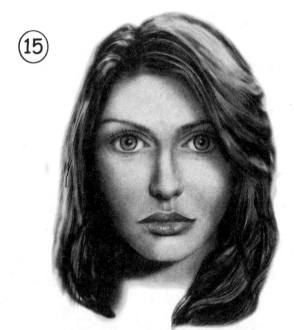

Add more contrast with dark tones
and blend. Use kneaded eraser to
add highlights.

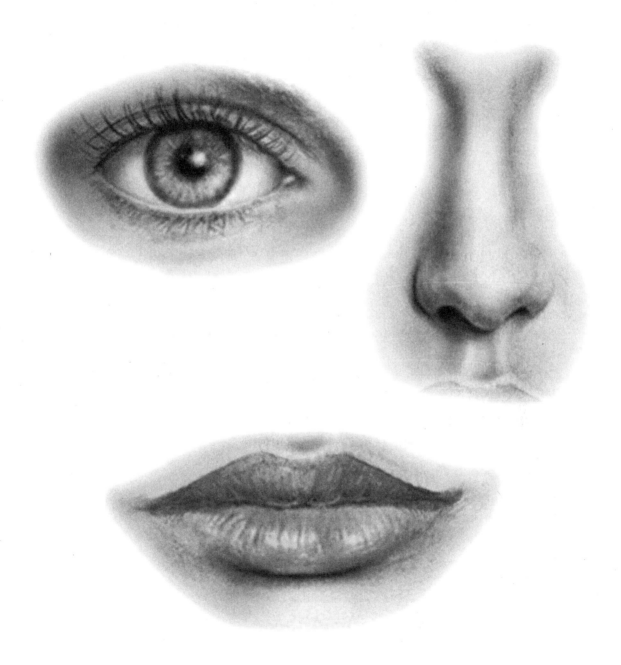

THE HUMAN SKULL

KNOW:
• Simple steps to draw a realistic human skull.
• Major bones of the head.

UNDERSTAND:
• The basics of proportion for creating a skull.
• A basic human skull can be realistically drawn with a few simple lines and shapes.

DO:
• Practice drawing a basic human skull using the suggested techniques.
• Begin with a simple circle and geometric shapes, then refine these shapes to become more organic.

VOCABULARY:

Cranium: The part of the skull that encloses the brain.

Human Skull: Supports the facial structures and forms a cavity for the brain.

Mandible: The lower jawbone.

Organic Shapes: Flowing, curving forms associated with nature, usually irregular, asymmetrical, and without definitive names, unlike geometric shapes, which have precise, uniform measurements.

Proportion: The comparative relationship in size and placement between elements.

Draw a Human Skull

1. Start with a circle

2. Add a rectangle

erase dotted area

3. Add jaw line

angle lines at points

4.

add curve

round and erase sharp edges

5.

add eyes

"house" shaped nose

smile

6.

erase dotted areas

add "arrow" points

add 2 slightly curved "teeth" lines

7.

curve tops of teeth

brow ridges

inner nose detail

add teeth

8. Shade

CVH

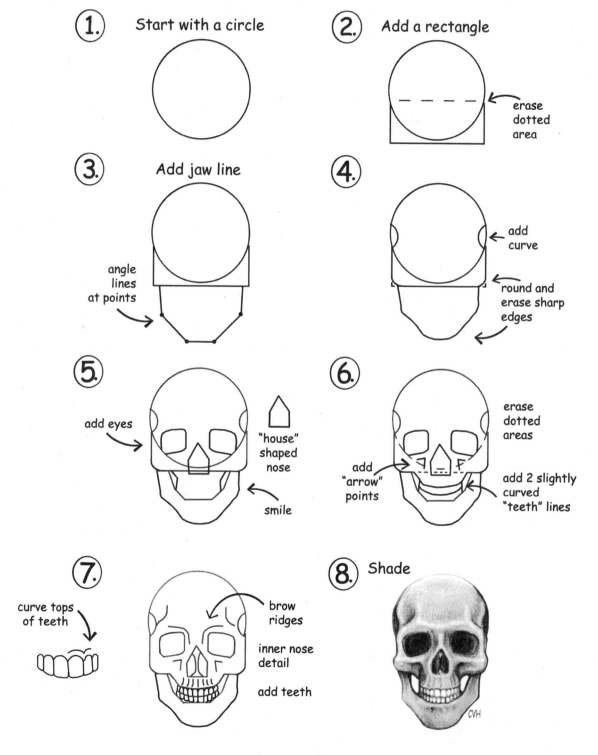

Shading the Skull

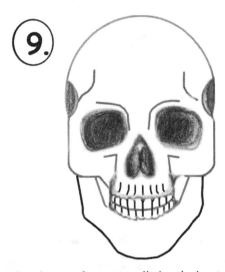

9.

Apply a layer of tone to all the darkest areas, including the eye sockets, temples, and nose area. Use a blending tool to soften harsh lines around the teeth and round out the nose cavity for a more organic look.

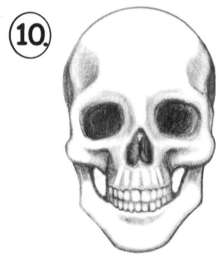

10.

Introduce mid-tones with lighter pencil pressure, filling in medium hues and blending them into the darker areas. Focus on areas above and below the teeth, sides of the forehead, around the nose and eye sockets, and between the teeth. Enhance the cheekbones by rounding and enlarging them as necessary, and blend any harsh outlines for smoothness.

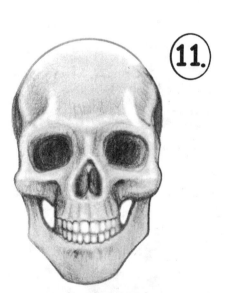

11.

Add the lightest tones while erasing any prominent outlines, as real life objects do not have outlines

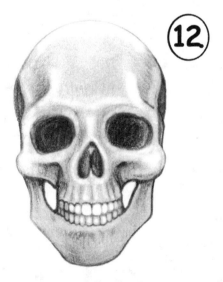

12.

Use a blending tool for overall smoothness. With a kneaded eraser, restore highlights that may have been diminished during blending, especially in the centers of the front teeth, around the sockets, at the temples, and at the top of the head.

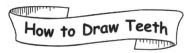

Start with a simple jaw/chin shape

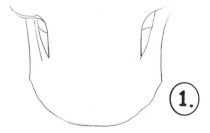

1.

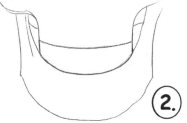

2.

Draw the basic outlines of where the teeth will go by adding horizontal curves to indicate both rows of teeth.

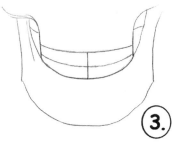

3.

Draw one vertical line in the center to separate the left and right sides.

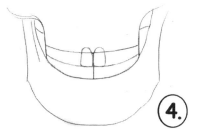

4.

Add the two front teeth. They do not have to touch each other. The curves at the top should go above the guideline.

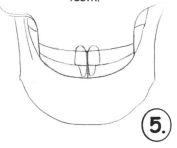

5.

Draw the two center lower teeth. These are smaller and more narrow than the top. The curve is above the guideline.

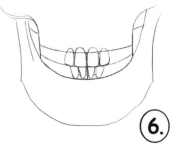

6.

Add another tooth to the left and right of all of the front teeth. Notice the shape of the curves and the direction they are angled. The lower additions are placed lower than the first lower teeth. Draw tiny connecting lines behind the teeth.

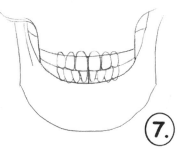

7.

Add the next side teeth, one on each side top, two on each side bottom. These appear smaller than the previously drawn teeth.

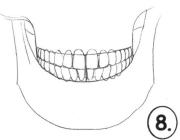

8.

Continue to add small curves on the guidelines until there are no more spaces.

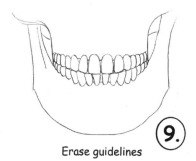

9.

Erase guidelines

Note: Most adults have 32 teeth, which is 12 more than children.

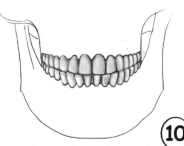

10.

Remove harsh lines with a kneaded eraser. Smooth tones and gently shade the tooth so it is not bright white.

Chapter 3

Perspective

ONE POINT PERSPECTIVE

KNOW:
One Point Perspective.

UNDERSTAND:
• In linear perspective, all lines converge at **a single point** on the horizon.
• Receding lines create the illusion of straight edges extending back into space.

DO:
• Craft an original street scene artwork using a horizon line, vanishing point, and receding lines to convey a 3D illusion.

INCLUDE:
• A minimum of 6 buildings.
• A road.
• Architectural details such as windows, bricks, and doorways.
• Optional "extras" like a car, street signs, or billboards.

VOCABULARY:

Horizon Line: The apparent line where earth or water meets the sky.

One Point Perspective: A drawing method that shows how things appear to get smaller as they get further away, converging towards a single "vanishing point" on the horizon line.

Receding Lines: Lines that appear to retreat from the foreground into the distance.

Vanishing Point: The point on the horizon line where parallel lines seem to converge, creating an illusion of depth.

vanishing points are imaginary points where parallel lines appear to meet

one-point
Linear Perspective
using horizon line, vanishing point and receding lines

use a ruler!

1. Start with a horizon line and a vanishing point.

VANISHING POINT

horizon line ↘

Draw receding lines for the street (should look like a triangle) →

Bring the base of the triangle to the bottom of your paper.

2. Draw a rectangle. This is your first building.

VANISHING POINT

3. Draw a line from the corners of the rectangle to the vanishing point. These are your receding lines.

VANISHING POINT

receding line ↓

receding line ↑

Draw a vertical line between the receding lines to show the "far end" of the building.

4. Finish by erasing the receding lines from the "far end" to the vanishing point. (erase dotted area)

VANISHING POINT

Choose a point where the next building will be. Draw a line from this point to the vanishing point. Then, make a vertical line like you did in Step 3.

YOUR AD HERE

VANISHING POINT

6. Repeat until all buildings are drawn on both sides. Add windows, doors, etc. to complete the scene

CVH

5. Start your next building. Notice how this one is "behind" the second building. Repeat step 3.

VANISHING POINT

TWO POINT PERSPECTIVE

KNOW:
Two Point Perspective.

UNDERSTAND:
• In linear perspective, lines converge at **two points** on the horizon to create depth.
• Techniques of perspective are used to create the illusion of depth.
• Variations in the size of subjects and their overlapping contribute to the illusion.
• Objects drawn lower on the page seem closer to the viewer, while those placed higher appear further away.

DO:
Craft an original artwork using a horizon line, **two** vanishing points, and receding lines to convey the illusion of a 3D street scene.

INCLUDE:
• A minimum of 7 buildings and 2 roads.
• Architectural details such as windows, bricks, and doorways.
• An array of "extras" to enrich the scene.

VOCABULARY:

Depth: The perceived distance from the front to the back or from near to far in an artwork.

Two Point Perspective: A form of linear perspective in which all lines appear to meet at one of two points on the horizon.

The buildings you are drawing may fall below or rise above the horizon line.

two-point Linear Perspective
using horizon line, vanishing point and receding lines

1. Start with a horizon line and TWO vanishing points and a vertical line for your first building.

VANISHING POINT

VANISHING POINT

2. Next, draw receding lines from your center vertical line to BOTH vanishing points.

VANISHING POINT

VANISHING POINT

3. Draw 2 more lines on either side of the center vertical line. This will be your first building.

VANISHING POINT

VANISHING POINT

4. Create another, smaller building. Notice that this new buildings' top is BELOW the horizon line.

use a receding and a vertical line

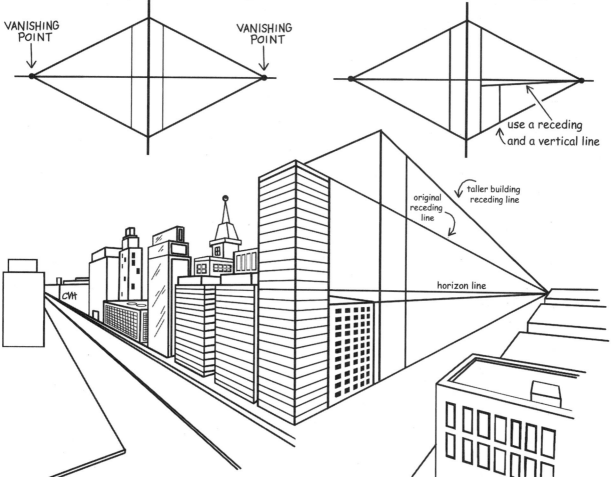

taller building receding line

original receding line

horizon line

CVH

97

AERIAL VIEWPOINT

KNOW:
Aerial Viewpoint.

UNDERSTAND:
• Techniques used to create a "bird's-eye" view.
• The application of receding lines to convey depth.

DO:
• Create an original "bird's-eye" view of a city scene using a vanishing point and receding lines to illustrate depth.
• Show the contrast between near and distant parts of objects within the scene.

INCLUDE:
• A minimum of 8 buildings.
• Architectural details such as windows, bricks, and doorways.
• Trees, roads, and other elements surrounding the buildings.
• Rooftop details like fans, pools, vents, helicopter pads, and other rooftop features.

VOCABULARY:

Aerial Viewpoint: The perspective from a significant height, also known as a bird's-eye view.

Bird's-Eye View: A view from above, simulating the perspective of a bird, commonly used in creating blueprints, floor plans, and maps.

AERIAL VIEWPOINT
a "bird's eye" view of the city
using one-point perspective

1. First, draw several square shapes aroung a central vanishing point. These will be the roof's of your buildings!

2. Next, draw receding lines from each corner (without passing through the shapes) to the vanishing point.

VANISHING POINT

use a ruler!

VANISHING POINT

6. Finish by adding trees, roads and other "extra's" around the base of the buildings.

3. After you have drawn all the receding lines, draw the bottom of each building.

Be careful not to draw over other buildings!

TIP: the "window lines" recede to the vanishing point too!

4. ERASE the receding lines from the bottom's of the buildings to the vanishing point

5. Add "window" patterns and roof details

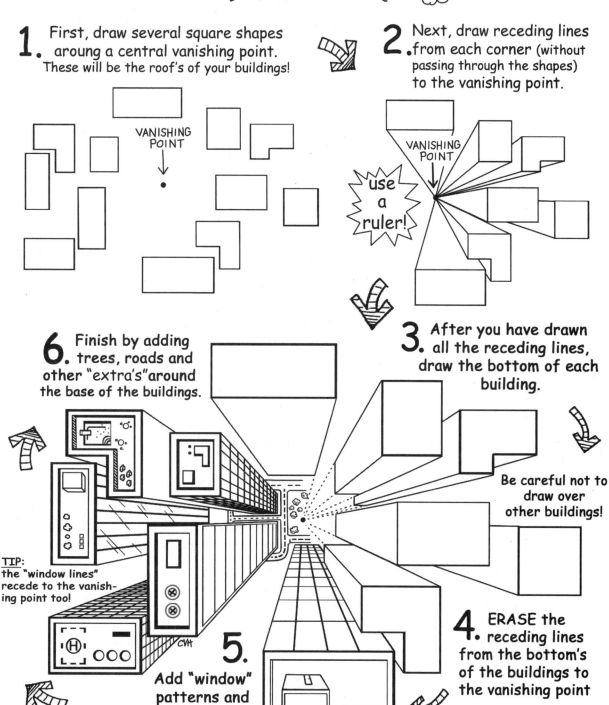

BLOCK LETTER PERSPECTIVE

KNOW:
Differences between near and far objects in a scene.

UNDERSTAND:
• The illusion of depth can be achieved using one-point perspective techniques.

DO:
• Employ the provided techniques to create 3D lettering using one-point perspective, receding lines, and block letters to spell out your name.
• Use shading to enhance the depth of the receding lines. As an added detail, consider incorporating a beveled edge or frame around the letters.

VOCABULARY:

Block Letters: A writing style where each letter is distinct and capitalized, ensuring clarity and separation.

Vanishing Point: A point in the distance where the converging edges of an object seem to disappear, crucial in perspective drawing.

TIP:
Try to create sharp corners in your letters to ensure the edges are not rounded, as sharp edges are easier to work with in perspective drawing. As you practice and get better, feel free to experiment with rounded or bubble letters for a challenge.

Remember: Use a ruler for precision!

Having trouble with your block letters? Refer to the Block Letter Alphabet Cheat Sheet on page 102 for guidance.

BLOCK LETTERS: Draw your name using perspective

(1) First, draw a box for each letter of your name. Make sure there is a little space between each box.

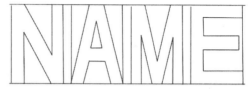

(2) Next, "carve" out your letters from each box. Use the edges of the box as part of each letter as needed.

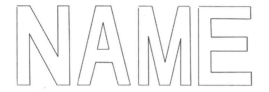

(3) Erase the lines you don't need. Create a point centered under your letters. This will be your vanishing point.

Vanishing point can be above, below, to the left or the right of the block letters.

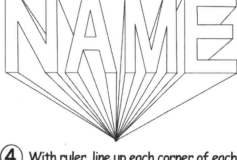

(4) With ruler, line up each corner of each letter to the vanishing point and draw a line. Stop your line when it touches another lewtter. It helps to do all the bottoms of the letters first.

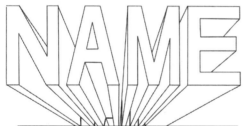

(5) Next, draw a line slightly above the vanishing point and erase any lines below it. Then, extend lines from the far ends of each letter so they align with the fronts.

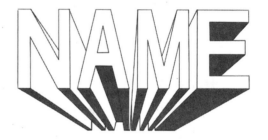

(6) Erase the lines no longer needed. Shade the base of each receding letter a dark hue or color.

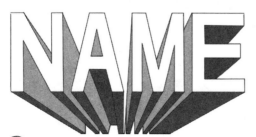

(7) Next, color the remaining receding sections a lighter shade.

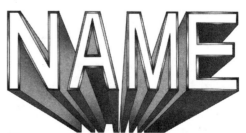

(8) Finish it off by adding a bevel line inside each letter. Shade for a "carved" look.

Block Letter

Alphabet "Cheat Sheet"

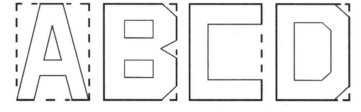

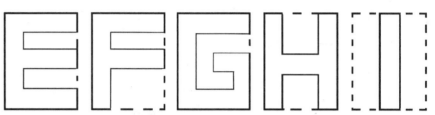

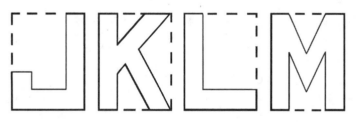

Don't know how to make a "block" letter?

1. Start with a block

2. Draw letter inside using block edges

3. Erase edges that are not part of letter

4. That's it - you're done!

TIPS:

Draw all of your blocks first, then draw letters inside.

When drawing a word, don't forget to leave a little space between each block.

Tips for Shading

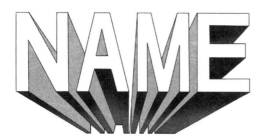

Darken the bottom of each receding line near the front (where it touches the letters) using a gradual pressure so this section appears blended. The darkest tones should be closer to the front while they dissipate as they move toward the back as shown.

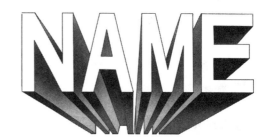

Next, do the same with the receding lines that mark the vertical parts of the letter. Making tones darker in corners and directly next to letters. It is subtle but helps to define the brightness of the letters even further.

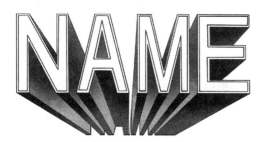

Next, for an extra design, draw lines that follow along the contours of the inside of the letter. It creates the look of a beveled edge.

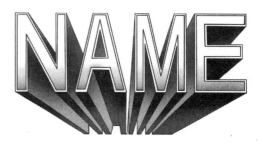

Lastly, apply a gentle layer of tone to the front surfaces of the letters as desired.

DRAW AN ICEBERG

KNOW:
How to create a sense of depth in artwork.

UNDERSTAND:
• Overlapping and differences in the size of objects in a scene help to achieve the illusion of depth.
• Drawn objects that appear close to us are large and usually close to the bottom of the page. Objects that appear farther from us in a drawing are usually small and higher on the page.

DO:
Craft an original artwork that demonstrates overlapping and depth, featuring at least three icebergs of different sizes, water ripples, and a horizon line.

VOCABULARY:

Horizon Line: The apparent line where water or land meets the sky, marking the limit of one's view.

Organic Shape: A naturally occurring, irregular shape, as found in nature.

Perspective: The technique that simulates three-dimensional space on a two-dimensional surface, enhancing the artwork's depth and sense of receding space.

Overlapping: The placement of objects over one another to suggest depth and relative positioning.

Draw an Iceberg

1. Start with an organic shape

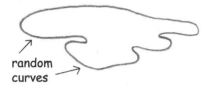

random
curves

2. Add vertical lines at every curve going downward

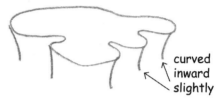

curved
inward
slightly

3. Connect the verticals you just made with a curved base

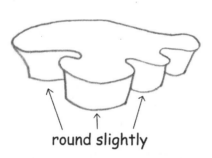

round slightly

4. Add some more smaller organic shapes higher up on the page

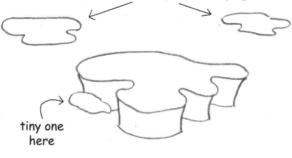

tiny one
here

5. Connect the smaller shapes with vertical lines

background icebergs
thinner than
foreground icebergs

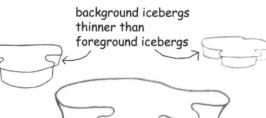

See next page
for shading
information

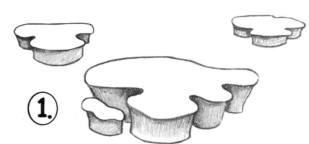

1.

Add tone to the 3D edge of each iceberg. Use heavier pencil pressure near the top and less pressure as the shading moves toward the bottom.

Next, add some texture to the top of the iceberg. This should be a light layer of tone that follows the contour of the front/tops of each berg. Blend the tones to smooth them.

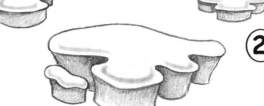

2.

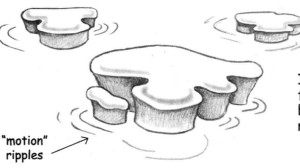

3.

"motion" ripples

In the area around the icebergs, draw a few lines that follow the contour of the bottom edges. These will look like motion ripples in the water.

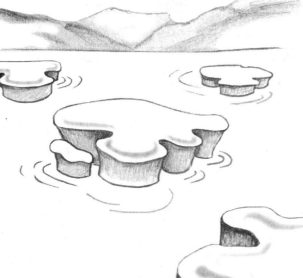

4.

Finally, draw a light horizon line in the background and add "extra's" as desired.

DRAW 2 TURNTABLES

KNOW:
Another way to use receding lines and create a sense of depth in an artwork.

UNDERSTAND:
• Objects that appear closest to the viewer are usually drawn larger and close to the bottom of the page. Objects that appear farther away in a drawing are usually drawn smaller and higher on the page.

DO:
Create an original artwork featuring two turntables, applying the principles of perspective to convey depth.

VOCABULARY:

Perspective: A technique that creates the illusion of three-dimensional space on a two-dimensional surface. Perspective helps to create a sense of depth or receding space.

2 Turntables

① Start with 2 diagonal lines

vanishing point

wider at base

② erase dotted areas

Draw 2 parallel lines

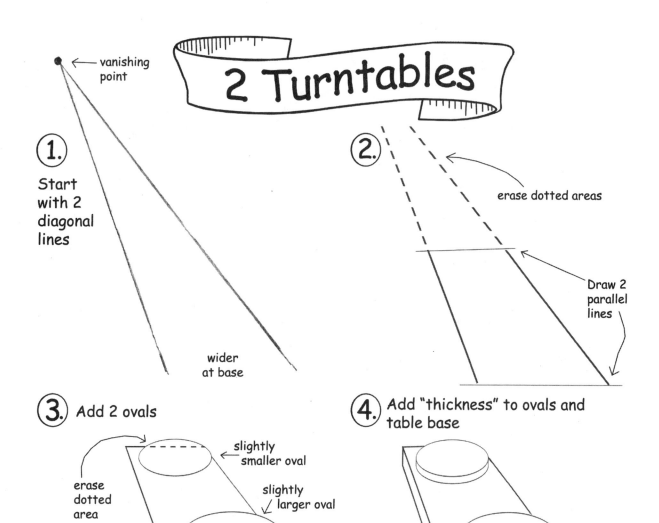

③ Add 2 ovals

slightly smaller oval

erase dotted area

slightly larger oval

④ Add "thickness" to ovals and table base

⑤ Add needle arms and ovals in center of records

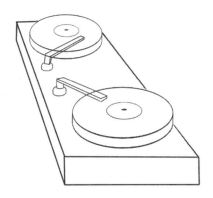

See the next page for shading information

Add a light layer gradient tone that is darker near the top edge of the 3D edges.

7.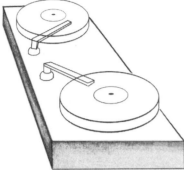

8. Add a dark layer of tone to each record. Use heavy pressure on the sides and lighter pressure near the front and back of each record. Try to shade in the direction of the contours so that each line looks like a groove in the record.

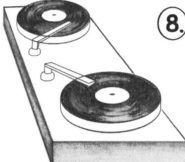

9.

Add a light layer of tone to the 3D edge of record.

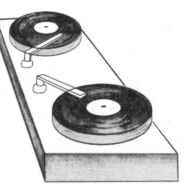

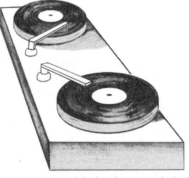

10. Add shadows with light tones to the rectangular prism. Erase any guidelines seen through needle arms.

Erase a few thin lines in each record that follow the contour of the oval shape to further define grooves.

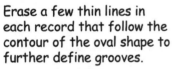

11.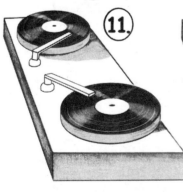

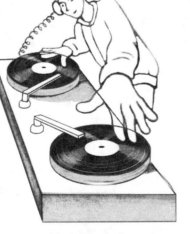

12. Add a sketch for any "extra's" (like a DJ!)

13. Shade

AN OPEN BOOK

KNOW:
Receding lines contribute to the illusion of depth in a drawing.

UNDERSTAND:
The part of a drawing closest to the bottom of the page appears larger, enhancing the perception of depth.

DO:
Craft an original artwork of an open book using the techniques you've learned. Enhance your drawing with "extras" such as a candle, quill pen, inkwell, or text on the pages.

VOCABULARY:

Perspective: A technique that creates the illusion of three-dimensional space on a two-dimensional surface, adding a sense of depth.

Receding Line: A line that appears to move back into space, contributing to the illusion of depth.

An Open Book

1. Draw an angled line with a "flying-bird" shape on top as shown.

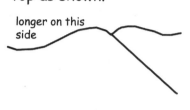

longer on this side

2. Add a slight diagonal line to the left "wing"

3. Turn that line you just drew into a rectangle. Notice the short lines are at an angle.

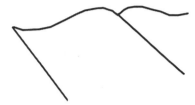

make it angled

4. Create 2 curves and one line to indicate the "far end" of book. Add a "flying bird" shape to bottom like you did in step 2.

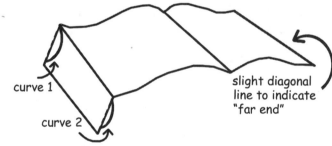

curve 1

curve 2

slight diagonal line to indicate "far end"

5. Add a curve at the "far end" of the book and a dented line at the base as shown. Erase dotted area.

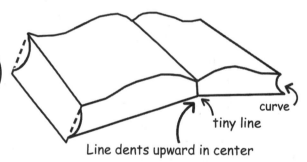

curve

tiny line

Line dents upward in center

6. Add cover under your pages

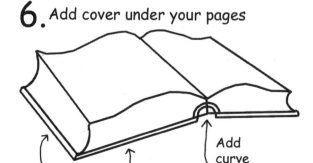

Add curve here

Draw lines at edges to indicate book cover thickness

7. Finally, add lines for pages. Add "extras" to make it more interesting.

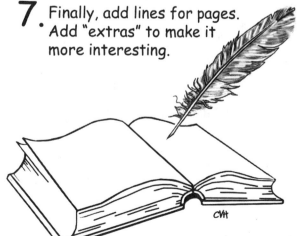

CVH

OPEN GATES

KNOW:
Vertical lines, Parallel lines.

UNDERSTAND:
In most architectural drawings, vertical lines are typically parallel, as are horizontal lines, but it's rare for both to be perfectly parallel and straight in the same drawing. For this exercise, all vertical lines will be straight and parallel, while horizontal lines may vary.

DO:
Craft an original artwork of opening gates using the techniques provided. Enhance your drawing with additional details such as scroll designs, bars, brickwork, and more.

VOCABULARY:

Architectural Drawings: Drawings that depict human-made buildings.

Horizontal: Lines or planes that are straight and flat, running parallel to the horizon— opposite of vertical.

Parallel: Lines or edges that are straight and on the same plane, never crossing. Parallel lines maintain a consistent direction.

Perspective: A technique that simulates three-dimensional space on a two-dimensional surface, adding a sense of depth.

Vertical Line: A line or direction that runs straight up and down.

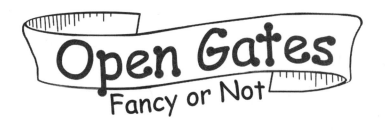

Open Gates
Fancy or Not

use a ruler!

1. Start with an angled rectangle like this one

angled downward here

angled upward here

2. Repeat that shape, but this time make it a mirror image

angled downward here

angled upward toward the center

3. Add a skinny rectangle on each side and 2 lines inside each gate (angled upward)

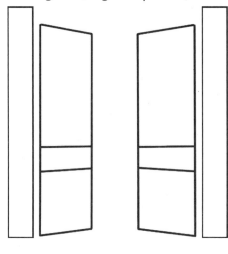

4. Add parallel lines that are close together inside the gate.

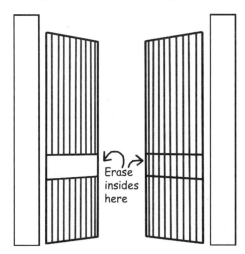

Erase insides here

5. Add fancy scrolls inside gate and on top if you want. Use your imagination!

Add a few rectangles for "bricks" inside pillar

Extend fence on both sides if you have space

CVH

Chapter 4

Holidays & Seasons

VALENTINE
Heart Lock and Key

KNOW:
Drawing objects from unique angles can enhance the appeal of your artwork.

UNDERSTAND:
• How to add depth and interest to your drawings.
• How to take simple shapes and change them into more complex forms.

DO:
Craft an original artwork featuring a heart-shaped lock and an old-fashioned key, using the suggested techniques to depict length, width, and depth.

VOCABULARY:

Depth: The third dimension in art, indicating the perceived distance from front to back or near to far.

Perspective: The technique used to create the illusion of 3D onto a 2D surface. Enhancing the artwork's depth.

Length: The measurement or extent of something from end to end, often used to describe the longer side of objects.

Width: The measurement or extent of something from side to side, often used to describe the shorter side of objects.

Heart Lock with Key

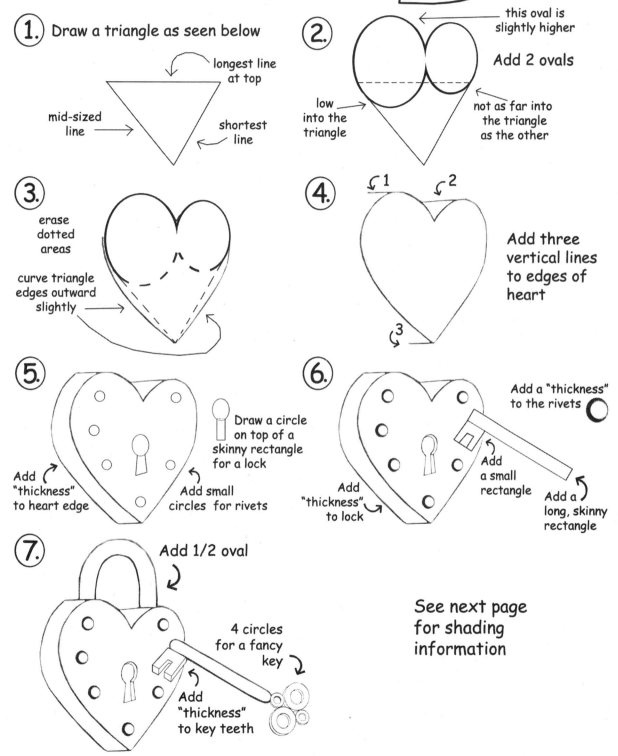

1. Draw a triangle as seen below

longest line at top

mid-sized line

shortest line

2. this oval is slightly higher

Add 2 ovals

low into the triangle

not as far into the triangle as the other

3. erase dotted areas

curve triangle edges outward slightly

4. 1 2 3

Add three vertical lines to edges of heart

5. Draw a circle on top of a skinny rectangle for a lock

Add "thickness" to heart edge

Add small circles for rivets

6. Add a "thickness" to the rivets

Add a small rectangle

Add "thickness" to lock

Add a long, skinny rectangle

7. Add 1/2 oval

4 circles for a fancy key

Add "thickness" to key teeth

See next page for shading information

119

Tips for Shading

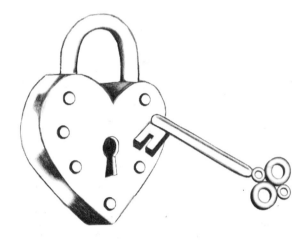

When starting to shade, add the darkest tones first

Then, add the mid tones. This is a lighter lay down of tone next to the dark areas which will help the dark transition into the light smoothly.

Next, add the lightest tones and smooth.

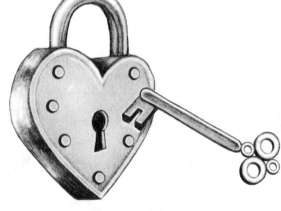

erase parts for shiny edge

Use a blending tool to smooth out the shading. Restore highlights that may have been obscured during blending by carefully erasing with a kneaded eraser.

ROSE

KNOW:
The distinction between geometric and organic shapes.

UNDERSTAND:
• Connecting a series of simple geometric shapes can form a complex, organic object like a rose.
• Asymmetry, where the two halves of the drawing are different, creates visual interest and emphasis.

DO:
Use the provided techniques to create an original artwork of a rose, showcasing an organic shape with overlapping petals.

VOCABULARY:

Asymmetry: An object that is different on both sides, which draws attention to specific areas within the drawing.

Overlapping: The placement of parts of objects over one another to create the illusion of depth. When one part covers another, they are overlapping.

Balance: A design principle that arranges elements to create a sense of stability in an artwork.

Geometric Shape: A shape or form defined by mathematical properties, typically featuring straight lines and angles, resulting in a structured appearance.

Organic Shape: A shape that occurs naturally, characterized by flowing, unpredictable contours, commonly found in nature.

How to Draw a Rose

1. Lightly draw a small oval above a large circle

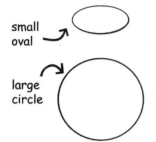

small oval

large circle

2. Connect the shapes with 2 angled lines

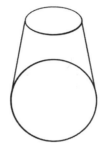

3. Add a diagonal/curved line as seen below

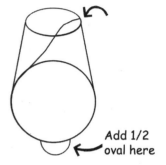

Add 1/2 oval here

4. Erase dotted areas

5. Add curve

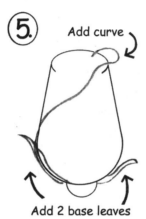

Add 2 base leaves

6. Connect curve with 2 lines

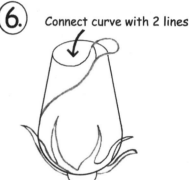

Add 3 more base leaves

7. Add small oval here

Add small curve here

erase dotted areas

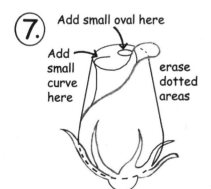

8. Add another petal

curve this line outward

stack cylinders in center

Add a thin stem

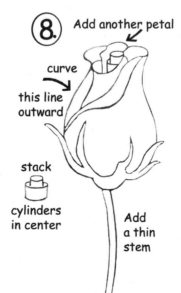

See next page for shading information

Tips for Shading

1. an oval and a triangle make a raindrop shape

Add a leaf using a "rain drop" shape with points added. Draw small curves where the stem meets the flower.

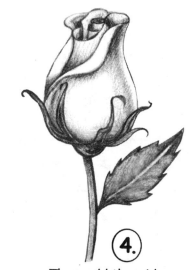

Add points around the edges

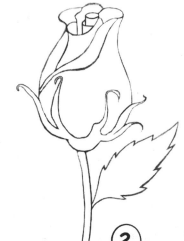

2.

Start with a basic rose outline.

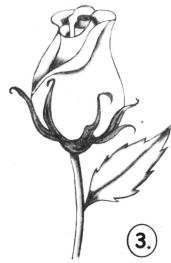

3.

Add tone to the areas that will be the darkest. This includes parts of the stem and overlapping areas on the rose. Shade a line down the center of the leaf for a vein.

4.

Then, add the mid tones. This is a lighter lay down of tone next to the dark areas which will help the dark transition into the light smoothly. Leave a line below the leaf vein untouched for now.

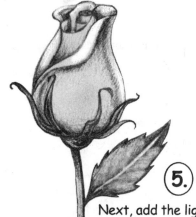

5.

Next, add the lightest tones and smooth.

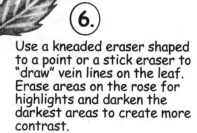

6.

Use a kneaded eraser shaped to a point or a stick eraser to "draw" vein lines on the leaf. Erase areas on the rose for highlights and darken the darkest areas to create more contrast.

LOVE SWANS

KNOW:
Mirror symmetry, Reflection.

UNDERSTAND:
• Mirror symmetry is where one half of an object or drawing reflects the other.
• Perfect symmetry is rarely found in nature.
• Symmetry represents order and helps us to make sense of the world around us.

DO:
Create a symmetrical design of "Love Swans" using basic shapes, following the provided tips and techniques.

VOCABULARY:

Balance: An even use of elements throughout a work of art.

Mirror Symmetry: A very formal type of balance consisting of a mirroring of portions of an image. Its opposite is asymmetry or asymmetrical balance. Mirror symmetry is sometimes referred to as reflective or bilateral symmetry.

Symmetry: When one-half of an object is the mirror image of the other half.

Whatever you do to one side, try and match it on the other . . .

Love Swans

using Mirror Symmetry

1. Start with 2 oval shapes almost touching

2. About 2/3 of the way down, draw a line through the ovals

erase area under the line (shown as dotted above)

3. Add triangle tails to both sides

make small triangle here

diagonal line here

erase dotted areas

4. Draw a circle touching the diagonals

erase dotted areas

5. round this triangle

Draw a "seagull" shape

erase dotted areas

6. Add a tiny oval and rectangle in center

elongated "S" shape

Add a wing

7. erase

Draw "heart" shape inside neck area

8. beak detail

9. Shade

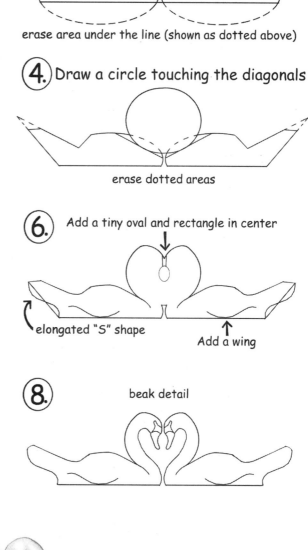

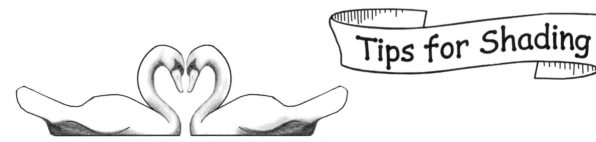

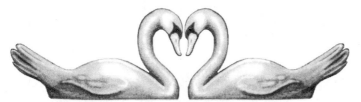

Use a light touch and add some tone to areas under the wings, on the face and at the curve of the neck. Most swans are white so we don't want to use too much pressure when shading. Add a dark eye on the face.

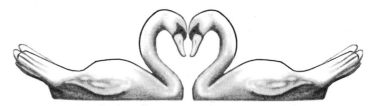

Then, add the mid tones. A slightly lighter tone next to the dark areas. Shade in a few lines to describe the tail feathers.

Add the lightest tones, leaving much of the swans untouched and smooth. Use a kneaded eraser to lighten hard lines and remove smudges or areas that need more highlight. Remove the tail feather guidelines that are no longer needed.

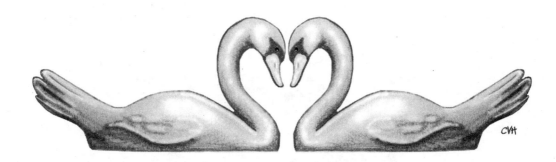

128

BARBED WIRE HEART

KNOW:
Connecting a few simple geometric shapes can form a more complex object.

UNDERSTAND:
• Overlapping techniques are useful in drawing objects to convey depth.
• Curved lines that follow the contour of an object can effectively indicate its form.

DO:
Create an original artwork of a heart entwined in barbed wire. Used curved, overlapping lines over the heart to create the illusion of the wire "wrapping" around it, adding depth to the drawing.

VOCABULARY:

Form: A three-dimensional element of art (involving height, width, and depth) that encompasses volume.

Overlap: When one object partially covers another in a drawing, a crucial technique for suggesting depth. This, along with variations in size, placement, and perspective techniques, can help in achieving a sense of three-dimensionality.

Barbed Wire Heart

1. Start with 2 circles

overlap

2. Add triangle on bottom

edges touch

overlap

3. Erase lines inside

4. Add a slightly curved diagonal line

round edges

5. Erase to make dash line

6. Add Barbs

(see bottom sides for details on barbs)

7. Add another line between barbs

8. "Wrap" more lines around heart

9. Add more barbs and more lines

cross some lines so wire looks twisted

MAKE A BARB
1.
2.
3.
4.
5.
6.

10. Add "drips"

11. Shade

Erase curved lines near the edges to create shiny spots

CVH

MAKE AN EASY BARB

twist lines and add an "X"

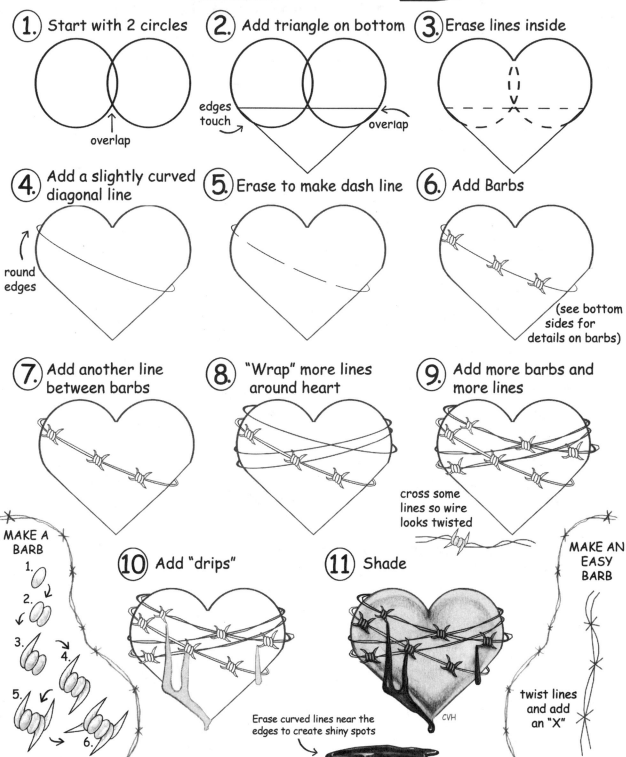

SCROLL AND ROSE

KNOW:
• Connecting simple geometric shapes can form a complex, organic object.
• Curved lines can convey perspective through overlapping.

UNDERSTAND:
• Overlapping and differences in the size of objects in a scene help to achieve the illusion of depth.
• High contrast shading can help to give the appearance of form and 3D.

DO:
Use the provided steps to create your own version of a banner wrapping around a rose blossom. Add a message on the banner and apply shading. Refer to the shading techniques found in "How to Draw a Rose" on page 124 and "Ribbons and Banners Shading" on page 53 for guidance.

VOCABULARY:

High Contrast Shading: A technique that emphasizes a stark difference between dark and light areas in an artwork, often with limited use of mid-tones, to enhance the visual impact.

Overlap: The effect when one object partially covers another, suggesting depth and layering in the artwork.

Scroll and Rose

1. Start with a spiral

2. Add a base (looks like a wine glass)

3. Add "wings" and 3 petals

"wings"

4. "Thicken" wings

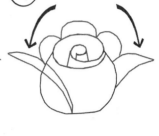

5. Add curvy bottom petals and stem nub

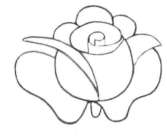

6. The rose is done! Next, start scroll

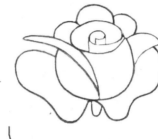

angled curvy line

7. Vertical lines from each curve

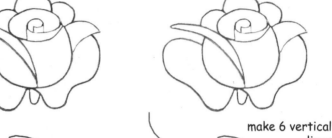

make 6 vertical lines

8. Close the scroll using pointed ends

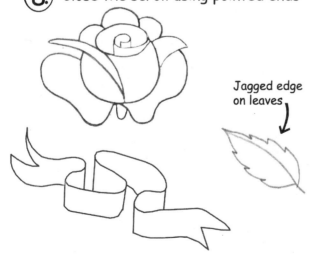

Jagged edge on leaves

9. Add a stem, leaves and lettering Shade it!

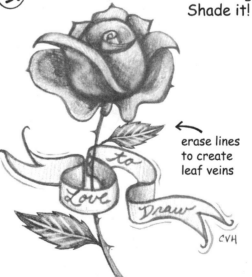

erase lines to create leaf veins

Love to Draw

CVH

POT O' GOLD

KNOW:
• Simple shapes combined together can create more complex objects.
• Many objects (man made and natural) are based on the cylinder.

UNDERSTAND:

• Disks are short cylinders.
• Using the principles of a cylinder (rounded base and an ellipse top) can create a variety of shapes when used in drawing.

DO:
Create the illusion of a 3D pot filled with "disks" of gold coins. Shade.

VOCABULARY:
Cylinder: A tube that appears three-dimensional
Disk: A 3D oval, a flat, thin, round object.
Ellipse: A circle viewed at an angle (drawn as an oval)

Pot O'Gold

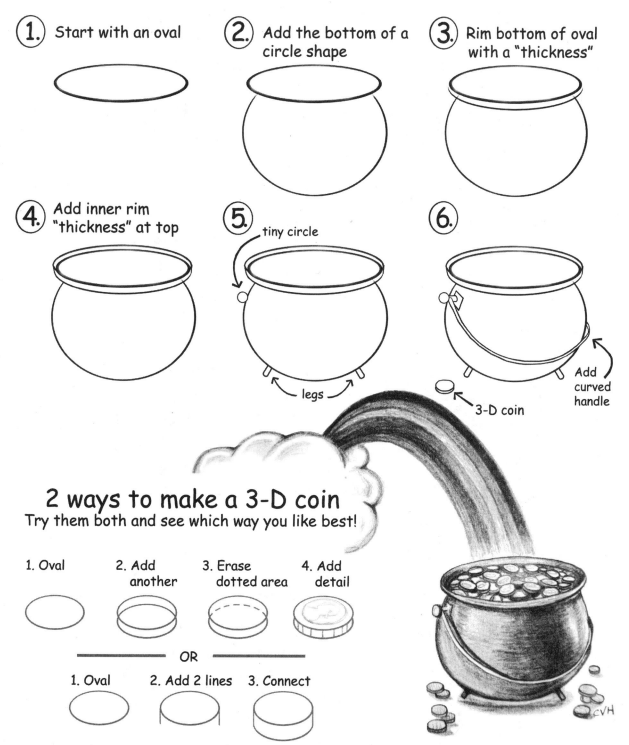

1. Start with an oval

2. Add the bottom of a circle shape

3. Rim bottom of oval with a "thickness"

4. Add inner rim "thickness" at top

5. tiny circle
legs

6. Add curved handle

3-D coin

2 ways to make a 3-D coin
Try them both and see which way you like best!

1. Oval 2. Add another 3. Erase dotted area 4. Add detail

OR

1. Oval 2. Add 2 lines 3. Connect

CVH

135

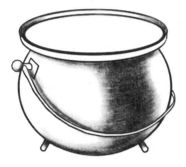

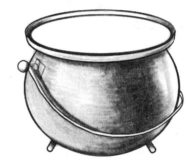

Start by adding tone to the areas that will be the darkest. This includes parts under the rim, a shadow from the handle, under the base, and a section on the right as illustrated.

Then, add the mid tones. This is a lighter lay down of tone next to the dark areas which will help the dark transition into the light smoothly.

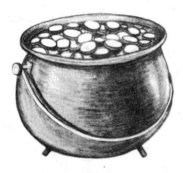

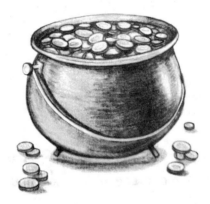

Next, add the lightest tones and smooth. Inside the pot, sketch some quick, short cylinders to represent coins. Fill in the areas between coins with tone.

Use a kneaded eraser to add highlights in the shiniest, lightest spots. Add shadow under pot and more coins on the outside. Add a light layer of tone over the coins, focusing on darkening spaces between the coins and the 3D edge.

Know · Understand · Do

CUTE EASTER STUFF

KNOW:
• Simple shapes combined together can create complex objects.
• Adding hatch marks around an outlined object will indicate texture.
• Drawing hatch lines within an object will help to show form, volume, and shading.
• Drawing cross contour lines on an object will help convey its three-dimensionality.

UNDERSTAND:
• The techniques of "hatching" and "cross-hatching" are effective for depicting shadow, texture, or form in an object.
• Texture is used by artists to show how something might feel or what it's made of.
• Lines which travel across the form of an object represent the third dimension in a linear fashion (basket).

DO:
• Use the provided guidelines to draw a baby chick, focusing on creating texture.
• Draw a basket using ovals and cross contour lines to emphasize its three-dimensionality.
• Incorporate "extras" to make your artwork unique and original.

VOCABULARY:

Cross Contour: A method of drawing that creates the illusion of 3D form which outlines and highlights the figurative shape of an object

Hatching: Parallel lines placed closely together. When additional lines are layered at an angle, this technique becomes "cross-hatching."

Texture: The perceived surface quality in an artwork, suggesting how it might *feel* to the touch.

Volume: The perceived space within a 3D form.

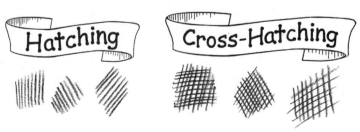

Cute Easter Stuff

1. Start with an oval

2. Add another overlapping oval

erase dotted area

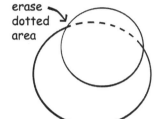

3. Add 2 smaller 1/2 circles at base

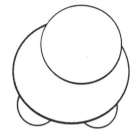

4. Add triangle beak

erase

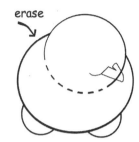

5. Add eye and 2 thin legs

6. Add 3 toes to each leg

7. Make outer edges "fluffy" with hatch lines

8. Shade

Easter Basket

1. Start with 2 ovals

bigger

smaller

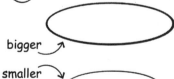

2. Connect sides

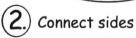

erase dotted area

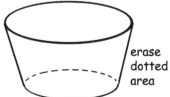

3. Add 1/2 oval for handle

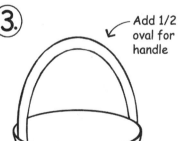

4. Draw cross contours to illustrate depth and perspective. Apply shading. For egg design ideas, refer to the next page.

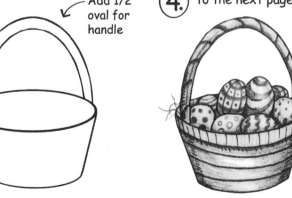

139

EASTER EGGS

KNOW:

A 2D shape can appear as a 3D form when contour lines, patterns, and shading are added.

UNDERSTAND:

The technique of "wrapping" lines and patterns around an object to give it a three-dimensional (3D) appearance.

DO:

Create an original pattern "wrapped" around a shape to create a festive Easter egg form.

VOCABULARY:

Cross Contour: A drawing method that outlines and accentuates the three-dimensional shape of an object, creating the illusion of form.

Pattern: The repetition of shapes, lines, or colors in a design.

Repetition: The repeated use of specific elements of art to create consistency and rhythm in an artwork.

Easter Eggs

1. Start with a basic egg shape

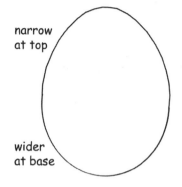

narrow at top

wider at base

2. Add curved lines to show depth

3. Add a decoration or pattern

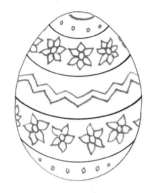

or try these . . .

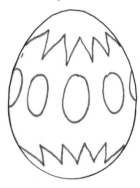

Add color or shade

BASKET OF EGGS

Start with a couple of eggs

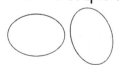

Add more <u>under</u> them

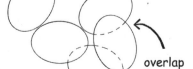

overlap

Add more . . .

Decorate and shade

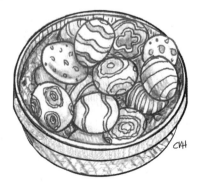

Draw your egg outline. Lightly mark off the areas of shadow, including the cast shadow on the surface below the egg.

Start shading by adding tone to the areas that will be the darkest. This includes a section across the center of the egg and around the bottom.

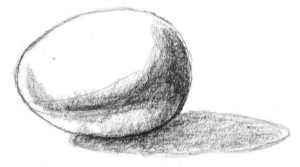

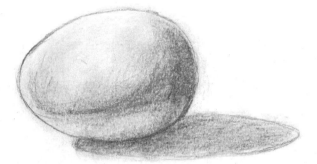

Then, add the mid tones. This is a lighter lay down of tone next to the dark areas which will help the dark transition into the light smoothly. Add some tone to the cast shadow as well.

Next, add the lightest tones and smooth with a blending tool.

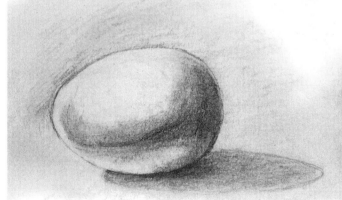

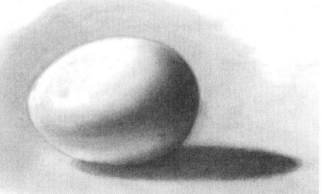

Add some light tones to the background so that the actual egg appears lighter. Deepen tones in dark areas to create more contrast.

Smooth with a blending tool. Use a kneaded eraser to add highlights in the lightest spots that may have been dulled by the blending process. Deepen some of the darkest tones to create more contrast.

SPRING TULIP

KNOW:
• Combining a series of simple geometric shapes can result in a complex, organic object.
• The difference between geometric and organic shapes.

UNDERSTAND:
• Overlapping and differences in the size of objects in a scene help to achieve the illusion of depth.

DO:
Draw your own version of a Spring Tulip bouquet, incorporating at least 3 flowers using the provided tips and tricks. Personalize your artwork by adding an element not shown, such as a vase or stems tied with a ribbon. Color your drawing as you see fit.

VOCABULARY:

Geometric Shape: Mathematical figures formed using points, line segments, circles, and curves, characterized by their precise and uniform measurements.

Organic Shape: Enclosed spaces with a length and width, though they do not require geometry or mathematics. They appear freeform and natural since they don't have uniformity and perfect measurements.

Overlap: When one object partially covers another, suggesting depth and layering in the composition.

Pattern: A regular and orderly repetition of figures or shapes within an artwork.

Shape: A closed space made when a line connects to itself.

Spring Tulip

① Start with a circular shape

② Add a "cone" hat

③ Erase the upper part of circle

erase dotted area →

looks like a raindrop!

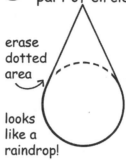

④ Add another "raindrop"

draw this one at an angle →

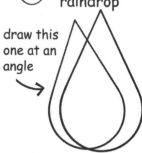

⑤ Erase the area inside the first raindrop

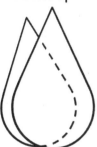

erase dotted areas

⑥ Add another "raindrop"

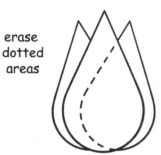

⑦ Add two points

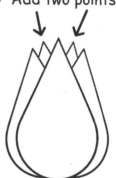

⑧ Add curved lines for pistils

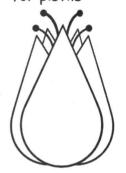

⑨ Add 1/2 circle for stem base

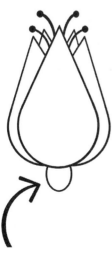

⑩ Add 2 lines for the stem

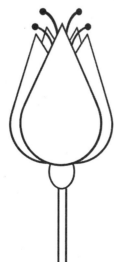

⑪ Add an angled leaf

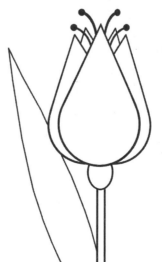

⑫ Shade

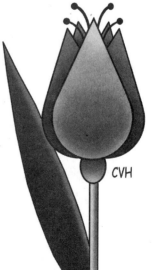

CVH

145

CHERRY BLOSSOM

KNOW:
Balance, Organic Shape, Pattern, Perspective, Repetition, Symmetry/Asymmetry.

UNDERSTAND:
• Connecting simple shapes can be the first step to creating complex forms.
• Major parts of an object in a drawing can be broken down into simplified shapes. Once the simple shapes are discovered, more detail can be added.

DO:
• Starting with lines and circles, follow the steps provided to add one shape at a time to create a cherry blossom branch.
• Shade or color as desired.

VOCABULARY:

Asymmetrical Balance: When an artwork's composition is not symmetrical, but balances visual weight between its two sides.

Organic: Organic shapes are irregular and might be found in nature, as opposed to regular, mechanical shapes.

Perspective: The technique used to create the illusion of 3D onto a 2D surface. Perspective helps to create a sense of depth or receding space. This can be seen in the cherry blossom drawing as the flowers vary in size while some are overlapping.

Still Life: A drawing, painting or photo of inanimate objects positioned on a table (traditionally vessels, fruits, vegetables, etc.)

Symmetry: An object that is the same on both sides. This artwork is asymmetrical.

Cherry Blossoms

1. Start with a zig-zag backwards "Z"

Draw this lightly. It is a guideline and will eventually be erased

2. Add small circles at each bend

3. "Thicken" the stick by adding lines on either side

← Add an open end here

4. Erase the dotted center (original guides)

Oval

5. Add a guideline circle for the 1st blossom

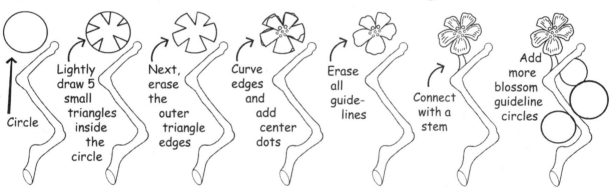

Circle

Lightly draw 5 small triangles inside the circle

Next, erase the outer triangle edges

Curve edges and add center dots

Erase all guide-lines

Connect with a stem

Add more blossom guideline circles

6. Add petal details

7. Transform circles into blossoms

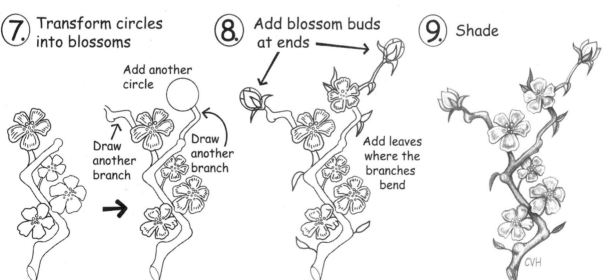

Add another circle

Draw another branch

Draw another branch

8. Add blossom buds at ends →

Add leaves where the branches bend

9. Shade

CVH

HALLOWEEN CREATURES

KNOW:
Original cartoon style characters can be created by connecting simple, geometric shapes.

UNDERSTAND:
• To make a work original, that work must have elements that are not copied or traced.
• Expressive qualities in your drawing add a feeling, mood or idea to your character.

DO:
Practice creating an original cartoon-style character using the guidelines provided. Draw lightly so the guidelines can be erased if needed. Add or change elements as necessary to make it unique. Use your imagination and add a lot of "extra's".

VOCABULARY:
Cartoon: A usually simple drawing created to get people thinking, angry, laughing, or otherwise amused. A cartoon usually has simple lines, uses basic colors, and tells a story in one or a series of pictures called frames or panels.

Expressive Qualities: The feelings, moods and ideas communicated to the viewer through a work of art.

Original: Any work considered to be an authentic example of the works of an artist, rather than a reproduction, imitation or a copy.

Halloween Creatures

A little **SCARY** but mostly cute!

(1.) Start with a body made from simple shapes . . .

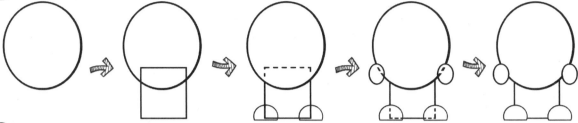

(2.) Next, choose an expressive set of eyes . . .

 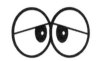 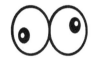

(3.) Finally, add as many details as you need to build a unique, interesting character

erase guidelines as needed

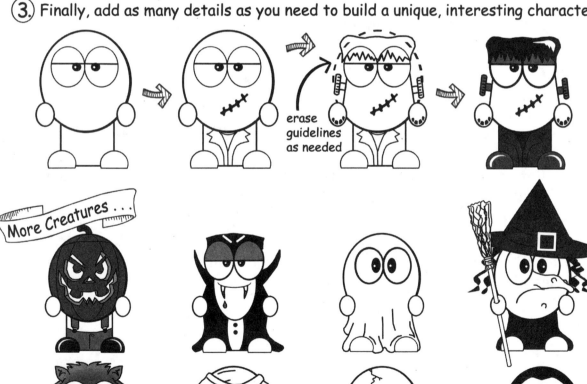

More Creatures . . .

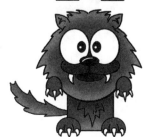 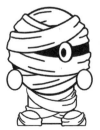 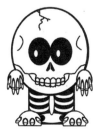

AUTUMN LEAF

KNOW:
Organic Shape, Symmetry, Asymmetry.

UNDERSTAND:
Overlapping simple shapes can be the first step to creating complex forms.

DO:
• Follow the steps provided (or position a selection of leaves from life) to create an original still-life drawing.
• Shade or color as desired.

VOCABULARY:

Organic: An irregular shape that is often found in nature which appears freeform as it lacks equal, perfect measurements.

Still Life: A drawing, painting or photo of inanimate objects positioned on a table (traditionally vessels, fruits, vegetables, etc.).

Symmetry (or symmetrical balance): The parts of an image or object organized so that one side duplicates, or mirrors, the other. Also known as formal balance, its opposite is asymmetry or asymmetrical balance. Symmetry is among the ten classes of patterns.

Have a real leaf available?
Trace the contour of
that leaf and
skip to **step 6**

Autumn Leaf

1. Start with a tear-drop shape

2. Add 2 more tear-drop shapes fanned out at sides

3. Draw points around the tear-drop shapes as seen below

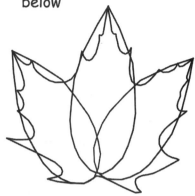

4. Erase the original tear-drop shape shown as dotted

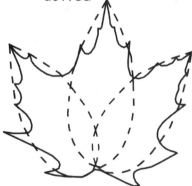

5. It should look something like the organic shape below

6. Draw "veins" from the large points down to the center base

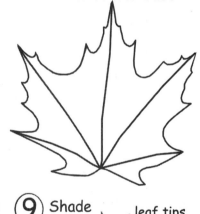

7. Add some smaller veins

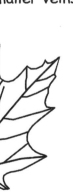

8. Add more veins & stem

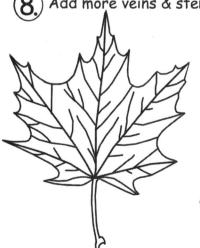

9. Shade

leaf tips can be darker

erase lines to create leaf veins

CVH

THANKSGIVING STILL LIFE

KNOW:
Contour Line, Overlapping, Perspective, "Still Life."

UNDERSTAND:
• Overlapping simple shapes is the first step toward creating complex forms.
• Large objects should be drawn lower on the page to appear closer, while smaller objects should be drawn higher to appear further away.
• When one object is placed in front of another, it creates the illusion of depth in an artwork.

DO:
• View and discuss examples of artworks that demonstrate overlapping and the depiction of near and far elements, focusing on how overlap and size differences contribute to the illusion of depth.
• Follow the provided steps (or arrange a selection of fruits and vegetables from life) to create an original still-life drawing with a Thanksgiving theme.
• Shade or color as desired.

VOCABULARY:

Contour Line: Lines that outline and define the edges of a subject, giving it shape.

Cross Contour: Lines that run across the form of a subject, illustrating its three-dimensional shape.

Overlap: When one object covers a part of another, suggesting depth.

Shading: The technique of varying tones to represent light and shadow, enhancing the dimensional appearance of a drawing.

Shape: A defined area enclosed by lines.

Still Life: Artwork depicting inanimate objects, often arranged on a surface, such as vessels, fruits, and vegetables.

A **still life** is a
drawing or painting
of inanimate objects

Thanksgiving

Still Life
TIPS:
• Draw lightly
• Draw big
• Start step 1 on right
side of your paper

1. Start with a circle
shape on the RIGHT
side of your paper

dent

2. Add a circle with an
angled oval

overlap

3. Add another circular shape

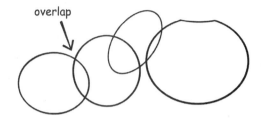

overlap

4. Erase the areas indicated with a
dotted line

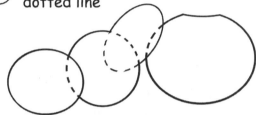

5. Add stems

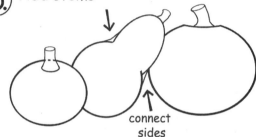

connect
sides

6. Add an oval

erase inner
squash lines

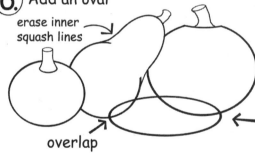

overlap

7. Erase dotted areas

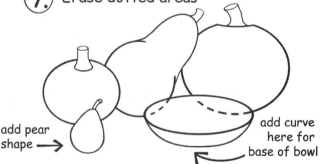

add pear
shape →

add curve
here for
base of bowl

8. Fill bowl with oval/circle shapes

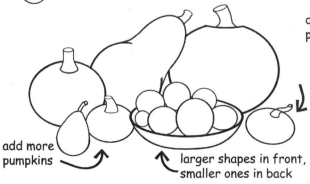

add more
pumpkins

larger shapes in front,
smaller ones in back

9. Shade with colored pencils

draw lines for
pumpkin segments

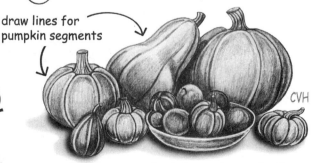

CVH

See next page for information on shading.

Add lines on the pumpkins that follow the cross contours of the shape.

Start filling in the areas that will be the darkest. This includes the bottom of each pumpkin and between the fruits in the bowl.

Next, add the mid tones. The medium hue that is neither dark nor light that will help the darkest tones transition onto the lightest.

Add the lightest tones and smooth with a blending tool. Add lines and shading to stems.

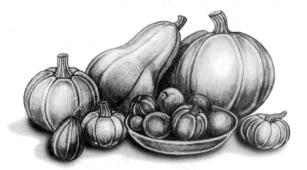

Erase areas of highlight, especially near the contour lines around each pumpkin. Add smooth, dark smudges below the pumpkins for cast shadows.

CAN OF CRAN...

KNOW:
Cylinders, Pop Art.

UNDERSTAND:
• Using cylinders in art can create the illusion of a three-dimensional circular tube.
• Andy Warhol's Campbell's Tomato Soup painting became an iconic representation of Pop Art in 1962.

DO:
Create a cylindrical can using ovals and lines as shown. Wrap designs and text around the can to craft a label, conveying a three-dimensional effect.

VOCABULARY:

Andy Warhol: (August 6, 1928 - February 22, 1987) was an American artist who was a leading figure in the visual art movement known as pop art. His works explore the relationship between artistic expression, celebrity culture and advertisement that flourished in the 1960's.

Cylinder: A geometric figure with straight parallel sides and a circular or oval cross-section.

Oval: A stretched, two-dimensional shape that looks like an elongated circle.

Pop Art: An art movement that focuses attention upon familiar images of the popular culture such as billboards, comic strips, magazine advertisements, and supermarket products.

 Can of Cran . . .

1. Start with an oval

2. Add another oval

3. Connect with 2 horizontal lines

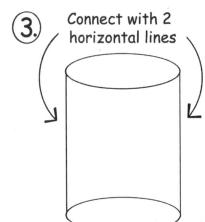

4. Draw a thin oval inside the top lid area to indicate a "thickness"

follow the contour of the bottom rim

5. Fill the lid with a series of lean ovals

6. Draw a rounded line to indicate the label area

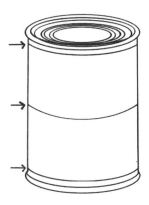

7. Draw a light, curved line to indicate where your words will be

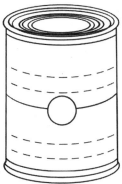

8. Sketch out your text

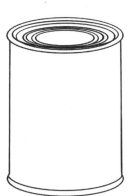

9. Shade

CVH

PUMPKIN

KNOW:
Shading, Layering, Foreshortening, Overlapping.

UNDERSTAND:
• Value added to a two-dimensional (2D) shape creates the illusion of a three-dimensional (3D) form.
• The lightness or darkness of a value can indicate where the light source falls on an object (in this case, the creases in the pumpkin are further away from the light, so they appear darker).
• Foreshortening is a technique an artist can use to depict an object in a picture so as to produce the illusion of projection or extension in space.

DO:
Draw a pumpkin using the tips and tricks provided.

Tip: The first pumpkin has a center segment that is higher than the rest which helps to show the sides receding back. The second pumpkin has a center segment that is lower on the page while the sides appear higher. Both pumpkins use foreshortening.

VOCABULARY:
Blend: To merge tones applied to a surface so that there is no crisp line indicating beginning or end of one tone.

Foreshortening: A way of representing an object so that it conveys the illusion of depth, seeming to thrust forward or go back into space. Foreshortening's success often depends upon a point of view or perspective in which the sizes of near and far parts of a subject contrast greatly.

Overlapping: The effect created when one object partially covers another, contributing to the illusion of depth.

Shading: The technique of transitioning between light and dark areas in an artwork to suggest form and volume.

Draw A Pumpkin

1. Start with a long oval

2. Add two more ovals

these are lower than the 1st oval

erase dotted areas

3. Add two more ovals beside those drawn in step 2

4. Add a stem

ellipse

5. Add details

6. Shade

darker at creases

or try this . . .

1. Start with an oval-circle shape

2. Add a small oval in the center top area

3. Draw curved lines () coming from oval

4. Add 2 more curves

5. Continue curves all the way around

add dents

6. Add stem at oval and shade

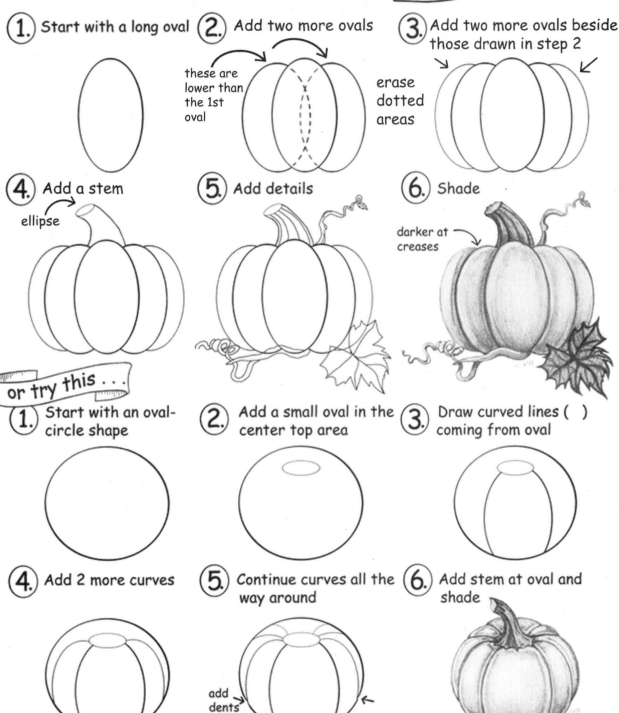

JACK O'LANTERN

KNOW:
Balance, Form, 3D, Symmetry.

UNDERSTAND:
• Adding patterns and shading to a drawing can enhance its form and dimension.
• "Carving" designs into a pumpkin drawing can achieve a realistic look with curved designs that adhere to the surface's cross contours and receding lines that define 3D edges.

DO:
Start with a basic pumpkin (refer to the previous exercise) and then "carve" a design onto it using the provided tips and techniques. Add lots of "extras" and ensure that all "carved" parts are connected to avoid any floating elements. Apply shading to complete the drawing.

VOCABULARY:

Balance: The way the elements of art are arranged in an artwork to create a feeling of stability, a pleasing arrangement, or proportion of parts in a composition.

Form: A three-dimensional shape (height, width, and depth) that encloses volume.

Three-Dimensional: Having, or appearing to have, height, width, and depth.

Receding lines: Lines that appear to be moving away from the observer, contributing to the perception of depth.

Symmetry: Symmetrical balance (or Symmetry) means that the work of art is the same on one side as the other, a mirror image of itself, on both sides of a center line.

Jack O' Lantern

1. Start with a basic pumpkin outline

2. Draw the outline of eyes, nose and mouth

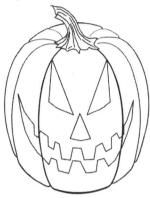

3. Erase any lines inside the eyes, nose and mouth

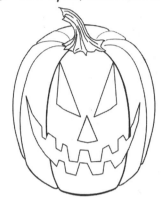

4. Draw short diagonal lines at corners of eyes, nose and mouth

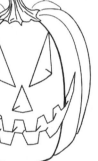

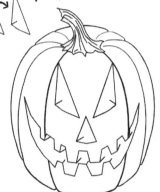

5. Connect with angles to create a "thickness"

6. Shade

The lightest values should be in the "carved" holes to show that the pumpkin has a candle in it!

Get Creative

All of the "carved parts" must be connected ...no floating pieces!

CVH

CHRISTMAS BARN

KNOW:
How to create a house that appears to have length, width, and depth using one-point perspective.

UNDERSTAND:
One way to create the appearance of a 3D house showing perspective at a ¾ view.

DO:
Create an original holiday barn in a landscape scene showing perspective. Add lots of 'extras' to make it unique and original.

VOCABULARY:

Horizontal Lines: Straight lines that extend from left to right or right to left.

Landscape: An artwork that depicts scenery, typically including some portion of the sky.

One Point Perspective: A drawing method that shows how objects appear to diminish in size as they recede from the viewer, converging towards a single "vanishing point" on the horizon line.

Perspective: The technique used to create the illusion of three dimensions on a two-dimensional surface, providing a sense of depth and receding space.

Receding Lines: Lines that give the impression of moving away from the observer, enhancing the perception of depth.

Three-Quarter (3/4) View: A perspective of a face or object that is halfway between a full frontal and a side view.

Vertical Lines: Lines that run up and down, from top to bottom or bottom to top.

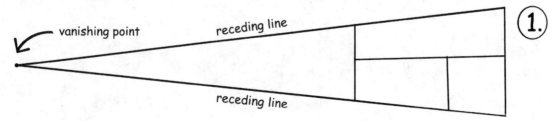

Draw a vanishing point with receding lines. Draw the three vertical lines and one horizontal as shown.

Christmas Barn

2. Draw a rectangle (with shapes inside as seen below)

upward angle →

thinner here

wider here

3.

Erase the receding lines no longer needed.

Add 3 angled roof lines

← erase dotted area

4.

Add thickness

window

door

angle upward

← erase dotted

5.

3 lines for chimney

Add lines for doors and windows

6.

top of chimney

circle for wreath

finish windows and door

7.

Add windows and a tiny roof

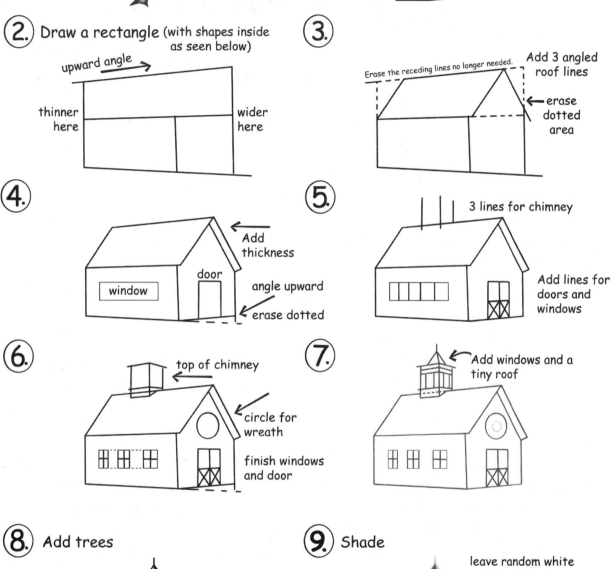

8. Add trees

9. Shade

leave random white patches for snow

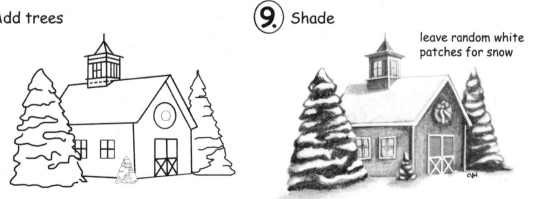

CHRISTMAS ORNAMENTS

KNOW:
Geometric shapes, Highlight, Repetition, Texture.

UNDERSTAND:
• The difference between shape and form.
• How to arrange elements in an artwork so that they appear symmetrical or equally balanced.
• How to create an effective design using simple shapes.
• How to create the appearance of texture in artwork.

DO:
• Use the provided steps to create an original ball ornament starting from a basic circle.
• Use learned 3D techniques which concentrate on overlapping and shading to convey the illusion of depth.

VOCABULARY:
Balance: A principle of design, balance refers to the way the elements of art are arranged to create a feeling of stability in a work; a pleasing or harmonious arrangement or proportion of parts or areas in a design or composition.

Repetition: The recurrence of a pattern or element in artwork, enhancing rhythm and unity. For example, the ornament cap features a repeated line pattern.

Texture: The technique an artist uses to make an object look like it *feels* a certain way. For instance, the bow might illustrate a smooth texture, whereas the ornament could have a glossy surface.

Christmas Ornaments

1. Start with a circle

2. Add a small oval directly above it

3. Add vertical lines decending from the oval edges

close with a curved line

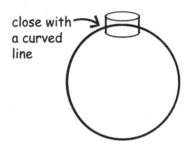

4. Add a loop in the center of the oval

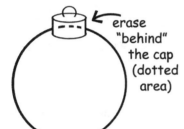 ← erase "behind" the cap (dotted area)

5. Add vertical lines on cap to show texture

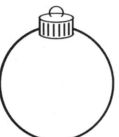

6. Add a hook and a shiny spot

Holly Berry border

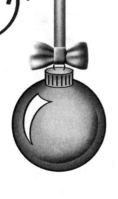 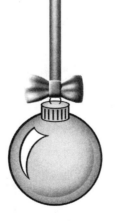 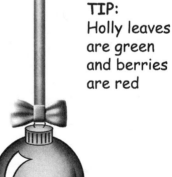

TIP:
Holly leaves are green and berries are red

Create a greeting card using at least 3 ornaments

Bow Shading

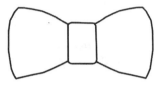

Start with a rounded rectangle at the center with curves coming from the sides to make the bow.

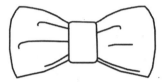

Add lines in the bow to show changes and folds in fabric.

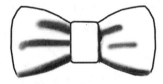

Shade in the darkest areas of the bow first, including inside the fold creases and at the base.

Add the mid-tones.

Use a blending tool to smooth tones together.

Erase any dark outlines as well as the lightest areas of highlight.

SIMPLE SNOWFLAKE

KNOW:
45 and 90 degree angles, Repetition, Rotational Symmetry.

UNDERSTAND:
• No two snowflakes are alike.
• Variation in sizes of objects when drawing them creates interest and depth.

Optional: In fine art, a focal point draws attention to a specific area of interest.

DO:
• Follow the steps provided to create an original snowflake design focusing on rotational symmetry.
• Combine a variety of snowflake styles and sizes to create a winter design.

Optional: Add a focal point using minimal color (colored pencil) in one or two areas of the scene or some text to create interest. Add a focal point in one or two areas to the design by adding more pencil pressure (or add minimal color) to make certain parts stand out with contrast.

VOCABULARY:
Focal Point: The portion of an artwork's composition in which interest or attention centers. The focal point may be most interesting for any of several reasons: it may be given formal emphasis; its meaning may be controversial, incongruous, or otherwise compelling.

Rotational Symmetry: The property a design has when it looks the same after rotation as it did at its starting point.

Symmetry: An object that is the same on both sides.

Simple Snowflake

1. Use a ruler and draw a symmetrical cross

this will create 4 equal 90 degree angles)

2. Draw a smaller "X" shape through the cross

this will create 8 equal 45° angles

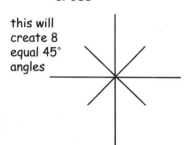

3. Draw a line through each ending of the cross and "X" lines

4. Draw a tiny circle at the end of each "X" line

5. Add a 2nd, longer line through the ends of the cross and "X" lines

6. Add a small circle in the center

The Simplest Snowflake

Or Try Small Circles

Chapter 5

Animals

CARTOON ANIMALS

KNOW:
You can make almost ANY original cartoon creature using the steps provided.

UNDERSTAND:
These basic, generic steps can be modified or expanded to create an ORIGINAL cartoon character.

DO:
Create both a front AND side view of a character. Use your imagination and add a lot of "extras."

VOCABULARY:

Cartoon: A usually simple drawing created to get people thinking, angry, laughing, or otherwise amused. A cartoon usually has simple lines, uses basic colors, and tells a story in one or a series of pictures called frames or panels.

Expression: Imagery in art that depicts an emotional feeling. You will notice that the more intense the emotion, the more areas of the face are involved.

Original: Any work considered to be an authentic example of the works of an artist, rather than a reproduction or imitation.

Cartoon Animals

Follow these steps to make a front view of almost ANY cartoon creature!

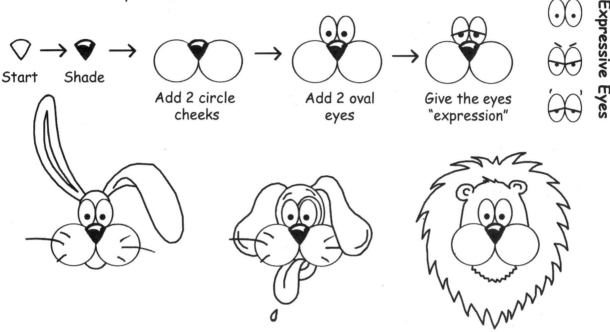

Start → Shade → Add 2 circle cheeks → Add 2 oval eyes → Give the eyes "expression"

Expressive Eyes

Follow these steps to make a side view of almost ANY cartoon creature

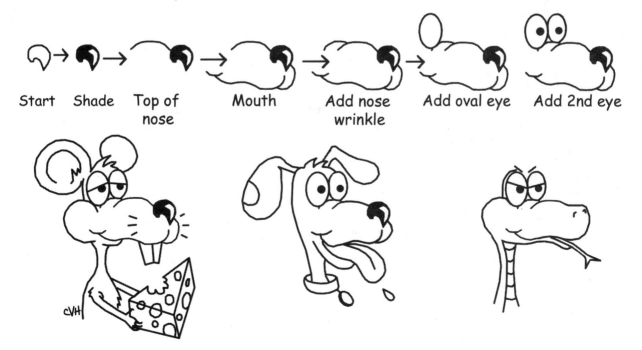

Start Shade Top of nose Mouth Add nose wrinkle Add oval eye Add 2nd eye

173

DUCK FAMILY

KNOW:
• How to create a sense of depth in an artwork.
• How to take a few simple shapes and combine them to create a recognizable duck.

UNDERSTAND:
• The use of overlapping and variations in size and placement of objects contributes to the illusion of depth.
• Lines, shapes, textures and shadows can be drawn to indicate a sense of believability in an artwork.

DO:
Create an original artwork featuring a duck family, including at least one large duck and four smaller ducks, with water ripples to indicate movement in a landscape setting.

VOCABULARY:

Landscape: There is usually some water and sky or land and sky in the scene.

Perspective: The technique used to create the illusion of 3D onto a 2D surface. Perspective helps to create a sense of depth or receding space. The placement and size of the ducklings in this scene will help to show perspective.

Motion lines: Also known as movement action or speed lines are the abstract marks that appear behind or around an object in a drawing to make it appear as if it is in motion. In this drawing, curved lines will serve as water ripples, small waves on the water's surface caused by the ducks' movement.

Duck Family

1. Start with a small circle

2. Add a rounded beak

3. Slightly curve neck

4. Add oval body

5. Triangle shaped tail

6. More tail detail . . .

7. Add front neck and chest

8. Erase dotted areas

9. Add an eye and water rings to indicate motion

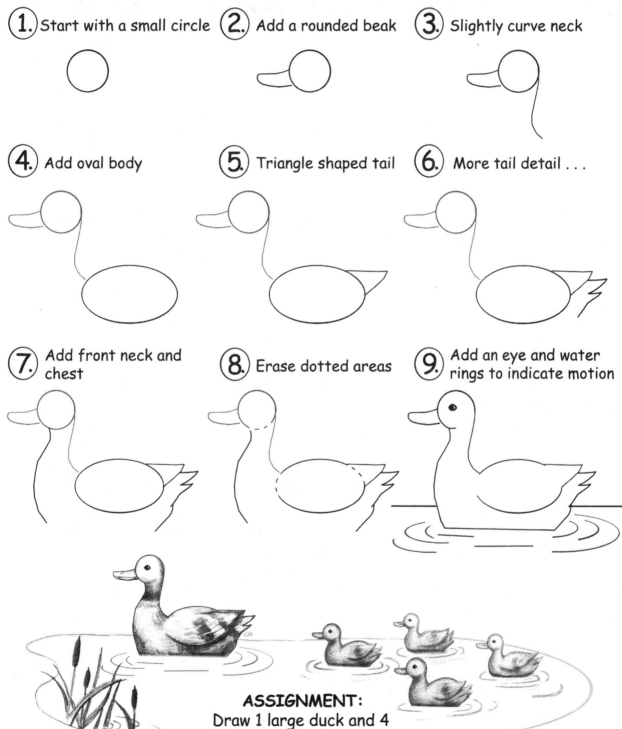

ASSIGNMENT:
Draw 1 large duck and 4 smaller ducks in a pond

175

BUNNY RABBIT

KNOW:
Texture, Overlapping, Hatch Marks.

UNDERSTAND:
The techniques an artist uses to show how something might *feel* or what it is made of in an artwork.

DO:
Create an original artwork of a bunny rabbit, indicating a "furry" texture using short hatch lines. Apply shading to enhance depth and dimension.

VOCABULARY:

Hatching: Closely spaced parallel lines that suggest texture and shade that are used to create tonal or shading effects in a drawing.

Overlapping: The effect when one object partially covers another, suggesting depth and layering in the composition.

Texture: The perceived surface quality in artwork suggested by the artist's technique such as brushstrokes or pencil lines.

Textures can be described with terms like flat, smooth, shiny, glossy, glittery, velvety, feathery, soft, wet, gooey, furry, sandy, leathery, crackled, prickly, abrasive, rough, bumpy, corrugated, puffy, rusty, slimy, and more.

Drawing hatch marks around the contours of the drawing will help to create the illusion of a furry texture

Bunny Rabbit

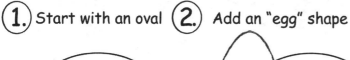

① Start with an oval

② Add an "egg" shape

overlap

③ Add 3 skinny ovals for legs

erase dotted areas

circle

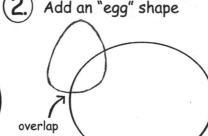

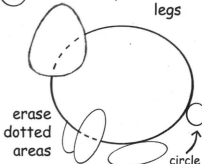

④ Add ears, face and circle feet

overlap circles for paws

⑤ Erase dotted areas

connect with short line

⑥ Add "fur" around circle tail

zig-zag lines for "fur"

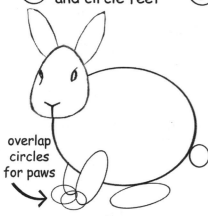

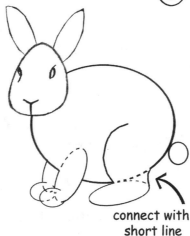

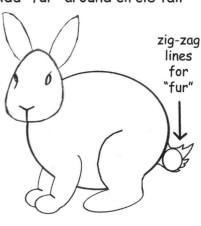

⑦

skinny oval in ear

small bump

dent

lip

curved toe lines

toes

erase circle inside tail

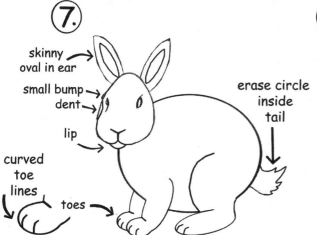

⑧ Add "fuzzy" edges and shade

Draw hatch marks around the contour

sample

DRAW A PENGUIN

KNOW:
• Combining simple shapes can lead to the creation of more complex objects.
• Incorporating additional elements into a drawing can enhance interest, convey a narrative, and add detail. Adding extra elements to a drawing can add detail, create interest, or tell a story. Please see page 105 for ice berg instructions.

UNDERSTAND:
Using overlapping and layering techniques can enhance the sense of depth and realism in a drawing.

DO:
Use the provided steps to create an original artwork of a penguin. Position the penguin "on top" of an iceberg, placing it within a scene.

VOCABULARY:
Detail: A part of a whole. A distinctive feature of an object or scene which can be seen most clearly close up.

Layer: An item or material placed over another, creating a stratified effect.

Overlap: The effect when one object partially covers another, suggesting depth and layering in the composition.

Draw a Penguin

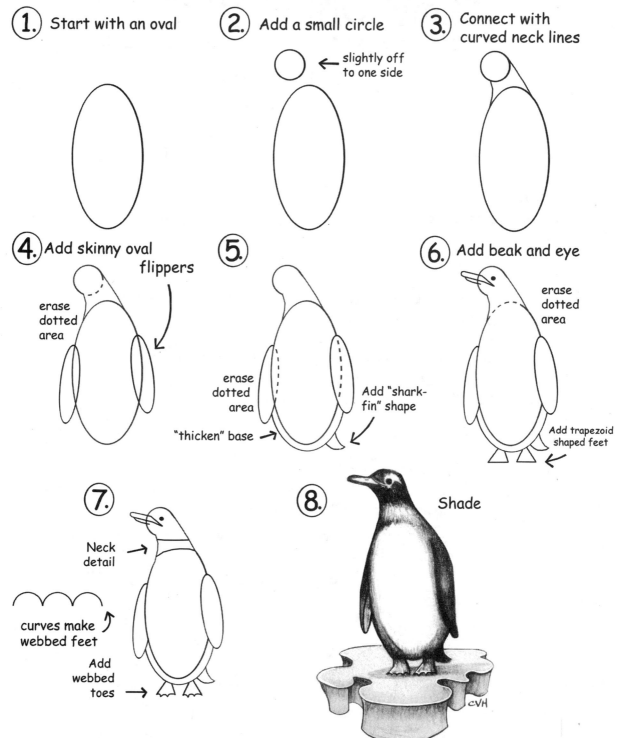

1. Start with an oval

2. Add a small circle
 ← slightly off to one side

3. Connect with curved neck lines

4. Add skinny oval flippers
 erase dotted area

5. erase dotted area
 "thicken" base →
 Add "shark-fin" shape

6. Add beak and eye
 erase dotted area
 Add trapezoid shaped feet ←

7. Neck detail →
 curves make webbed feet ↗
 Add webbed toes →

8. Shade
 CVH

DRAWING WINGS

KNOW:
Symmetry and Asymmetry.

UNDERSTAND:
Balance helps to create interest or design in an artwork. Symmetry and asymmetry offer two kinds of balance.

DO:
• Practice symmetry by drawing a creature with wings that are identical on both sides, using the provided ideas.
 OR
• Practice asymmetry by drawing a creature with wings in different positions on each side, using the provided ideas.
• Add "extras" like a halo, horns, or a pitchfork.

VOCABULARY:

Asymmetry: An object is different on both sides

Balance: A principle of design, balance refers to the way the elements of art are arranged to create a feeling of stability in a work

Symmetry: A balanced and proportionate similarity that is found in two halves of an object.

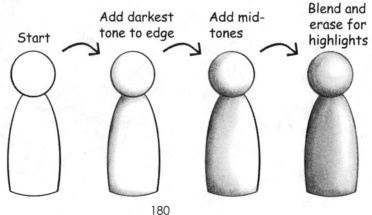

Start | Add darkest tone to edge | Add mid-tones | Blend and erase for highlights

Drawing Wings

1. Start with a peg person base

Angel Wings

2. Lightly sketch wings

dots indicate where the wing bends or folds

3. curve the angles

draw 5 short feathers

4 long feathers

4. shorter medium longer

Layer feathers and shade

CVH

1. Start with a peg person base

Devil Wings

2. Lightly sketch angled wings

3.

4. CVH

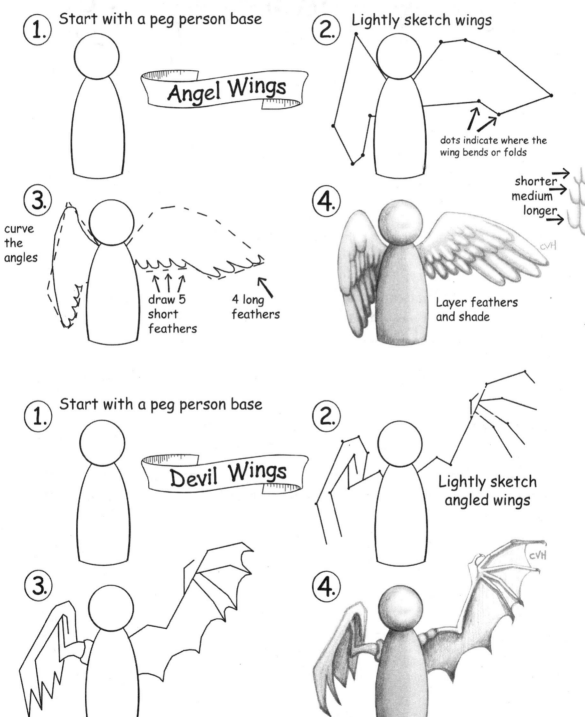

BIRDS IN FLIGHT

KNOW:
Silhouette and Contour.

UNDERSTAND:
• Silhouettes are detailed outlines filled in with a solid color, lacking internal detail.
• How to create recognizable silhouettes.

DO:
Create an original landscape scene featuring at least 3 bird silhouettes in flight. Make sure each bird has a detailed outline including feathers, head, body, and tail details.

TIP: Your silhouette has been drawn well if other people can recognize what it is!

VOCABULARY:

Contour: The outline and other visible edges of a subject in a drawing.

Silhouette: A detailed outline filled in with a solid color, typically set against a contrasting background. Often used for portraits, silhouettes emphasize the outline without interior details.

A silhouette is
a detailed outline

Birds in Flight

Below are three
samples of the many
types of bird
silhouettes you
can draw

1. Start with a wide "V" shape

3. Thicken "V" and add tiny triangle tail

2. Add a small circle in center bottom "V"

4. Fill in with a solid color and add "feather" detail to wing edges

1. Start with a wide "W" shape

3. Add circle head and triangle tail

2. "Thicken" the "W"

4. Fill in solid and add feather detail
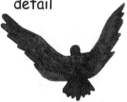

1. Start with a wide "V" shape
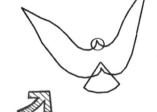

3. Add "shark fin" shape at head and triangle tail

2. Thicken the "V" and close the sides with angled lines
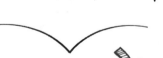
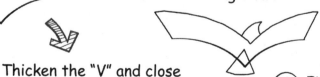

4. Fill in solid and add feather details

CVH

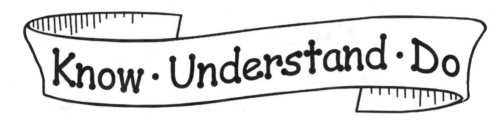

DRAW A PITBULL

KNOW:
Combining simple shapes can lead to the formation of more complex objects.

UNDERSTAND:
• Every complex object can be simplified and broken down into a series of connected geometric and organic shapes.
• When items in a drawing are subtly shaded as opposed to outlined, they appear more realistic.

DO:
Create an original artwork of a pitbull dog. Use light contour lines to depict muscle striations and shading to add depth.

VOCABULARY:

Complex: Refers to the combination of art elements to create detailed and multifaceted relationships within an artwork. An artwork composed of numerous shapes in varying colors, sizes, and textures is considered complex.

Contour Lines: The lines that define the outer edges and visible boundaries of an object or figure, contributing to its perceived shape and volume.

Subtle: The quality of being understated, delicate, or nuanced.

Draw a Pitbull Dog

1. Start with . . .

a small circle

over a slightly larger oval

2. Connect with neck lines

add bump

3. Add pointy ears and legs

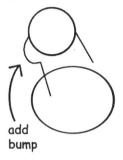

thicker at top

bend here

4. Erase dotted areas

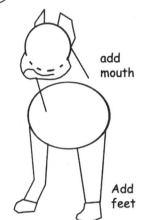

add mouth

Add feet

5. Add hind quarters

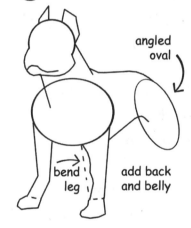

angled oval

bend leg

add back and belly

6. Add more details . . .

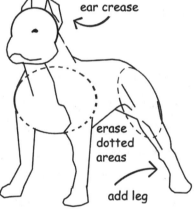

ear crease

erase dotted areas

add leg

7.

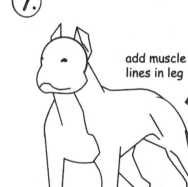

add muscle lines in leg

add another leg

8.

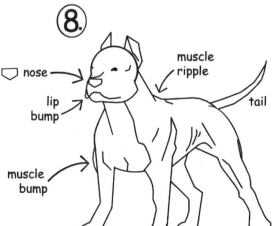

nose

lip bump

muscle bump

muscle ripple

tail

9.

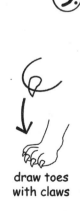

draw toes with claws

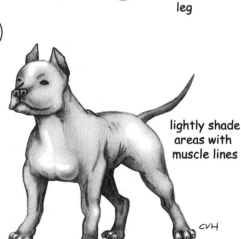

lightly shade areas with muscle lines

CVH

IN THE DOGHOUSE

KNOW:
Simple steps to create a ¾ view of a house.

UNDERSTAND:
How to create a house that appears to have length width and depth.

DO:
Create an original paneled doghouse within a landscape scene that demonstrates perspective. Include a dog of your choosing and apply shading to enhance depth.

VOCABULARY:

Horizontal Lines: A straight line that moves from left to right or right to left.

Landscape: Artwork depicting natural scenery, often including sky.

Perspective: A technique that creates the illusion of three-dimensional space on a two-dimensional surface, adding depth.

Receding Lines: Lines that appear to gradually move away from the viewer.

Three-Quarter (3/4) View: A view of a face or any other subject which is half-way between a full and a side view.

Vertical Lines: A line that runs from top to bottom or bottom to top.

In The Doghouse

1. Start with three vertical lines

2. Connect them at the top and bottom

← straight line →

← angled →

3. Draw an arrow pointing upward

overlaps here ↘

doesn't touch

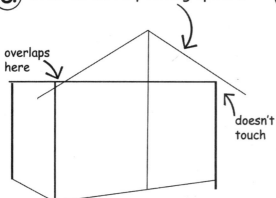

4. Add "thickness" to the roof

receding lines

5.

erase dotted area ↘

angled boards

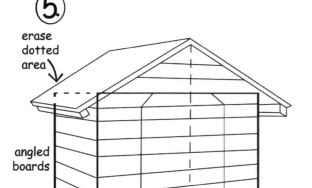

6. Add a dog and shade

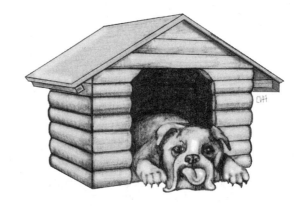

LION HEAD

KNOW:

The steps to create a lion head.

UNDERSTAND:

• A simple grid can aid in the drawing of a proportionate lion face.

• The techniques an artist uses to show how something might feel or what it is made of in an artwork.

DO:

Use the provided steps to practice drawing a lion's head. Create the texture of the mane with curving lines and apply shading to add depth.

VOCABULARY:

Grid: A framework or pattern of criss-crossed or parallel lines that can be used as guidelines for placement of drawn objects.

Proportion: Simple steps to create a version of a lion's head.

Texture: The way something looks like it might feel like in an artwork .

Draw a Lion Head

1. Start with the lines seen here

letter "X"

2. Add eyes, cheeks and chin

3. Circle head

round ears →

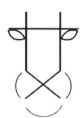

4. Egg shaped mane

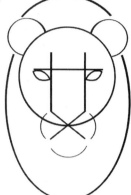

5. Draw "zig-zag" lines around mane

add curve in front of ears

erase dotted areas

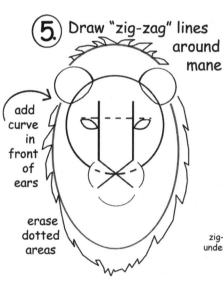

6. Add heart shaped nose

curve nose sides

round the mouth

zig-zag under chin

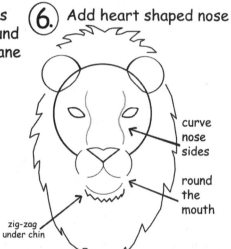

7.

hair in ears

pupils in eyes

more fur lines

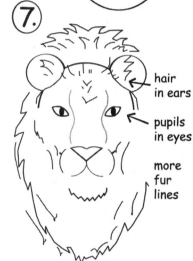

8. More fur . . .

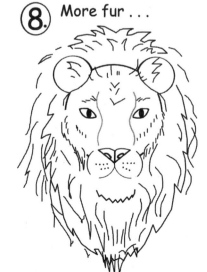

9. Shade

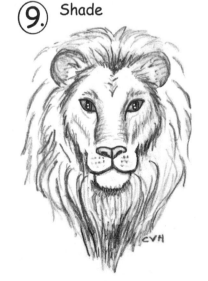

189

COW SKULL

KNOW:
Combining simple shapes can lead to the formation of more complex objects.

UNDERSTAND:
Layering simple shapes, connecting them with lines, and then erasing unnecessary parts is a technique artists use to achieve a realistic representation.

DO:
• Practice breaking down objects into simple shapes by observing items around the room and visually simplifying them.
• Use the provided steps to craft your rendition of a cow skull.

VOCABULARY:

Combine: To join two or more objects together.

Layer: Something placed over another surface.

Overlap: When shapes are in front of other shapes in a drawing. If one shape overlaps another it communicates the illusion of depth.

Draw a Cow Skull

1. Start with
a circle

2. Add an oval
overlap

3. Add a rectangle
skinny
and
long

4. Erase inside

5. Add small squares
chop corners here
and here

6. Connect outer rim
connect

7. Erase insides

8. Add squares
triangle eye shape

9. Add curved horns
round all corner points
1/2 circle in eye
add nostrils using a "W" shape

10. Shade and add "extra's" like cracks or barbed wire

Moooo!

CVH

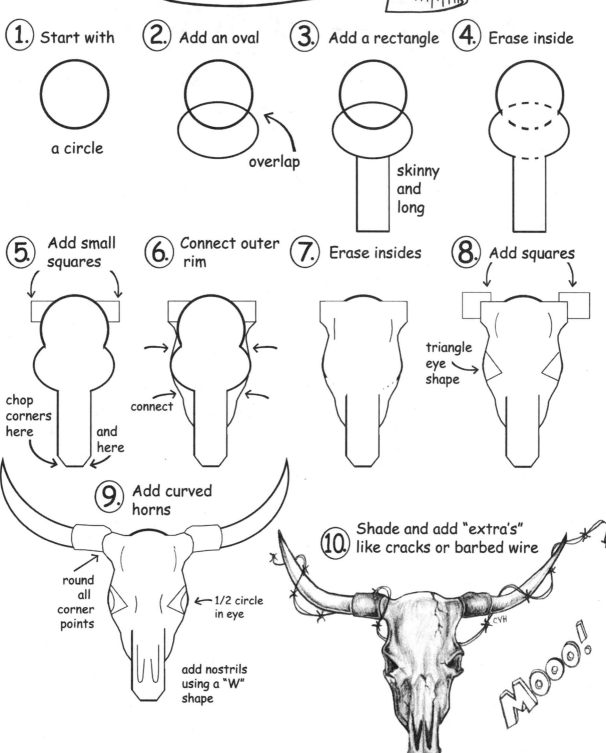

DRAW A COBRA

KNOW:
Combining simple shapes can lead to the creation of more complex objects.

UNDERSTAND:
Creating cross contour lines on a drawing helps to define the inside details of an object.

DO:
• Use the provided steps to craft your own version of a coiled cobra snake.
• Apply shading to add depth.

VOCABULARY:

Cross contours: Lines that travel across the form. Cross contour lines may or may not be visible on the subject. In this drawing, cross contours are added to the belly of the snake in step 10 to convey three-dimensional depth, length, width, space, distance and perspective.

Volume: The perceived space occupied by a three-dimensional form.

Draw a Cobra

1. Small circle

2. Add brow line

3. Add mouth line

4. Add nose

5. Draw backwards "S"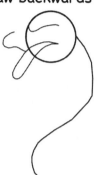

6. Mouth line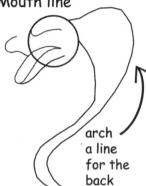

arch a line for the back

7. Add fangs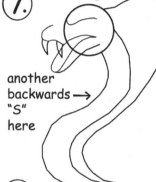

another backwards → "S" here

8. Erase dotted area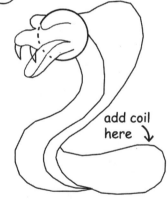

add coil here ↓

9. Add back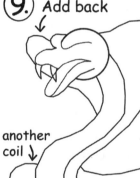

another coil ↓

10.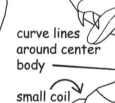

curve lines around center body →

small coil ↓

one more coil

11.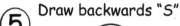

finish eye, add tongue and nostrils

12.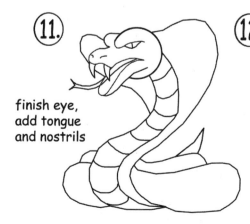

Shade

CVH

CLIMBING TIGER

KNOW:
Layering, Overlapping, Pattern.

UNDERSTAND:
Drawing the contours of an object first, then going back over the work to add finer details is one successful method to creating a realistic artwork.

DO:
Use the provided steps to draw a climbing tiger. Make your tiger unique by designing an original stripe pattern that "wraps" around its body, using the "wrapping" to suggest form. Use cross contour lines to create a pattern of stripes. These stripes will help to indicate form.

VOCABULARY:

Cross Contours: Lines that travel across the form. Cross contour lines may or may not be visible on the subject. In this drawing, cross contours are added in step 8 of to show pattern as well as to convey its three-dimensional form.

Layering: The process of placing one item or material over another.

Overlapping: The effect when one object partially covers another, suggesting depth and layering in the composition.

Pattern: The repetition of shapes, lines or colors in a design.

Climbing Tiger

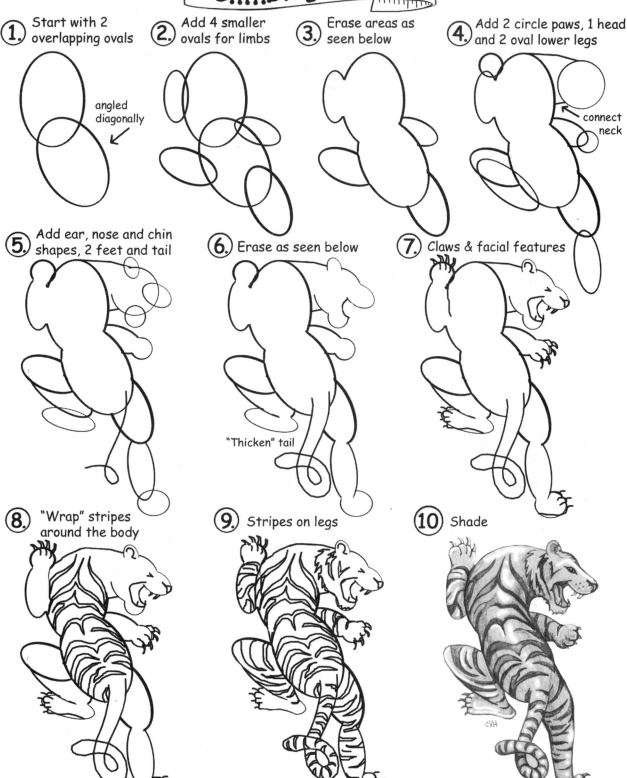

1. Start with 2 overlapping ovals
 angled diagonally

2. Add 4 smaller ovals for limbs

3. Erase areas as seen below

4. Add 2 circle paws, 1 head and 2 oval lower legs
 connect neck

5. Add ear, nose and chin shapes, 2 feet and tail

6. Erase as seen below
 "Thicken" tail

7. Claws & facial features

8. "Wrap" stripes around the body

9. Stripes on legs

10. Shade

CVH

195

DRAGON

KNOW:
Contour Lines, Overlapping, Pattern, Stylize.

UNDERSTAND:
How to start with a simple curvy line and progressively add elements to transform it into a distinctive artwork depicting a dragon.

DO:
• Use the provided steps to draw a stylized dragon.
• Use patterns and contour lines to illustrate detail and convey form.
• Apply shading to add depth.

VOCABULARY:

Contour Lines: Lines that define the outer edges and inner details of an object, highlighting its shape.

Overlapping: The effect when one object partially covers another, suggesting depth and layering in the composition.

Pattern: A recurring arrangement of shapes, lines, or colors within a design.

Stylize: To alter natural shapes, forms, colors, or textures in order to make a representation in a preset style or manner, rather than according to nature or tradition.

Dragon from the Orient

1. Start with a curvy line

2. Double the line thickness

3. Add a mouth and circle head

4. Add "horns" and brow and feet

5. Draw spines on back, claws and belly ridges

6. Add fang and spine details

7. More detail

8. Shade

CVH

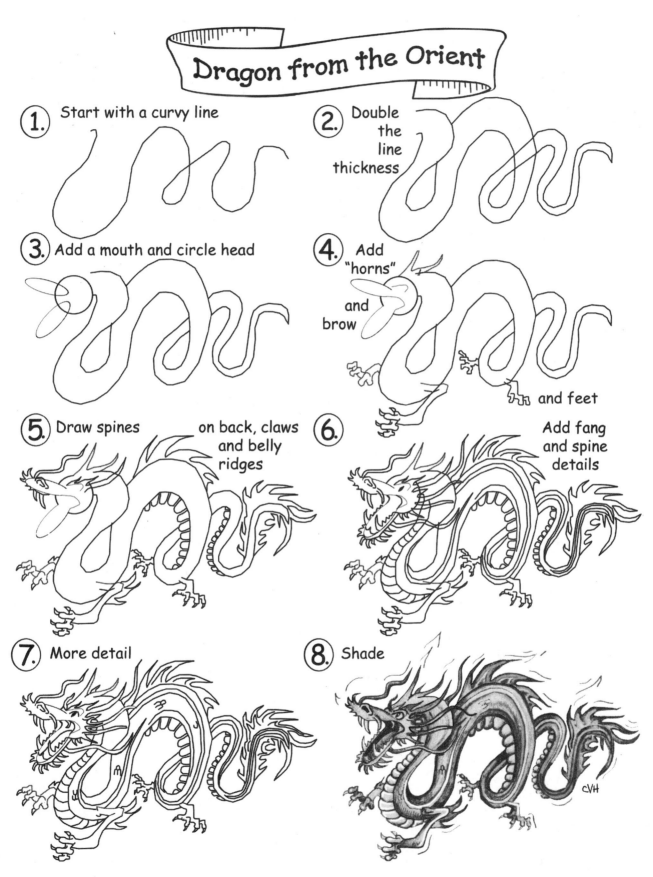

Chapter 6

Cool Stuff

PRAYING HANDS

KNOW:
Contour Lines, Symmetry.

UNDERSTAND:
• Simple contours can serve as foundational guidelines for constructing complex forms.

• Following steps to create an image can help to develop focus, attention to detail, and spatial awareness.

DO:
Create a realistic depiction of praying hands by following the provided steps. Incorporate unique "extras" such as Rosary beads or handcuffs to personalize your artwork. Don't stress about achieving perfect symmetry on both sides, as natural forms often exhibit slight variations. Apply shading to add depth.

VOCABULARY:

Contour Lines: Lines that define the outer edges and inner details of an object, illustrating its shape.

Guidelines: Temporary lines or marks made on paper to assist in determining the placement of final elements. These lines are often adjusted or erased as the artwork progresses, as seen in the initial steps of the "Praying Hands" drawing.

Symmetry: A characteristic where both halves of an object mirror each other, showing balanced proportions.

Praying Hands

1. Start with this simple geometric shape

(Angle at points)

2. Draw two angled lines inside

(Angle at points)

add rounded base →

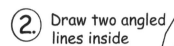

erase dotted

3. Add three "⌄" shapes

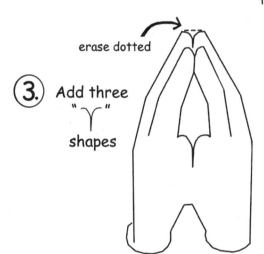

4. Add knuckles, fingernails and cuff detail

← Add bumps in knuckle areas

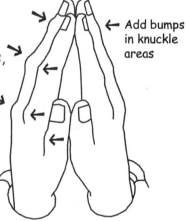

5. Add wrinkle, fingernail and cuff details. Start guideline for beads.

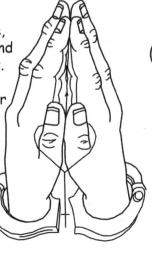

6. Add bead and cross details. Shade.

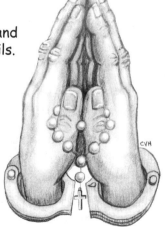

CVH

SKELETON HAND

KNOW:
Bones of the Hand, Contour line and Observation.

UNDERSTAND:
Drawing from observation to achieve a realistic likeness.

DO:
While observing a human hand, draw the bones of a skeleton hand while learning the names of each bone using the tips and tricks provided. As you draw, examine your hand and make note of where the knuckles are. These represent the sections between the bones.

TIP: A helpful starting point for this exercise is to trace your own hand. For the most accurate outline, hold your pencil at a 90-degree angle during tracing.

VOCABULARY:

Contour: The outline and visible edges of an object, figure, or mass.

Observation: Receiving knowledge of the outside world through the senses. Observation in art means drawing what you see.

Contrast: The technique of using unlike visual elements near one another to intensify the characteristics of the work. Contrast simply means a difference between objects in an artwork: light and dark, angles and curves, small and large, or opposite colors.

Extra Tip: When drawing the bones, be sure each bone terminates at a knuckle before starting the next.

Extra: This looks really cool when drawn on black construction paper using a white drawing material such as oil pastel. Start by using pencil for the outline of the hand then go in and add each bone using white. Color in the bones when the drawing is complete to create a realistic skeleton hand. This will show contrast in the form of light against dark.

Skeleton Hand

1.

Start by tracing your hand. If you are right handed, trace your left, etc.
TIP: To get the best hand shape, keep your pencil at a 90°angle.

2.

Next, add the digital phalanges above the first knuckle.
NOTE: This bone looks like a rounded arrow head in the finger-nail area.

3.

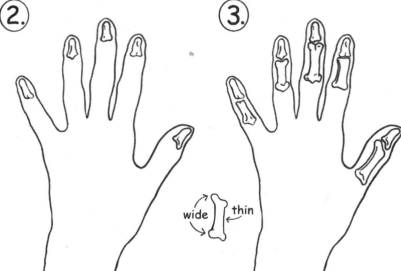

wide thin

Add the intermediate phalanges. These bones are wide at the ends and lean in the center.

4.

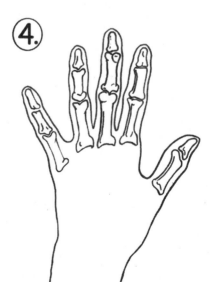

Next, add the proximal phalanges.
This will complete the finger portion of the skeleton hand.

5.

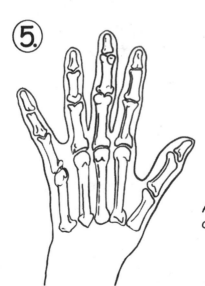

Then, draw the metacarpals. These almost reach the wrist area.

6.

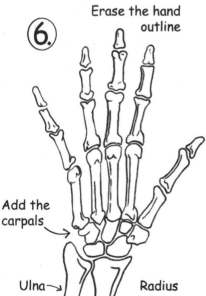

Erase the hand outline

Add the carpals

Ulna→ Radius

THREE SKULLS

KNOW:
• Mirror Symmetry/Balance.
• Major bones of the head.

UNDERSTAND:
• Basic proportion techniques to create a realistic skull.
• Mirror symmetry is when the parts of an image or object are organized so that one side duplicates (mirrors) the other.
• Perfect symmetry is rarely found in nature.
• Simple shapes serve as the foundation for developing complex forms.

DO:
Discuss the major bones of the head and the basic proportions of a human skull. Create an original artwork of "Three Skulls" using simple geometric shapes embellished into complex forms while indicating mirror symmetry. Refer to the human skull shading techniques on page 89.

VOCABULARY:
Balance: The way the elements of art are arranged to create a feeling of stability in a work; a pleasing or harmonious arrangement of parts in a design or composition.

Cranium: Portion of the skull that encloses the braincase.

Human Skull: Supports face structures and forms a cavity for the brain.

Mandible: The lower jawbone.

Mirror Symmetry: The parts of an image or object organized so that one side duplicates (or mirrors) the other.

Overlap: When shapes are in front of other shapes.

Proportion: The comparative sizes and placement of one part to another.

Three Skulls

1. Start with a circle

2. Add 2 more circles on each side

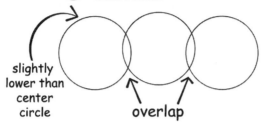

slightly lower than center circle

overlap

3. Add shapes beneath circles as seen below

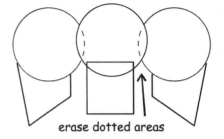

erase dotted areas

4. Add triangle noses, trim chin and erase dotted areas

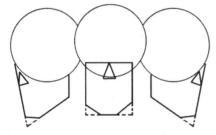

5. Add ovals for eyes near the lower half of the circles as seen below

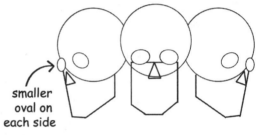

smaller oval on each side

6. Add brow ridges and cheek bones as indicated below

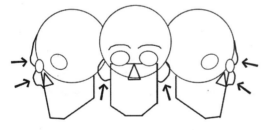

7. Add teeth lines and detail on sides

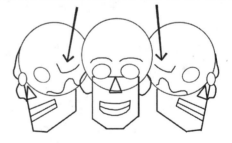

8. Add tooth detail, round the jaw line and erase dotted areas

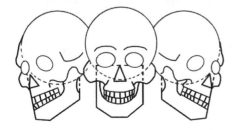

9. Smooth any sharp edges and shade

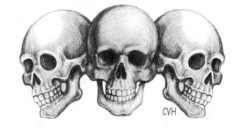

CVH

HAND POSITIONS
(Pointing Finger)

KNOW:

Foreshortening, Perspective.

UNDERSTAND:

How to create a three-dimensional illusion where the sizes of the closer and further parts of an object significantly differ.

DO:

Create an original drawing of a pointing hand as viewed from straight on. Make sure the pointing finger is much larger than the rest of the hand in order to give the appearance of foreshortening.

TIPS: When shading, apply the darkest shades between the fingers and at the knuckle creases. Lighten some areas on the upper knuckles, the centers of the fingers, and between the creases to introduce natural-looking highlights.

VOCABULARY:

Foreshortening: A way of representing an object so that it conveys the illusion of depth, seeming to thrust forward or go back into space. Foreshortening's success often depends upon a point of view or perspective in which the sizes of near and far parts of a subject contrast greatly.

Highlight: The brightest area on a surface that reflects the most light; in drawing, it's used to draw attention to or emphasize specific areas by manipulating values.

Perspective: A technique that imparts a sense of depth on a two-dimensional surface, simulating a three-dimensional space.

Point of View: The specific position or angle from which an object is viewed or considered, determining the direction of the observer's gaze.

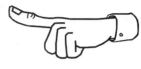

1. Start with a circle

2. Add an angled oval

overlap

3. Add a longer oval next to it

lower

slight overlap

4. Add another long oval

Draw at a downward angle

5. Add one last angled oval

6. Add an oval for the thumb

erase inner finger area

7. Connect knuckle tops with curved lines

Add an oval for the pinky

8. Add a fingernail

connect with curved lines here

erase dotted area inside pinky

9. Add knuckle wrinkles Erase dotted areas

add bump

connect

10. Shade

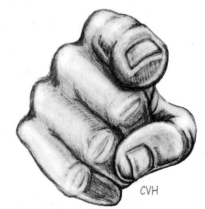

CVH

HAND POSITIONS
(Holding a Melting Clock)

KNOW:
Perspective, Proportion.

UNDERSTAND:
• The use of proportion, perspective, and observation in creating a drawing of a hand holding an object.
• Subtle differences in shape and size make our hands look unique.

DO:
Create an original drawing of a human hand holding an object (melting clock). Start with a series of "fanned out" ovals and build on those shapes, eventually turning them into finger forms. View your own cupped hand and observe the natural sizing and angles for reference.

VOCABULARY:

Guidelines: Any light line or mark made on a paper to help the artist decide where the final marks should go. These lines are usually temporary.

Form: A 3D shape (height, width, and depth) that encloses volume.

Highlight: The area on any surface which reflects the most light; to direct attention to or emphasize an area of a drawing through use of value.

Perspective: The technique artists use to project an illusion of the three-dimensional world onto a two-dimensional surface. Perspective helps to create a sense of depth and receding space.

Proportion: A principle of design, proportion refers to the comparative, relationship of one part of an object to another.

FUN FACT:
In 1931, Salvador Dalí created one of his most iconic pieces, "The Persistence of Memory," featuring surrealistic images of soft, melting pocket watches.

Hand Positions
Holding Items

1. Draw an angled oval

2. Add another

Draw light guidelines to help with finger placement

slightly lower

3. and another slightly smaller here

higher

4. Add a pinky

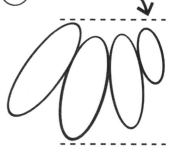

5. Add a thumb

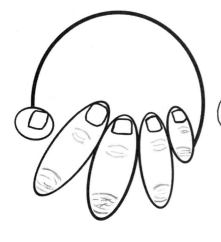

6. Erase guides. Add nails.

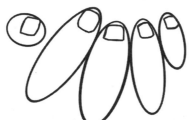

7. Add "wrinkles" at knuckle area

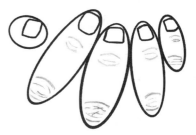

8. Add circle shape in palm area for clock

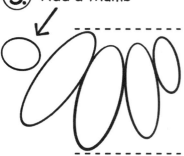

9. Draw extentions to each finger & "melting" drips

dent

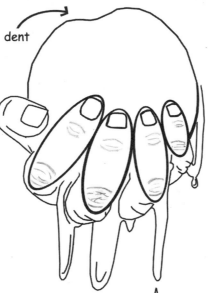

10. Add clock face. Shade

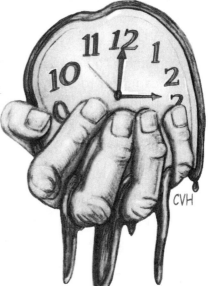

CVH

209

POCKET WATCH

KNOW:
Angle, Pattern, Perspective, Repetition, Roman Numerals.

UNDERSTAND:
• Placing simple geometric shapes in a specific pattern can act as a guide in creating a realistic object.

• Drawing parts of an object at angle can show perspective, an essential tool in creating a realistic impression of depth.

DO:
• Follow the steps provided to create a detailed "open" time piece based on simple geometric shapes.

• Using numbers or Roman Numerals, balance those numbers equally and in sequence around the clock face.

• Use learned 3D techniques which concentrate on perspective to convey the illusion of depth. Students will also consider size, position, detail and hue.

VOCABULARY:

Angle: The shape formed by two lines diverging from a common point. "Angle" can refer to both the space within these lines and a specific direction or viewpoint.

Perspective: The technique used to create the illusion of 3D onto a 2D surface. Perspective helps to create a sense of depth or receding space.

Roman Numerals: The numeric system in ancient Rome, uses combinations of letters from the Latin alphabet to signify values.

1	2	3	4	5	6	7	8	9	10	11	12
I	II	III	IV	V	VI	VII	VIII	IX	X	XI	XII

Pocket Watch

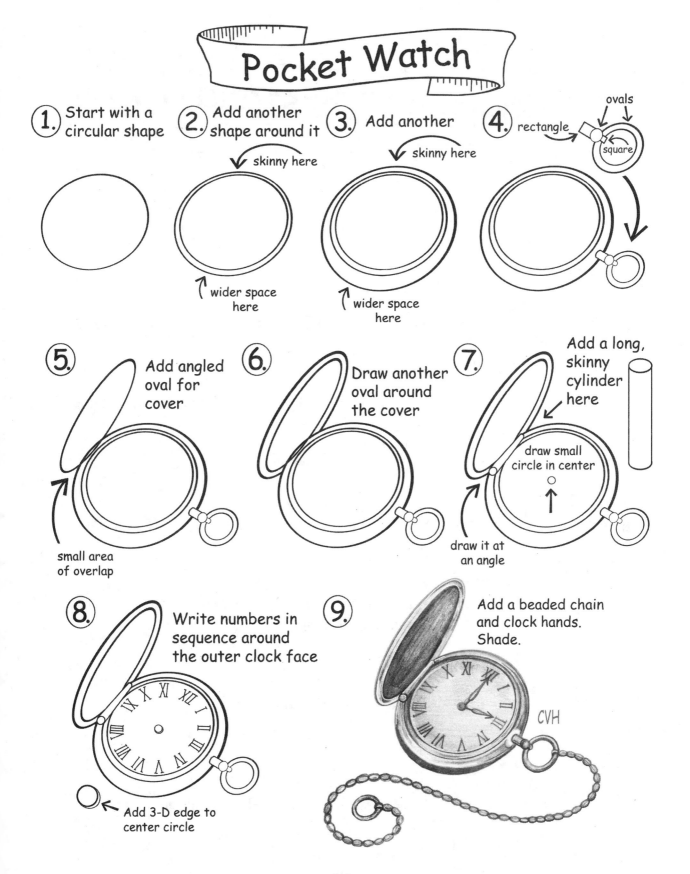

1. Start with a circular shape

2. Add another shape around it
 skinny here
 wider space here

3. Add another
 skinny here
 wider space here

4. ovals
 rectangle
 square

5. Add angled oval for cover
 small area of overlap

6. Draw another oval around the cover

7. Add a long, skinny cylinder here
 draw small circle in center
 draw it at an angle

8. Write numbers in sequence around the outer clock face
 Add 3-D edge to center circle

9. Add a beaded chain and clock hands. Shade.

CVH

CHAIN LINKS

KNOW:
Overlapping.

UNDERSTAND:
How to create the appearance of interlocking forms by using overlapping techniques and shading.

DO:
• Construct a realistic chain with interlocking links by following the provided tips and techniques.
• Apply shading to enhance depth and realism.
• Erase some areas on each link to create a metallic "shine" effect.

VOCABULARY:
Overlapping: The effect when one object partially covers another, suggesting depth and layering in the composition.

Add dark tone to the areas beneath the links and where they overlap.

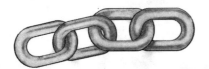

Add the mid tones and smooth.

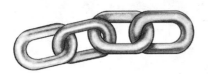

Erase areas of highlight to brighten them.

Chain Links

1. Start with a rectangle

inside a rectangle

2. Round all corners

(even on the inside)

3. Add another small rounded rectangle

it should touch the other small rounded rectangle

4. Surround that small rounded rectangle

with another large one

5. Erase dotted areas

6. Add portion of next link

inside

7. Complete the link

erase dotted area

8. Add another link

erase dotted area

9. Try turning this next link sideways

(links don't always lay flat)

10. Keep adding links until you achieve the desired effect

11. Shade

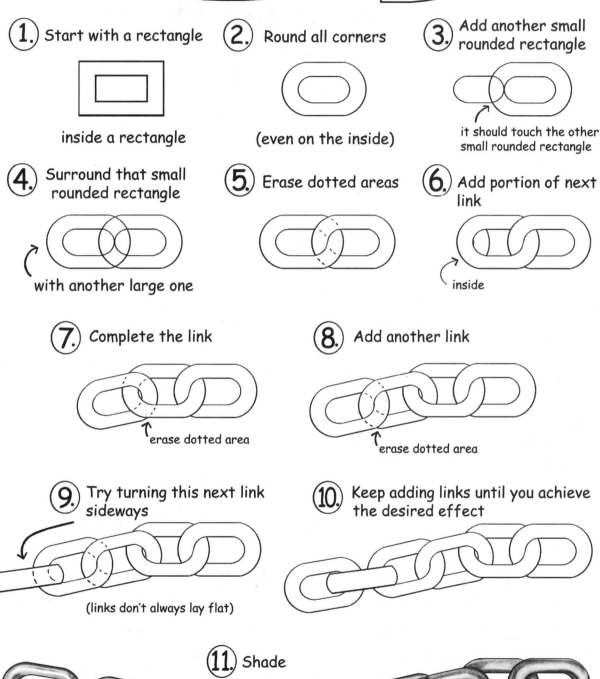

CVH

COMPASS ROSE

KNOW:
Balance, Compass, Repetition, Rotational Symmetry.

UNDERSTAND:
• How to arrange elements in an artwork so that they appear symmetrical or equally balanced.
• A compass rose is used to display the orientation of the cardinal directions and their intermediate points.

DO:
• Follow the steps provided to create an original Compass Rose design focusing on rotational symmetry.
• Shade with pencil or color with marker.

VOCABULARY:
Balance: A principle of design, balance refers to the way the elements of art are arranged to create a feeling of stability in a work; a pleasing or harmonious arrangement or proportion of parts or areas in a design or composition.

Compass: A navigational instrument that measures directions in a frame of reference that is stationary relative to the surface of the earth. The frame of reference defines the four cardinal directions (or points) - north, south, east, and west.

Compass Rose: (Sometimes called a Windrose) is a figure on a compass, map, nautical chart or monument used to display the orientation of the cardinal directions and their intermediate points.

Rotational Symmetry: An object that looks the same after a certain amount of circular movement around that object's center.

Symmetry: The quality of being made up of exactly similar parts facing each other or around an axis.

A Compass Rose is used to display the cardinal directions (North, South, East, West)

Compass Rose

1. Use a ruler and draw a symmetrical cross

2. Draw an "X" shape through the cross

this will create 8 equal 45° angles

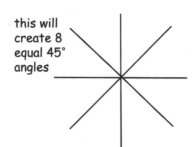

3. Place 4 dots at equal intervals on the "X" part

make a triangle using the top point of the cross and upper 2 dots

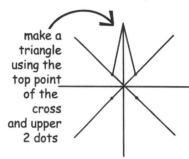

4. Draw a line from each dot to the nearest point of the first cross

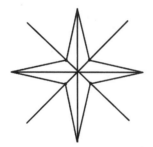

5. Make another set of points up from the previous

make 2 points on each "triangle"

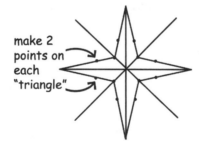

6. Draw a line from each dot to the nearest point of the "X" shape

7. Darken your lines with a thin marker and erase any extra pencil lines

8. Fill in the right side of each triangle with a dark color

9. Add "extras" including shading, letters to mark compass points and a circle

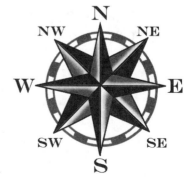

CUPCAKE TREATS

KNOW:
Balance, Ellipse, Repetition.

UNDERSTAND:
• The difference between shape and form.
• How to arrange elements in an artwork so that they appear symmetrical or equally balanced.
• Ellipses in art can help give the appearance of a 3D object.

DO:
• Follow the steps provided to create an original cupcake design that starts with simple shapes that are eventually connected to create complex forms.
• Use learned 3D techniques which concentrate on overlapping to convey the illusion of depth.

VOCABULARY:

Balance: A principle of design, balance refers to the way the elements of art are arranged to create a feeling of stability in a work; a pleasing or harmonious arrangement or proportion of parts or areas in a design or composition.

Oval (ellipse): A stretched, two-dimensional shape resembling an elongated circle, often representing a foreshortened circle in art.

Zig-zag: A pattern of lines that sharply alternate between moving up and down, forming a series of pointed peaks and troughs.

Cupcake Treat

zigzag - line with short, sharp angles

(1.) Start with an ellipse

(2.) Add slightly angled vertical lines on each side

(3.) Curve a zigzag pattern around the original oval

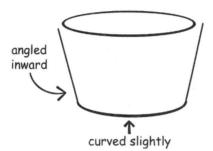

angled inward

curved slightly

(4.) Draw vertical lines coming from the zig-zag points

Erase the oval top (shown as dotted line)

(5.) Add a dollop of frosting

(6.) Define frosting edges

Top with a candy

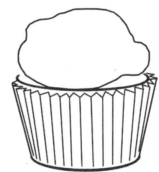

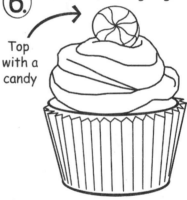

Decorate and Shade

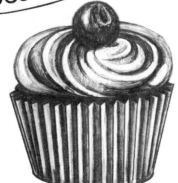

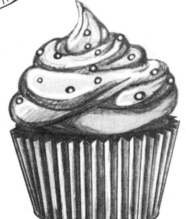

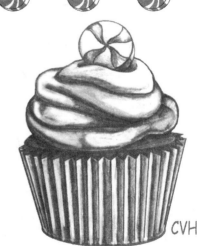

CVH

See shading tips on the next page

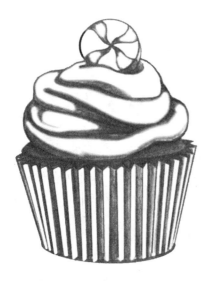

Start by adding tone to the darkest areas (folds of frosting, every other wrapper line)

Fill in mid-tones and blend

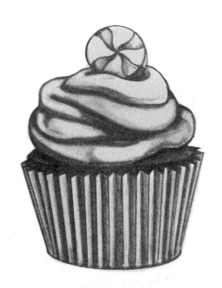

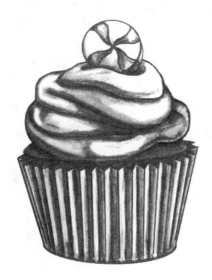

Erase areas for highlight

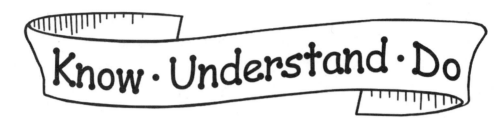

ALIEN SKULL

KNOW:
Geometric Shape, Angle.

UNDERSTAND:
• A simple circle can serve as the foundation for diverse artistic creations.
• Incorporating numerous small details into a larger design can enhance the complexity and appeal of an artwork.

DO:
• Create your version of an alien skull using the tips and tricks provided.
• Shade outside rim darker than the inside for a 3D, rounded effect.

VOCABULARY:

Angle: A shape formed by two lines diverging from or intersecting at a common point.

Geometric: Any shape or form that is mathematical in nature, often characterized by the use of straight lines and shapes derived from geometry.

Guideline: A faint line or mark made on paper to assist artists in determining the placement of final elements. These lines are typically erased or incorporated into the final piece.

Zig-zag: A pattern of lines that sharply alternate between moving up and down, forming a series of pointed peaks and troughs.

Alien Skull

1. Start with a circle

2. Draw a short rectangle

Add pointy shape on both sides

2 small triangles

3.

Draw an angled line (change direction at points)

add 2 small triangles

erase dotted

4.

add tiny triangles on both sides

2 angled shapes on both sides

erase dotted areas

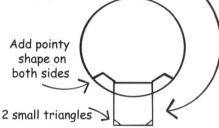

5.

erase dotted

"ʌʌʌ" shape

letter "M" shape

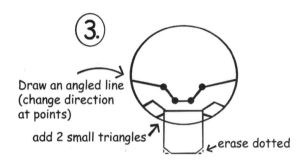

6.

draw a nose

(looks like a rocket)

thick lines for teeth

add 2 sharp points

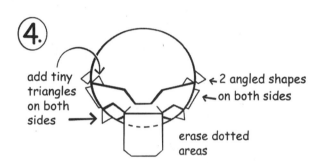

7.

Add a zig-zag lines above the teeth and brows

Erase guidelines under nose

start cross bones under skull

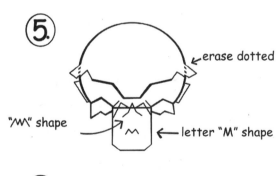

8.

Add your own details

Shade

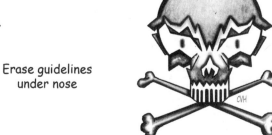

GET ON THE MICROPHONE

KNOW:
Sphere, Cylinder, Rectangle, Pattern, Cross Contours.

UNDERSTAND:
Connecting shapes to create recognizable, everyday forms.

DO:
• Choose a style and create your version of a microphone using the outline provided.
• Draw cross contours around the circle of the cordless microphone to create a spherical form.
• Draw cross contour lines around the angles of the old-school microphone to indicate angles and edges.

VOCABULARY:

Cross contours: Lines that travel across the form. Cross contour lines may or may not be visible on the subject. In these drawings, cross contours are added to the head of the microphone in step 4 to convey three-dimensional depth, length, width, space, distance, and perspective.

Cylinder: A three-dimensional shape that resembles a tube, circular in cross-section.

Pattern: A recurring repetition of shapes, lines, or colors within a design.

Sphere: A three-dimensional form shaped like a ball, circular from all possible points of view.

Get on the Mic

1. Start with a circle

2. Add the base

3. Add curved lines to show form

4. Shade

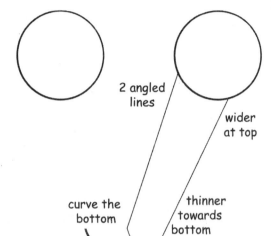

2 angled lines

wider at top

curve the bottom

thinner towards bottom

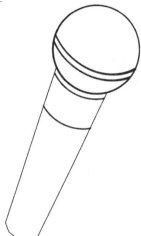

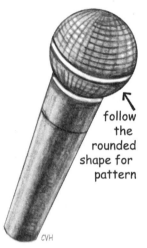

follow the rounded shape for pattern

CVH

old-school

1. Draw a tilted rectangle

2. Round the corners

3. Add angled shapes as seen below

4. Add details and shade

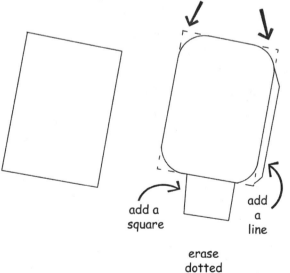

add a square

add a line

erase dotted areas

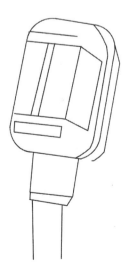

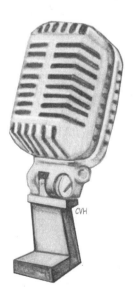

CVH

223

GRAVES WITH DRAPERY

KNOW:
Drapery, Texture.

UNDERSTAND:
• The process of transforming simple shapes into complex forms.
• Artists use texture to convey the appearance and *feel* of materials.
• The study of ways to represent drapery is essential in the development of an artist's skills. Drapery folds are composed of curving surfaces reflecting gradations of value.

DO:
Create a cemetery scene or headstone memorial featuring at least two graves. Incorporate three-dimensional edges, a wood-like texture, and fabric folds to enhance realism.

VOCABULARY:

Drapery: Cloth or a representation of cloth arranged to hang in folds.

Texture: The visual and tactile surface characteristics that are added to a work of art. It refers to the physical appearance or feel of an object. Simulated textures are suggested by an artist with different brushstrokes, pencil lines, etc.

Value: The degree of lightness or darkness in a color.

Graves with Drapery

1. Start with a 1/2 oval

2. Add "thickness"

thinner up here

rounded

thicker down here

angle

3. Add triangle shape

4. Another angle

5. Lengthen horizontals

wider here

6. Erase dotted area

add line here

and here

7. angle line

trim

here, too

8. Add "thickness" to cross edges

9. Add cracks and drapery

erase dotted areas

10. Shade

add "wood" look

CVH

See next page for tips on creating wood texture and drapery

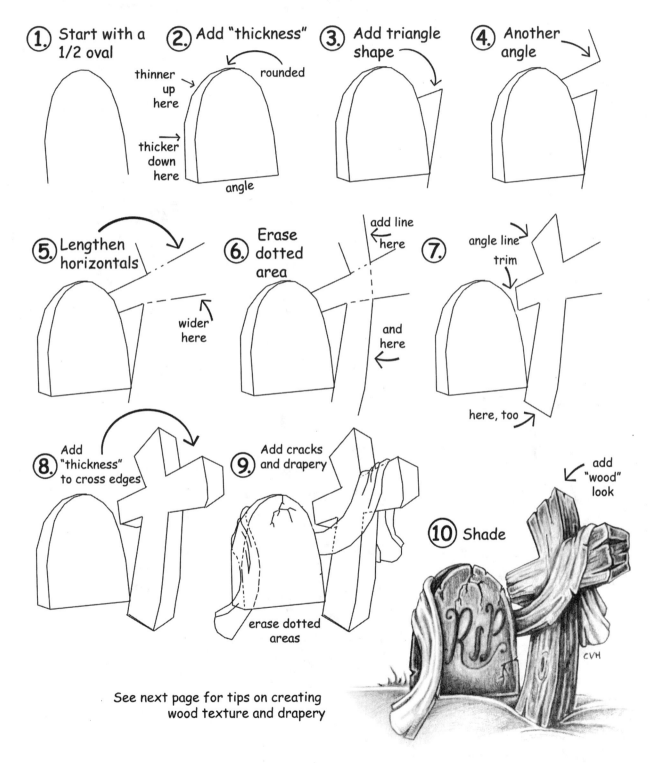

Start by drawing a pattern of curved lines

Add a few small circle shapes and draw lines around them

Add a light layer of tone over the pattern

Smooth with a blending tool

Add more lines to the pattern. Fill in the circle shapes to look like knots. Remove some areas of pigment with a kneaded eraser to form highlights

Drapery Folds

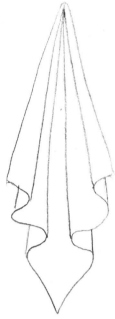

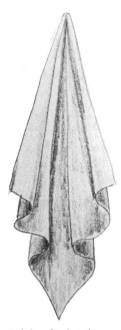

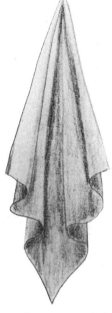

Start with folds of cloth outlined

Add a light layer of tone, pressing harder in areas where folds overlap

Smooth tones with a blending tool

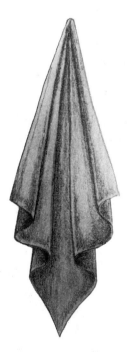

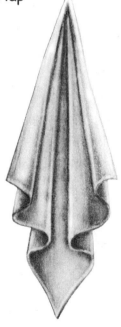

Add more tone to the darkest areas to add contrast

Erase the areas that are to be the lightest for a highlight

DRAW THE EARTH

KNOW:
Sphere, Continents, Curved lines, Cross Contours.

UNDERSTAND:
Lines and shapes drawn along the cross contours of a sphere will help to create the illusion of 3D.

DO:
• Choose a view of the Earth to draw.
• Add continents along the cross contours of the spherical shape so that they appear to move around the Earth.

VOCABULARY:

Continents: The Earth's seven major landmasses, including Asia, Africa, North America, South America, Antarctica, Europe, and Australia.

Cross contours: Lines that travel across the form to outline and highlight the figurative shape in a drawing. In these drawings, cross contours indicated by the placement and size of the continents.

Sphere: A three-dimensional form shaped like a ball, circular from all possible points of view.

Draw the Earth

This tutorial shows only two of the many views of our planet

CVH

1. Start with a circle 2. Create simple shapes for continents 3. Refine and connect shapes 4. Shade

CVH

BIRD CAGE

KNOW:
The simple steps to create a 3D bird cage.

UNDERSTAND:
• A transparent cylinder provides a view through the form from all angles.
• Lines that wrap around a shape help to define it's volume and create the illusion of form.

DO:
• Follow the steps provided to create a bird cage. Be sure to draw lines on the "front" and "back" to indicate the illusion of 3D.
• Add "extras" such as a bird for added detail.

VOCABULARY:

Cylinder: A shape that appears three-dimensional, typically with circular ends and straight sides.

Cross Contours: Lines that traverse an object's surface, illustrating its three-dimensional form. These lines can extend in any direction, accentuating the object's volume.

Ellipse: The shape of a circle when viewed at an angle, typically represented as an oval.

Transparent: See through.

The Bird Cage

use a ruler!

1. Start with a rectangle rounded at the top

2. Add an oval inside near the bottom

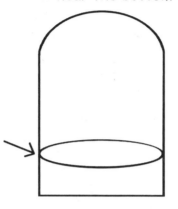

3. Add a curved line to "thicken" the oval

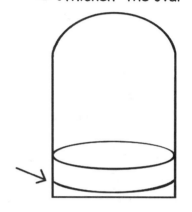

4. Erase area under oval (see dotted area)

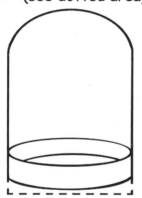

5. Add 2 more ovals

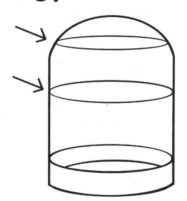

6. Add parallel lines curved near the top for bars

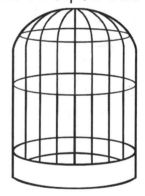

7. Add bars to the "far-end" of the cage

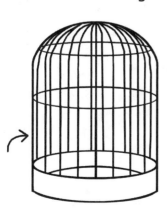

8. Add a decorative top and an open door

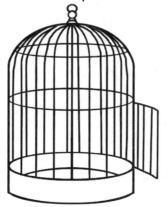

9. Add shading details and "extras"

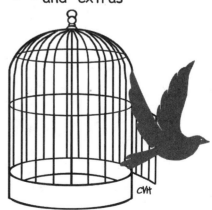

231

PAWS AND CLAWS

KNOW:
The simple steps to create paw prints and ripping claws.

UNDERSTAND:
• Simple shapes combined together can create recognizable forms.
• Small details can create powerful effects in drawing.

DO:
Use the provided steps to sketch a paw print and a set of ripping claws.

VOCABULARY:

Effect: A result or consequence of some action or process.

Organic Shape: A naturally occurring, irregular shape, characterized by its flowing, unpredictable contours, often found in nature.

Vertical: The direction going straight up and down.

Paws and Claws

Paws

(1.) Start with a wide egg shape

← narrow here

wider here

(2.) Add 2 lines

keep some space here

(3.) Draw diagonals

(4.) Round the edges

(5.) Add 2 more toes . . .

(6.) Add small, curved triangle shape for claws

Claws

make a raindrop shape → turn it upside down and curve it

(1.) Start with 4 curved claws

(2.) Draw a long triangle from each claw top

(3.) Shade

add jagged edges for a ripping effect

Darken inside each triangle

CVH

MANGA

KNOW:
Manga, Exaggerating Features, Caricature.

UNDERSTAND:
• Characteristics of Manga art.
• Use of exaggeration and distortion in an artwork to create a distinctive artistic style.

DO:
Follow the steps provided to create an original "Manga" style character.

VOCABULARY:

Anime: The word anime is a shortened form of the Japanese word animēshon, which means "animation." Anime is a style of Japanese film and television animation, typically aimed at adults as well as children.

Caricature: A representation in which the subject's distinctive features or peculiarities are deliberately exaggerated to produce a comic or grotesque effect.

Distortion: To change the way something looks, sometimes deforming or stretching an object or figure out of its normal shape to exaggerate the features.

Exaggerate: Overstate, embellish; enlarge or shrink in size.

Manga: A Japanese comic book or graphic novel genre known for its unique artistic style, which includes large, expressive eyes, exaggerated facial expressions, and vibrant hair. Manga often features simplified backgrounds, dynamic action scenes, and emotionally driven narratives.

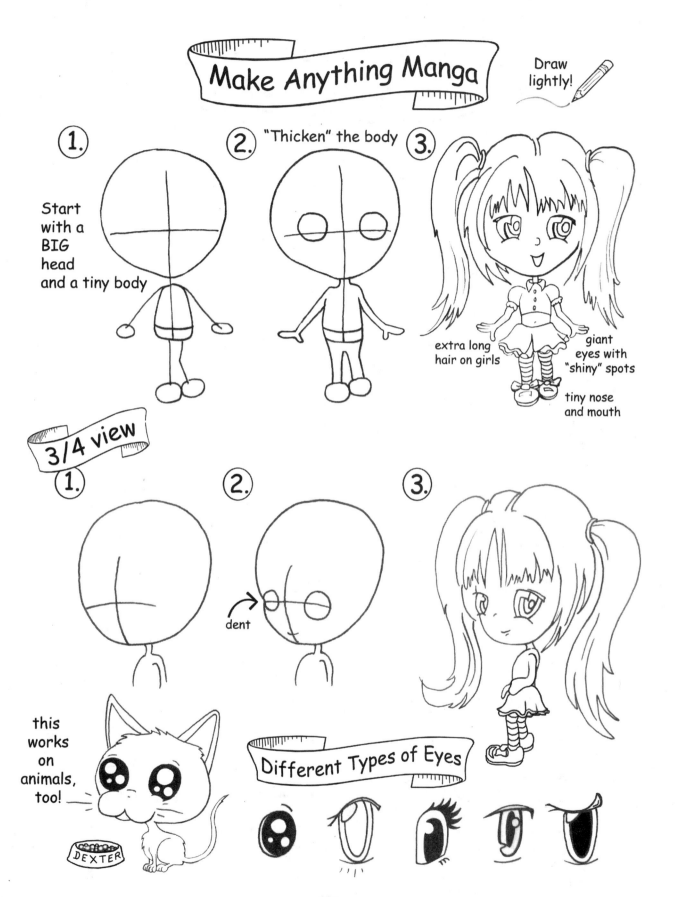

Make Anything Manga

Draw lightly!

1.

Start with a BIG head and a tiny body

2. "Thicken" the body

3.

extra long hair on girls

giant eyes with "shiny" spots

tiny nose and mouth

3/4 view

1.

2.

dent

3.

this works on animals, too!

DEXTER

Different Types of Eyes

235

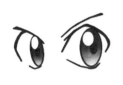

Manga Boy
3/4 face view

夢 dream
和 harmony

1. Start with a **BIG** head

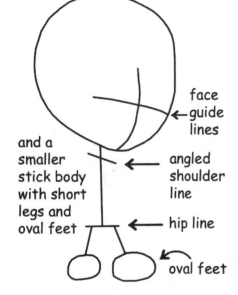

face ← guide lines

and a smaller stick body with short legs and oval feet

← angled shoulder line

← hip line

oval feet

2. Add to body

← cross arms

← rectangle hips

3. "Thicken" torso and legs

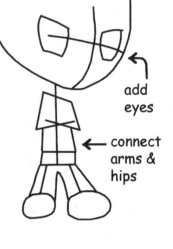

← add eyes

← connect arms & hips

4. "Thicken" arms and upper body

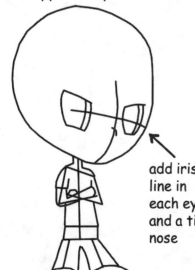

add iris line in each eye and a tiny nose

5. Erase center guidelines

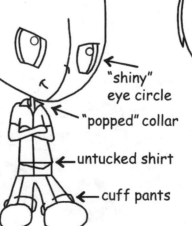
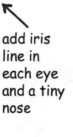

"shiny" eye circle

"popped" collar

← untucked shirt

← cuff pants

6. Erase bottom guides. Add spiky hair-do.

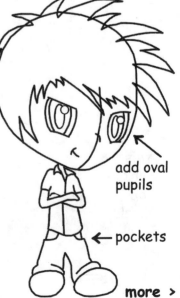

← add oval pupils

← pockets

more >

7. Erase head and shirt guide lines

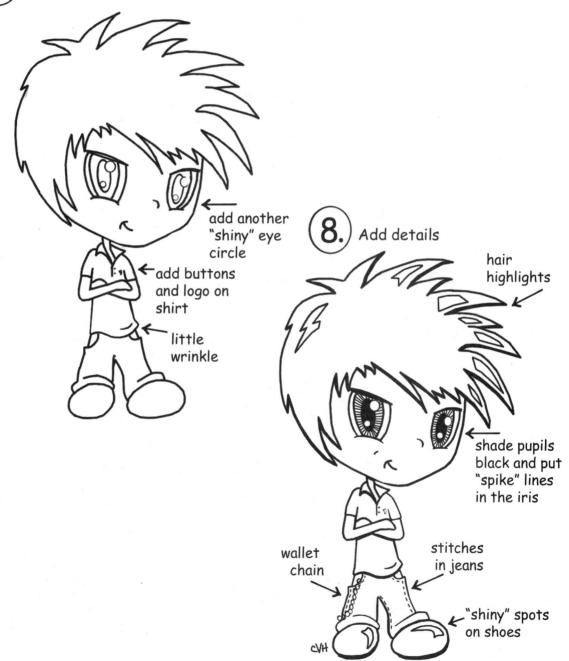

add another "shiny" eye circle

add buttons and logo on shirt

little wrinkle

8. Add details

hair highlights

shade pupils black and put "spike" lines in the iris

wallet chain

stitches in jeans

"shiny" spots on shoes

CVH

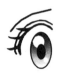 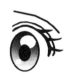

Manga Girl
3/4 face view

grace

happy

1. Start with a **BIG** head

face guide lines →

and a smaller stick body with short legs and oval feet

← angled shoulder line

← hip line

← oval feet

2. Add to body

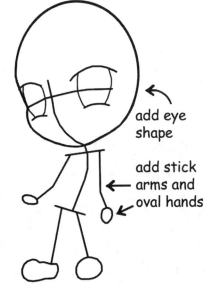

add eye shape

add stick arms and oval hands

3. "Thicken" torso and add skirt shape

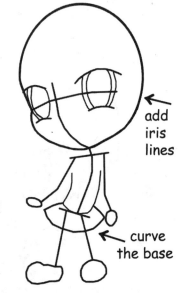

add iris lines

curve the base

4. "Thicken" arms and add a shirt

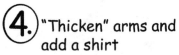

add oval pupil

erase eye guide-lines

add thumb

add ruffle to skirt

5. Add nose, mouth and hair "buns"

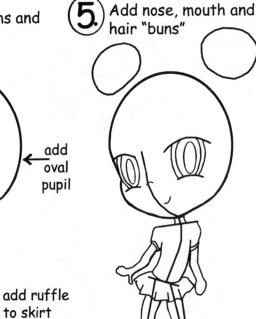

6. Erase center guides. Add hair.

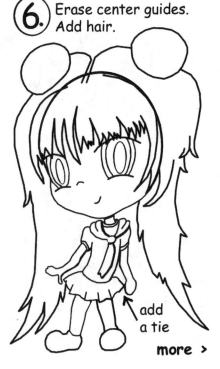

add a tie

more >

238

Manga Girl
finishing touches

7. Erase head lines

add "shiny" eye circle

add a teddy bear if you want

8. Add details

add clips in hair

freckles on nose

stripes on stockings

and other "extras"

hair highlights

shade pupils black and put "spike" lines in the iris

"shiny" spots on shoes

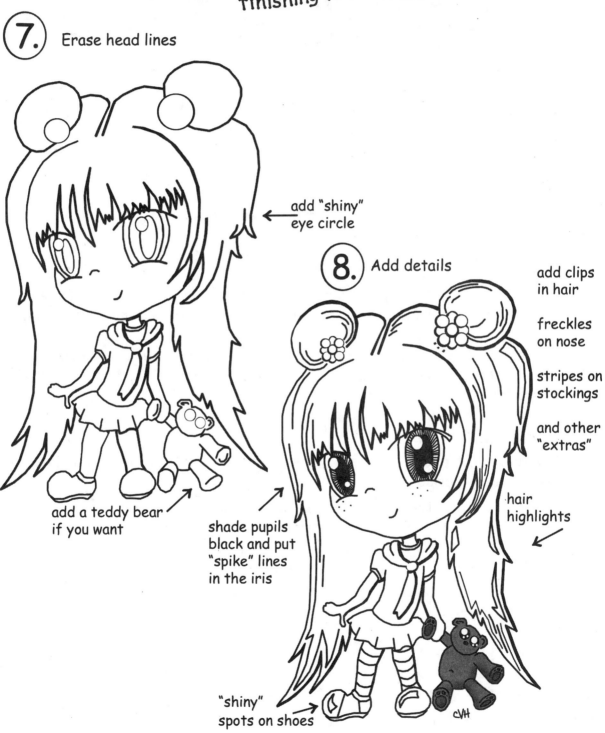

CVH

DRAW A LACE-UP CORSET

KNOW:
Overlapping.

UNDERSTAND:
How to create the illusion of layers, making parts of a drawing appear in front of or behind other elements.

DO:
• Discuss examples of two-dimensional images which have near and far elements, focusing on how overlap and differences in size help to achieve an illusion of depth.
• Use the provided steps to depict overlapping laces on a corset. The technique of overlapping, combined with size differences, will enhance the sense of perspective.

VOCABULARY:

Overlap: When one object partially covers another, suggesting depth and layering in the composition.

Perspective: The viewpoint or angle from which an object or scene is rendered, influencing how its dimensions are perceived.

Lace·Up Corset

1. Start with a "V" shape open at the bottom

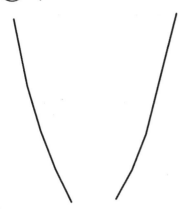

2. Add 1/2 ovals on each side for "hooks"

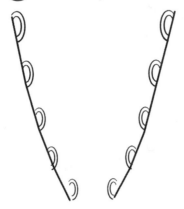

3. Erase "V" guide lines Add zig-zag as seen

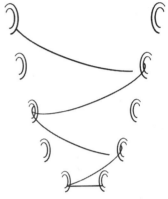

4. Add zig-zag to opposite side creating curved "X" shapes

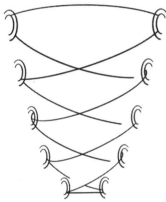

5. "Thicken" the laces by adding another line to each "X"

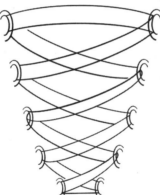

6. Erase ceratin lines so it looks like some laces are overlapping others

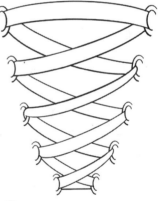

7. Add a bow

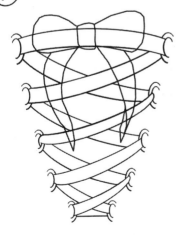

8. Erase area behind the bow

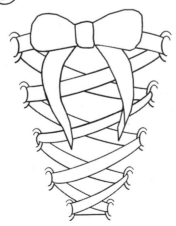

9. Shade

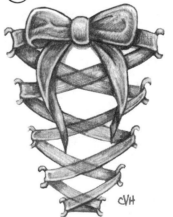

CVH

A FANCY TEA CUP

KNOW:
• Combining simple shapes can lead to the creation of complex objects.
• A cross-section of a cone can create the illusion of a vessel, like a tea cup.
• Adding patterns and shading creates form and dimension to an object.

UNDERSTAND:
Employing the structure of a cylinder, with its rounded base and elliptical top, can create the appearance of an object capable of containing volume.

DO:
Craft an original drawing of a tea cup and saucer, illustrating perspective. Incorporate "extras" such as a tea bag or spoon, and apply shading to enhance depth.

VOCABULARY:
Cone: The shape formed by extending two lines from the edges of an ellipse until they converge.

Ellipse: The shape of a circle when viewed at an angle, typically represented as an oval.

Overlap: When one object partially covers another, suggesting depth and layering in the composition.

Perspective: A technique that provides depth and a three-dimensional effect to a two-dimensional artwork, contributing to its realism and proportionality.

Volume: Refers to the space enclosed by a three-dimensional form.

A Fancy Tea Cup

①. Start with a long, thin oval

②. Add 2 angled vertical lines

③. Round the bottom

④. Add curves to both sides

erase dotted areas

⑤. Add two ovals

one here

bigger one here for saucer

⑥.

erase dotted

add thickness to rim

⑦.

Add "thickness" to rim

use oval to make a fancy handle

erase dotted

Add slight curve for saucer base

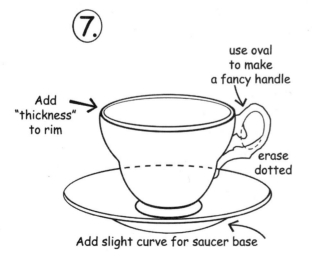

⑧. Add a fancy design like flowers or swirls

Shade

CVH

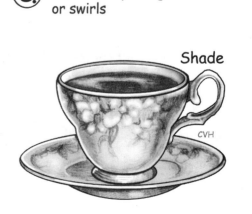

SNEAKER DESIGN

KNOW:
Balance, Design, Function, Line, Repetition.

UNDERSTAND:
• How fashion can create and divide social structures.
• Fashion can reflect identity and be an extension of one's personality.
• How to create an original design out of an existing structure.

DO:
From conceptualization to final product, create an original shoe design. Consider industry trends, design concepts, pattern, materials, color, line, symmetry, the wearer's personality, gender, age, likes/dislikes, etc., when designing the shoe.

Don't forget: The purpose of the shoe (sports, casual wear, etc.), shoe shape (high top, low, etc.), stitching, reinforced areas, logos, laces/straps/Velcro closure, grommets, sole texture, hang tags, etc.

PRESENTATION & REFLECTION:
You will need to include an artist statement/self-reflection with your piece. In paragraph form, please include the following information, as well as key vocabulary used in class:

1. Describe your shoe design and your inspirations. What identity are you trying to convey? (Who are the shoes intended for? etc.)
2. What areas have been easy or challenging in the design process?
3. Describe the strengths and weaknesses in your shoe design.
4. If you had to repeat this project, what would you do differently and why?

Sneaker Design

Task: Create an original sneaker design. Brainstorm your concept using the ideas below

1.

2.

3.

4.

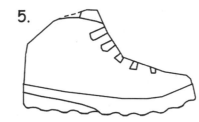

5.

6.

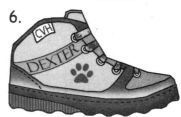

Some Generic Sneaker Shapes

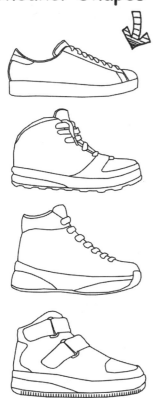

What do your shoes say about you?

1. Think about design elements that you like and make a list. It can include words, fonts, doodles, patterns, etc.

2. Decide what elements you want to include in your design. (line, font, text, graffiti, etc.)

3. Decide what identity you are trying to convey. Who are the shoes intended for?

Art Considerations:
industry trends
pattern
materials
color
balance
line
symmetry

Don't forget:
purpose of shoe
shoe shape
stitching
logo (endorsement?)
laces/straps
grommets
sole texture

TREASURE CHEST

KNOW:
•Simple shapes combined create complex objects.
•Adding pattern and shading to an object gives it form and dimension.

UNDERSTAND:
• Using the principles of a cube to create an object that appears to hold volume.
• The use of receding lines to show perspective.
• One method to create a simple 3D cube.

DO:
Create an original artwork of a treasure chest that demonstrates perspective. Add lots of "extras" inside the chest. Put it in a scene.

VOCABULARY:
Cube: A polyhedron having six square faces; a square that appears 3D.
Perspective: The point from which an object or scene is viewed.
Receding Lines: Lines that move back or away from the foreground.

 Treasure Chest

1. Start with an angled rectangle
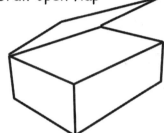

2. Add 3 receding lines
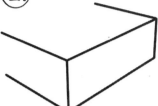

3. Connect
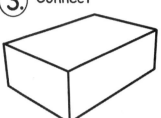

4. Draw open flap
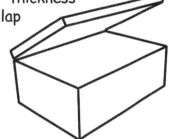

5. Add "thickness" to flap
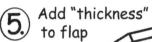

6. draw arch
add handle
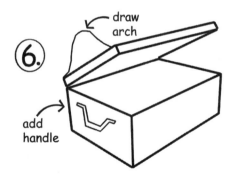

7. Connect box top
add details
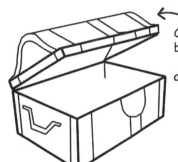

8.

Detailed Lock . . .

1.

2.

3.

247

Know · Understand · Do

SKELETON PIRATE

KNOW:
Geometric Shapes, Overlapping, and Layering.

UNDERSTAND:
• Layering simple shapes can be the first step to creating complex forms.
• The average human body can be measured as "7 heads high."

DO:
• Follow the steps provided to create your own version of a unique "Skeleton Pirate."
• Add lots of "extras" like a treasure chest, pirate ship, or scrolled treasure map.
• Put your character within the scene and shade.

VOCABULARY:
Geometric: Any shape or form having mathematical design. Geometric designs are often composed of straight lines and shapes derived from geometry, in contrast to organic, free-form lines.

Layering: The act of placing one element over another within a composition.

Overlapping: When one part of a design covers a portion of another, suggesting depth.

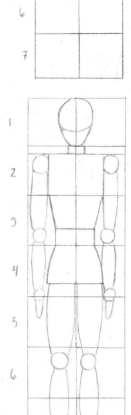

Draw a Skeleton Pirate

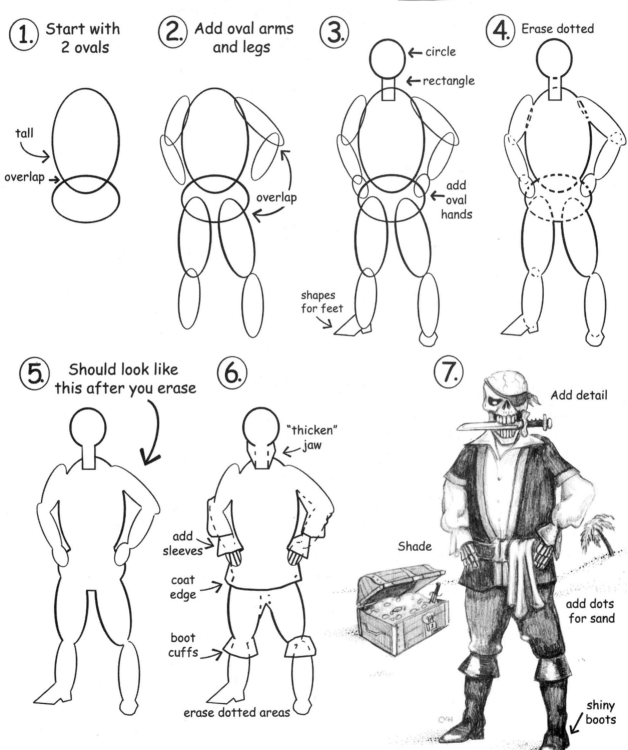

1. Start with 2 ovals

tall
overlap

2. Add oval arms and legs

overlap

3. ← circle
← rectangle
add oval hands
shapes for feet

4. Erase dotted

5. Should look like this after you erase

6. "thicken" jaw
add sleeves
coat edge
boot cuffs
erase dotted areas

7. Add detail
Shade
add dots for sand
shiny boots

WOODEN CROSS

KNOW:

Texture, Depth, Perspective, Parallel lines.

UNDERSTAND:

• Creating complex forms from simple shapes.

• Texture is used by artists to show how something might feel or what it is made of.

DO:

Create an original cross that features a wood-like texture and illustrates perspective.

VOCABULARY:

Depth: Creating the illusion of three-dimensional space on a two-dimensional surface. Artists use linear perspective to create depth with horizontal lines. Vertical lines help to create surfaces.

Perspective: The point from which an object or scene is viewed.

Texture: The way something looks like it might feel in an artwork. Simulated textures are suggested by an artist with different brushstrokes, pencil lines, etc.

Value: The lightness or darkness of a color.

Vertical: Lines that are drawn up and down and are parallel to the y-axis.

TIP: See page 226 for detailed instructions for a wood texture.

1. Start with 2 vertical lines

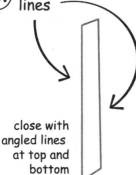

close with angled lines at top and bottom

2. Add 2 horizontal lines for a lower case "t"

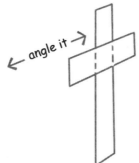

← angle it →

3. Draw 7 short angled lines

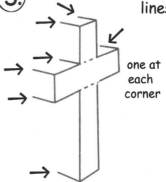

one at each corner

4. Connect lines to give the illusion of 3-D

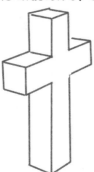

5. Add 2 parallel angled lines

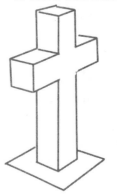

one in back

one in front

6. Connect the lines to create the base

7. Add 2 "⌄" shapes for base

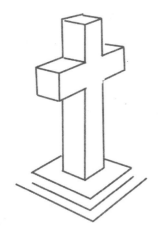

8. Close the base with vertical lines

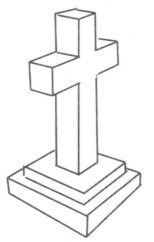

9. Shade with "wood look"

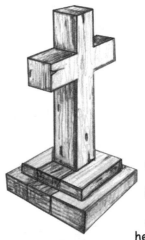

WOOD SAMPLE

a bunch of lines going in the same direction with a knot here and there

GRAPHIC WATER PUDDLE

KNOW:
Organic Shape, Depth, Perspective.

UNDERSTAND:
How to create the appearance of depth when drawing organic forms.

DO:
Create an original water puddle showing depth and thickness, using the tips provided. Shade. Don't forget the water droplets!

VOCABULARY:
Depth: The perceived distance from the front to the back or from near to far in an artwork. When referring to the smallest dimension of an object, this distance can also be termed its "thickness."

Organic: An irregular shapes typically found in nature, as opposed to regular, mechanical shapes.

Water Puddles

1. Start with an organic shape that appears larger in the front and smaller toward the back

2. Add a "thickness" that follows the contour of the shape on one side.

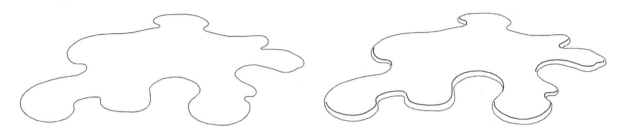

3. Shade the rim you just created

4. Add some random oval droplets

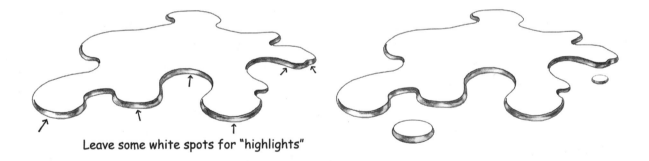

Leave some white spots for "highlights"

5. Lightly shade the rounded edges on the "top" of the puddle

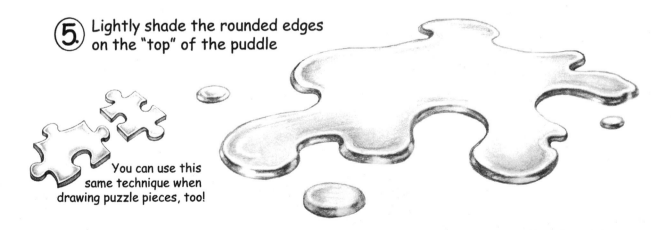

You can use this same technique when drawing puzzle pieces, too!

WATER PUDDLE FLOATERS

KNOW:
• Basic shape construction in drawing.
• Shape and form are two of the seven elements of art.

UNDERSTAND:
• The difference between shape and form.
• Volume.
• Layering/Overlapping.

DO:
Use the knowledge gained from the "Water Puddles" drawing project to create a puddle. Select an item from the "Water Puddle Floaters" sheet (or choose your own) to "float" on your puddle. Don't forget to shade your object and add water rings to indicate motion!

VOCABULARY:

Form: A three-dimensional shape (height, width, and depth) that encloses volume.

Shape: An enclosed space.

Volume: The space within a 3D form.

Water Puddle Floaters

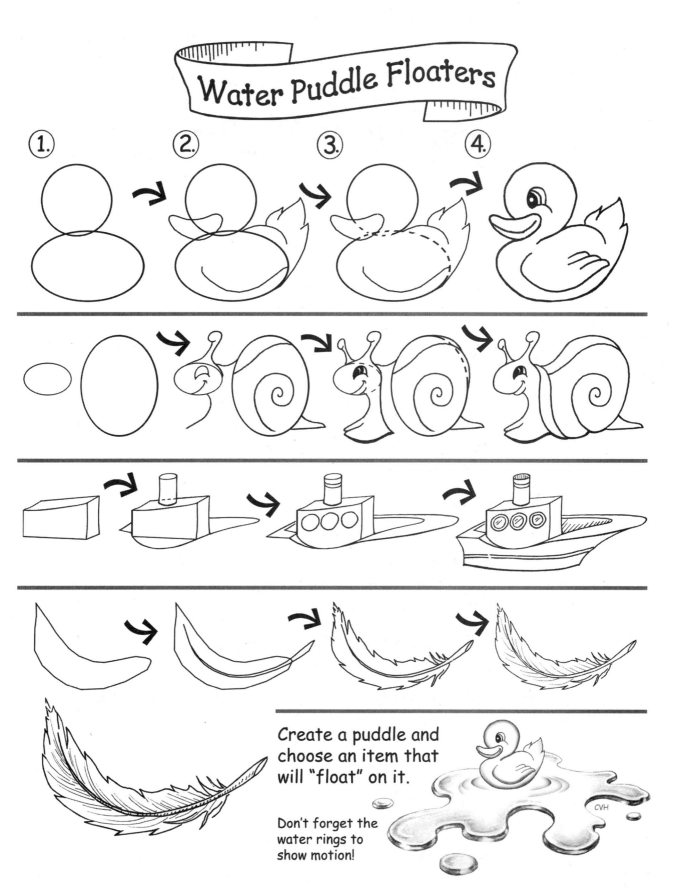

1.
2.
3.
4.

Create a puddle and choose an item that will "float" on it.

Don't forget the water rings to show motion!

CVH

FOOTPRINTS

KNOW:
Simple tips and tricks for creating a "mini footprint."

UNDERSTAND:
Everyday objects can be utilized to make prints, enabling the creation of designs and patterns.

DO:
Follow the steps provided to create a "mini-footprint" design. Create both right and left mini footprints and place them in a staggered pattern so they represent a realistic walking pattern.

VOCABULARY:

Footprint: The impression or mark left by a person walking or running.

Pattern: The repetition of any thing including shapes, lines, or colors.

Print: A mark or shape produced by pressing an object covered in wet color (typically ink or paint) onto a flat surface.

Repetition: A way of combining elements of art so that the same elements are used over and over again. Thus, a certain color or shape might be used several times in the same picture.

Stagger: To arrange unevenly or in a various zigzag or overlapping position.

This may take a little practice to get it right but it's a fun and interesting way to make a footprint

Footprints

1. Start with a water based acrylic or tempera paint

2. Make a fist. Paint the back side of your hand

3. On scrap paper, stamp your hand to remove any excess paint

4. Stamp again and add a big toe.
(Use your thumb!)

5. Add a second toe . . .
(Use your index finger)

6. A third toe . . .
(Use your ring finger)

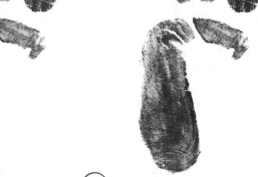

7. Add a fourth . . .

use your ring finger

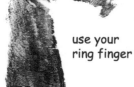

8. Add the last toe

use your pinky finger

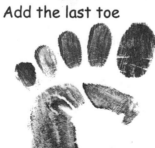

9. Try it again using your other hand and make a pair

257

HOW TO DRAW FIRE

KNOW:
Random Lines, Overlapping, Highlight, Value.

UNDERSTAND:
• Layering simple shapes can enhance depth and create form.
• Adjusting the value of tones during shading can help to create interest and re-alism.

DO:
• Follow the steps provided to create your own depiction of a fire.
• Apply value to depict areas of darkness and light.
• Erase some areas to create highlights.

VOCABULARY:

Highlight: The brightest area on a surface, reflecting the most light, used in art to draw attention to or accentuate specific areas by manipulating value.

Overlapping: When one element partially covers another.

Random Lines: Lines placed without a definite pattern or order, appearing haphazard or unplanned.

Value: The degree of lightness or darkness in a color or tone, crucial for depicting depth and dimension in art.

How to Draw Fire

1. Start with a tear drop shape

2. Draw random curvy lines inside

erase
dotted
areas

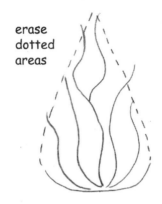

3. Add lines in dotted areas to "thicken" the flames

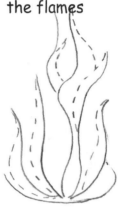

4. Add a few more random, curvy flames

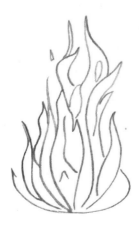

5. Lightly shade entire flame, partially erasing the center lines

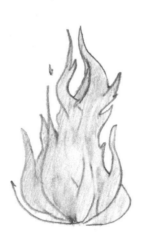

6. Shade

add small, separate flames

erase some areas to highlight them

darken tips

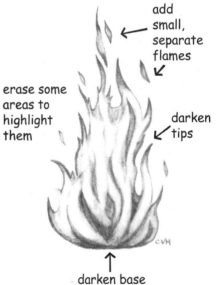

darken base

HOW TO DRAW A CANDLE

KNOW:
Cylinder, Highlight, Value.

UNDERSTAND:
• Cylinders in art create the illusion of a three-dimensional circular tube.
• Adjusting the value of tones during shading adds interest and realism.

DO:
• Follow the steps provided to create your own depiction of a burning candle.
• Apply value to indicate areas of darkness and lightness.
• Erase some areas to create highlights (more nearest the flame).

VOCABULARY:

Cylinder: A shape that appears three-dimensional, similar to a tube.

Highlight: The brightest area on a surface, reflecting the most light, used to draw attention to or emphasize specific areas by adjusting value.

Value: The degree of lightness or darkness in a color or tone, essential for conveying depth and dimension in art.

Draw a Candle

① . Start with a tall, skinny rectangle

② . Add an oval to the top and bottom to create a cylinder

← oval

erase dotted areas

← curve base

③ . Add oval →

line for wick

④ . Add point

curve flame base

Add "drips"

erase dotted areas

drip

⑤ . Add curved shape to top oval

⑥ . Shade

Erase some areas to create highlights (more nearest the flame)

wick detail looks like this

cVH

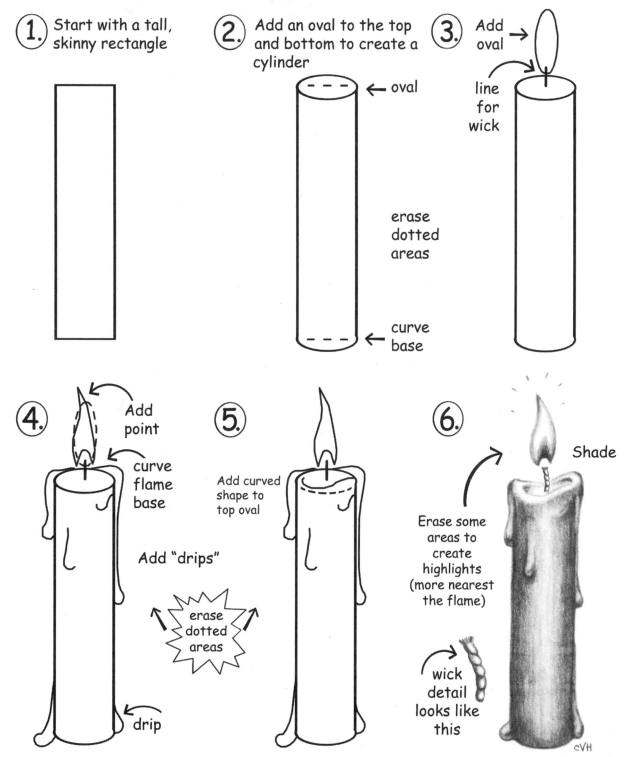

SKULL WITH FLAMES

KNOW:

Exaggerating Features, Highlight, Value.

UNDERSTAND:

Use of exaggeration and distortion in an artwork to create a particular style.

DO:

• Create your own version of a stylized skull with flames following the provided guidelines, OR practice sketching a generic human skull and emphasize the exaggeration of its features.

• Add "extras" and apply shading for depth.

• Erase some areas to accentuate the flames with highlights.

VOCABULARY:

Distortion: To change the way something looks, sometimes deforming or stretching an object.

Exaggerate: Overstate, embellish; enlarge or shrink in size.

Highlight: The brightest area on a surface, reflecting the most light, used in art to focus attention on or accentuate specific areas by manipulating value.

Skull with Flames

1. Stack these 4 shapes

oval →
geometric shape →
square →
another geometric shape →

2. Add details

temple
add eyes
trapezoid nose

3. Add rectangle shape on both sides

add eyes
erase dotted areas
∩ shape
ω shape

4. round edges

Make nose look like ⋀ this

more "∩" shapes
more "ω"
curve

5.

add 2 curved lines for teeth

6. "Thicken" eye socket

lines
erase dotted

7. Add cracks everywhere

individual teeth

8. Shade

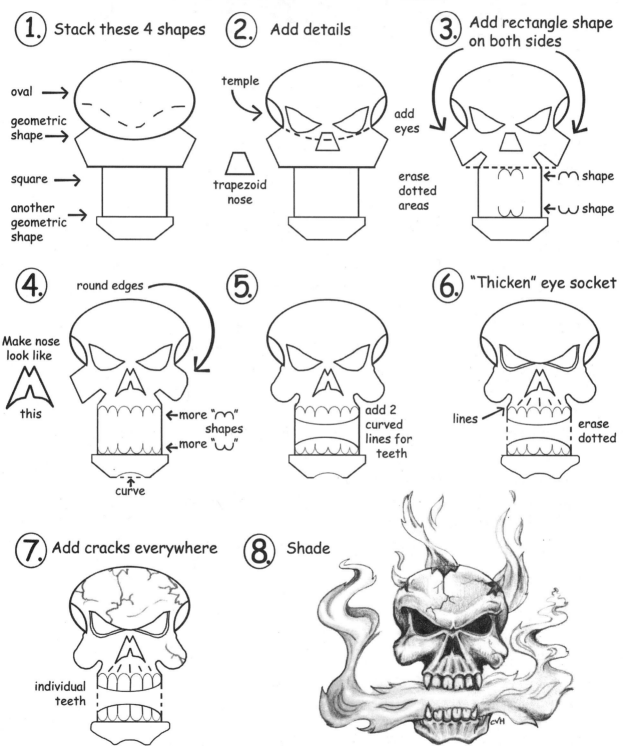

DRAW SPORTS BALLS

KNOW:
The simple steps to create a variety of sports balls.

UNDERSTAND:
• Small changes or additions to basic shapes can create specific, recognizable images.
• The distinction between shape and form.
• Shading and patterns can transform shapes into forms.

DO:
Use the provided steps to sketch at least two of the four sports tools illustrated. Apply shading for depth.

VOCABULARY:

Form: A three-dimensional shape (height, width, and depth) that encloses volume.

Shape: An area enclosed by lines or curves.

Volume: The amount of space occupied by a three-dimensional form.

Draw Sports Balls

① BASKETBALL
Draw a circle

② Add a slightly
curved diagonal

③ Add 3 curves as
seen below

④ Shade

 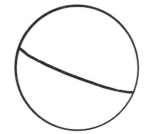 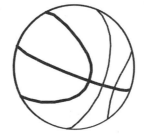

① FOOTBALL
Start with oval

add
curved
diagonal

② Add rounded
stripes at ends

③ Add "H" shapes
for laces

④ Shade

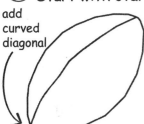 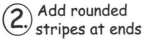 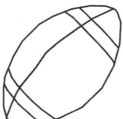 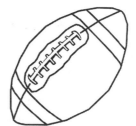 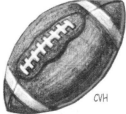

① BASEBALL
Start with circle

② Add 2 light lines
curving in center

③ Add open "V" for
stitch detail

④ Shade

① HOCKEY PUCK
Start with oval

② Draw 2 parallel
lines on sides

③ Round base to
connect

④ Shade

265

BASKETBALL HOOP

KNOW:
- Simple shapes combined together can create more complex objects.
- Overlapping.
- Cross Contour.

UNDERSTAND:
- Overlapping and layering items help to create a sense of realism in a drawing.
- Differences in the size of object parts can help to achieve the illusion of depth.

DO:
Create an original artwork of your version of a basketball hoop following the steps provided. Try the easy one first, then more difficult version. Don't trace. Apply shading for depth.

VOCABULARY:

Cross Contours: Drawn lines which travel across the form of an object. These lines may move in any direction but always describe the three dimensionality of an object or surface.

Overlap: When one element partially covers another, suggesting depth and layering in the composition.

Perspective: A drawing technique that creates the illusion of three-dimensionality on a two-dimensional surface, enhancing the sense of depth and space.

1. Start with an oval

2. Put a smaller oval inside

3. Add the base

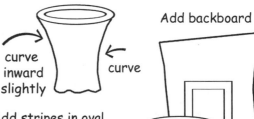

curve inward slightly

curve

Add backboard

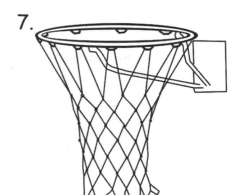

4. Add stripes (follow the contour of the sides)

5. Add diagonal stripes

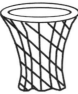

6. Add stripes in oval

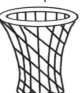

1.

2.

5.

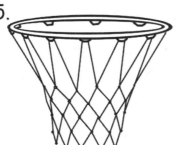

7.

3.

6.

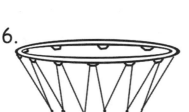

4.

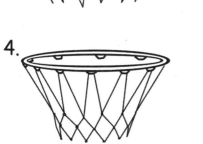

8.

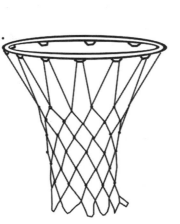

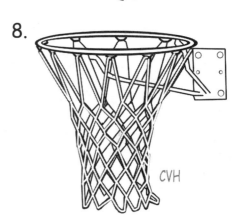

CVH

267

DRAW A BARE TREE

KNOW:
- A basic tree shape can be simplified to a cylinder.
- Asymmetry.
- The 'Y' Trick (branches resemble the letter 'Y').

UNDERSTAND:
- Cylinders in art create the illusion of a three-dimensional circular tube.
- Tree branches typically grow upwards and outwards, not downwards.
- Each tree is unique, no two are exactly alike.
- Trees might appear similar on both sides but are not symmetrical.

DO:
- Use the "Y Trick" technique to design your own tree.
- Apply shading for depth and dimension.

VOCABULARY:

Asymmetry: A design in which the two sides are not identical, offering a balance of differing elements.

Cylinder: A three-dimensional shape that resembles a tube, circular from all perspectives.

TIP:
Each step adds more branches. Draw them smaller and skinnier as they grow taller.

Draw a ^bare Tree

On many trees, ↑ the branches grow up towards the sun

1. Start with a block letter "Y"

2. Add "V" letters to tops of the "Y"

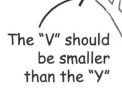

The "V" should be smaller than the "Y"

leave the tops open

3. Add 4 more "V" shapes

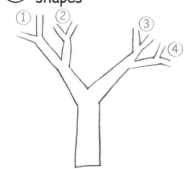

4. Add 8 more "V" shapes to the ends

skinnier and smaller

branches grow up and out

5. Add stick letter "Y"'s to all of the "V" shapes

UNEVEN is good! Draw some long and some short

like this →

6. Add another "Y" in the middle

(this fills up space)

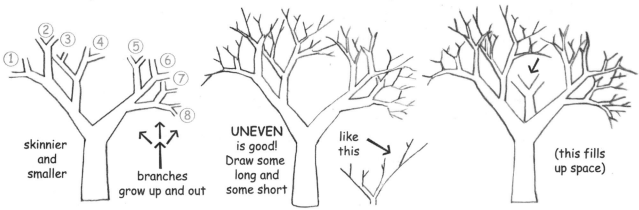

7. Add as many "Y" shapes as you need to fill up space

another one!

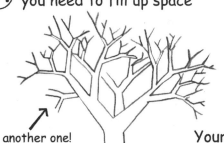

8. Shade

Your tree won't look exactly like this but that's good! Every tree is unique.

light →

shadow

choose one side to be in the shade, then darken every branch on that side, keeping the other side light

CVH

269

DRAW A PALM TREE

KNOW:
• A basic tree shape can be simplified as a cylinder.
• Asymmetry.

UNDERSTAND:
• Simplifying an artwork consists of breaking down the major parts of an object into basic, simple shapes.
• Each tree is unique, no two are exactly alike.
• Trees are typically asymmetrical.

DO:
• Use the provided steps to sketch a detailed palm tree, beginning with simple lines.
• Use a cylinder trunk to convey the illusion of depth. Students will also consider size, position, detail and shading.

VOCABULARY:

Asymmetry: A design principle where elements on one side of a composition differ from those on the other, creating a balanced but not mirrored appearance.

Cylinder: A three-dimensional shape that resembles a tube, perceived as circular from all angles.

Draw a Palm Tree

ALOHA!

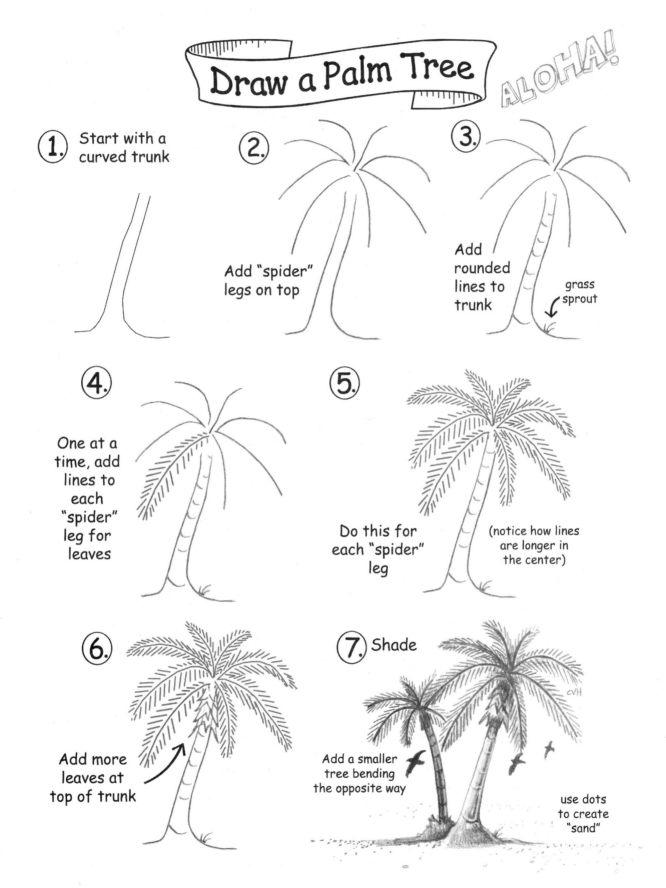

1. Start with a curved trunk

2. Add "spider" legs on top

3. Add rounded lines to trunk

 grass sprout

4. One at a time, add lines to each "spider" leg for leaves

5. Do this for each "spider" leg

 (notice how lines are longer in the center)

6. Add more leaves at top of trunk

7. Shade

 Add a smaller tree bending the opposite way

 use dots to create "sand"

 CVH

GRAFFITI ART

KNOW:
• Graffiti Art and rap music gained popularity in the early 1970s when art and music classes were cut from New York schools, leaving students in search of creative outlets.
• Texture.
• Pattern.

UNDERSTAND:
• The need for artistic expression.
• Textures can be visually created using lines and shadows.

DO:
• Utilize learned techniques to craft a textured brick wall.
• Choose or invent a font and/or design to place on your wall, be sure to incorporate shadows for depth.

VOCABULARY:

Artistic Expression: The communication of emotions and ideas through the creation of art. The process of creating allows an artist to express their innermost thoughts and feelings and share them with the world. Visual artists express through color, subject matter and style.

Font: A complete set of characters in a specific style and size, including letter spacing. Refer to the next exercise for a variety of cool lettering styles.

Pattern: An arrangement of repeated parts or decorative designs. The key here is the word repetition.

Texture: The way something looks like it might feel like in an artwork.

Graffiti Art

1. Start with 2 long rectangles

2. Center a 3rd brick underneath

3. Add another (stagger them)

4. Keep adding bricks until you have a complete wall

TIP: You can use a ruler to evenly space the bricks then erase lines in between, BUT, it looks more authentic if the bricks are not perfect rectangles

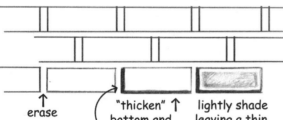

erase "thicken" bottom and left edges lightly shade leaving a thin, white edge

smudge with finger

5.

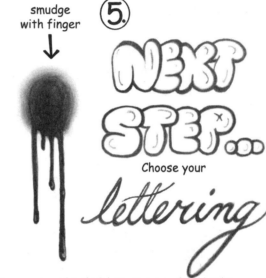

Choose your lettering

● Draw your word in thick letters on top of the bricks

● Erase inside the letters a little (you still want some brick to show through)

● Add some "drips" to the base of each letter

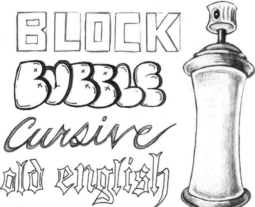

Choose one of these or make up your own lettering style

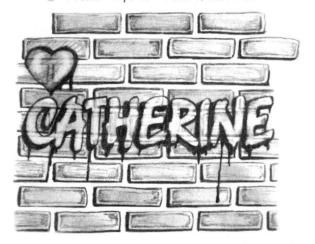

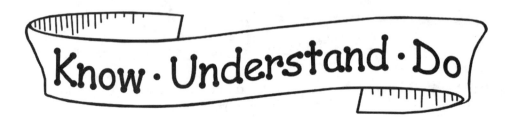

COOL LETTERING STYLES

KNOW:
• Font, Typeface, Lettering.

UNDERSTAND:
"Type" refers to letterforms produced electronically or photographically, most often using computers in the modern era. Before the late twentieth century, type was created using small metal or wooden blocks, each bearing a raised letter or character. When inked and pressed onto paper, these blocks left a printed impression.

DO:
• Design your own typeface or select a style from the handout.
• Use your chosen font to spell your name or complete the alphabet. Focus on incorporating details, thickness, or shading to enhance your lettering.

VOCABULARY:

Font: A complete set of characters, including letters and spacing, of one size and style of type.

Typeface: A full set of letterforms, numerals, punctuations and other characters unified by consistent visual qualities, also commonly referred to as a font.

Cool Lettering Styles

Block Letters: Make a box, carve out the letter inside with straight lines (no curves), then erase the parts of the box not used for the letter.

ABCDEFGH

Bubble Letters: Take the block letter and "blow it up" so there are no straight lines. It becomes a balloon!

ABCDEFGH

Shadow Lettering: The letter appears through the shadowed 3-D edge - not the actual letter.

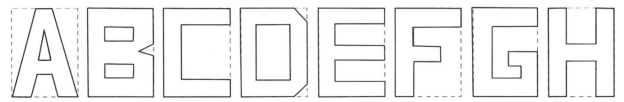

Fancy: Make one side of the letter thinner than the other. Put a curly-q at the end.

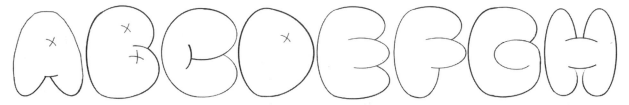

Tips for creating graffiti:

Overlap your letters, create an interesting pattern inside them, stagger them (have some letters placed higher or lower than the first), and make a shadow!

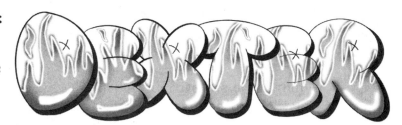

HOMEBOY SKULL

KNOW:
Exaggerating Features, Distortion, Value.

UNDERSTAND:
The artistic use of exaggeration and distortion to achieve a distinctive style.

DO:
• Create your version of a stylized skull wearing a hat following the provided guidelines, OR practice drawing a generic human skull and emphasize the exaggeration of its features.
• Add "extras" and apply shading for depth.
• Erase some areas to introduce highlights, enhancing the artwork's dimensionality.

VOCABULARY:

Distortion: Altering the appearance of something, which may include deforming or stretching an object or figure.

Exaggerate: Overstate, embellish; enlarge or shrink in size.

Highlight: The brightest area on a surface, reflecting the most light, used in art to focus attention on or accentuate specific areas by manipulating value.

Homeboy Skull

1 Draw 1 big and 2 small circles

2 Add a rectangle

3 Add chin and jaw lines

4 Add nose and hat line

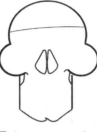

5 Add eye area details

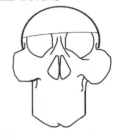

6 Add 4 teeth

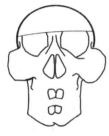

7 4 more teeth, hat tab & nose

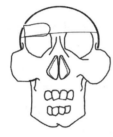

8 4 more teeth & rim eyes

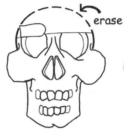

erase

9 4 more teeth & thicken tab

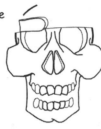

10 4 more teeth & mouth lines

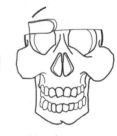

11 Add a tilted square

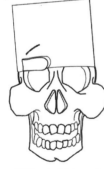

12 Round into hat

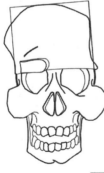

13 Add snaps & tooth lines

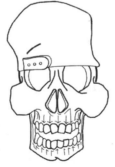

14 Eye line detail

15 Hat line detail

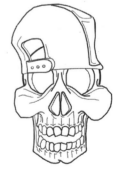

16 Add hat brim

17 Random cracks

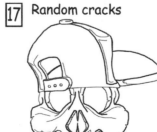

18 Shade

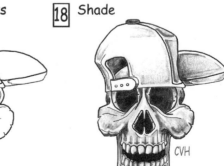

CVH

BACK OF THE HAND

KNOW:
• Creating a likeness from observation.
• Many objects, both man-made and natural, are based on the cylinder.

UNDERSTAND:
Employing a value scale for shading can enhance the realism of a rendering.

DO:
• Practice drawing your hand using the proposed techniques.
• Apply the darkest values between the fingers and along the knuckle creases. Erase specific areas on the knuckles, fingers, and the center of the hand to introduce natural-looking highlights.

VOCABULARY:

Cylinder: A shape that resembles a three-dimensional tube.

Highlight: The brightest section on a surface, reflecting most light, used in art to draw attention to or accentuate specific areas by adjusting value.

Back of the Hand

1.

Start by tracing your hand. If you are right handed, trace your left, etc.
TIP: To get the best hand shape, keep your pencil at a 90°angle.

2.

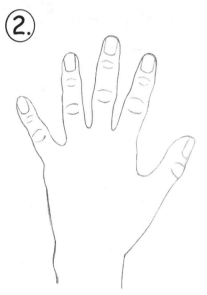

Next, add fingernails and a ⌣ shape for each knuckle.
NOTE: There are 2 knuckle joints in the actual finger, only one in the thumb.

3.

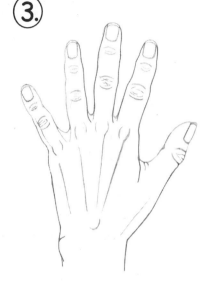

Look at your hand.
Do you see skin above the nails?
Do you have white tips on your nails?
Can you see the fine hand bones?
Do you have many knuckle lines?
If so - add them.

4.

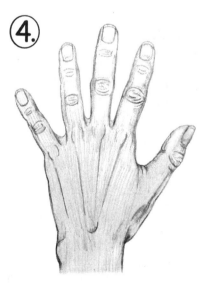

Lightly shade the entire hand gray. Darken the outline of the hand edges and the knuckles.

5.

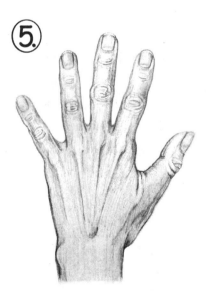

Shade the edges of the hand and each finger. Look at your real hand and notice the dark and light areas. Deepen the darker areas.

6.

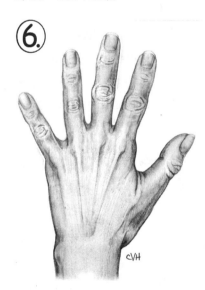

Add the finishing touches. Use your eraser to lighten the knuckles and the center of the fingers.

PALM OF THE HAND

KNOW:
• Creating a likeness from observation.
• Many objects, both man-made and natural, are based on the cylinder.

UNDERSTAND:
Employing a value scale for shading can enhance the realism of a rendering.

DO:
• Practice drawing your hand using the suggested techniques.
• Apply the darkest values between the fingers and along the knuckle creases. Erase specific areas on the knuckles, fingers, and the center of the hand to introduce natural-looking highlights.

VOCABULARY:

Cylinder: A shape that resembles a three-dimensional tube.

Highlight: The brightest section on a surface, reflecting most light, used in art to draw attention to or accentuate specific areas by adjusting value.

Palm of the Hand

1.
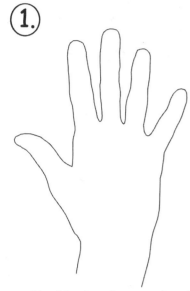

Start by tracing your hand.

TIP: To get the best hand shape, keep your pencil at a 90°angle.

2.
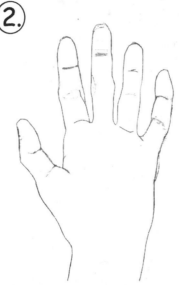

Relax your hand. The fingers will curl in a bit. Lightly sketch the changes in the finger angles.

3.
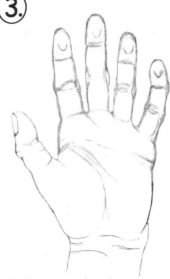

Look at your hand.
Do you see any part of your finger-nail? Everyone has a different line pattern in their palm. Draw yours.

4.
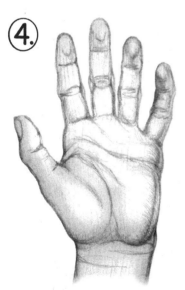

Lightly shade the entire hand gray. Darken the outline of the hand edges and the knuckle creases.

5.
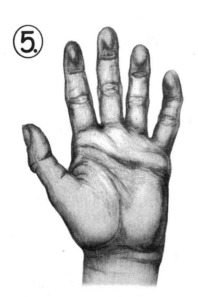

Shade the edges of the hand and each finger. Look at your real hand and notice the dark and light areas. Deepen the darker areas.

6.
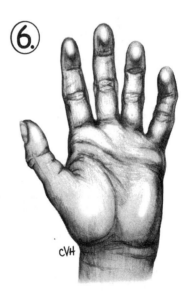

cVH

Add the finishing touches. Use your eraser to lighten the palm, betweeen the creases and the pads of the fingers.

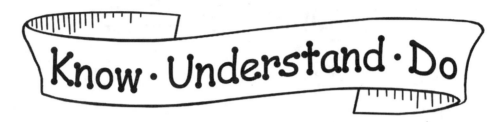

COMEDY & TRAGEDY MASKS

KNOW:
• Expression.
• Origins of the Comedy/Tragedy Masks.
• Overlap.

UNDERSTAND:
• These masks trace back to Ancient Greece.
• Masks have played an important role in the history of drama.
• They represent the universal symbol for theater.
• Expression is conveyed through non-verbal cues that denote emotion or facial movements reflecting emotional states.

DO:
Create an original Comedy/Tragedy mask drawing that shows expression using the steps provided.

VOCABULARY:

Comedy: A genre of entertainment that aims to amuse and induce laughter.

Overlap: The technique where one element covers a part of another, suggesting depth or layering in a composition.

Mask: A covering for the face, typically with openings for the eyes, used to conceal one's identity for various purposes such as parties, to entertain or scare (like at Halloween), for rituals, or in theatrical performances, including those in Greek, Roman, and Japanese traditions.

Tragedy: A dramatic genre characterized by serious themes and a somber tone.

Comedy & Tragedy Masks

1.

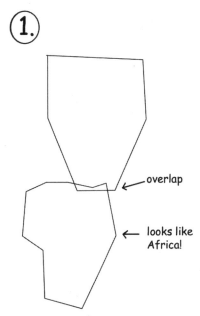

Start by blocking off the basic mask shape. Draw lightly as you will be erasing these guides in step 3.

2.

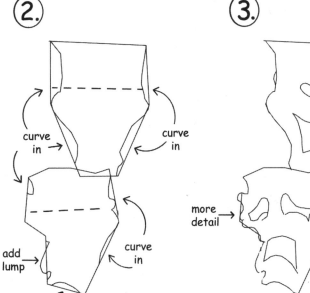

"Carve out" the details. Add guide lines for eyes.

3.

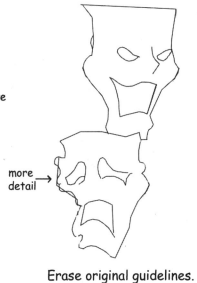

Erase original guidelines. Add eyes, nose and mouth.

4.

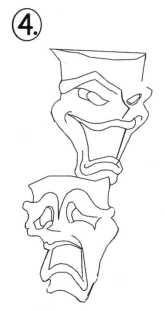

Add brows, lips and "thickness" to the eyes.

5.

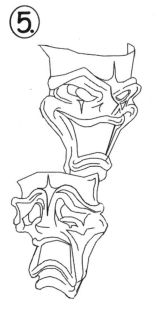

Add design lines.

6.

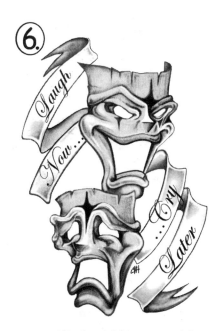

Shade. Add banner with text if desired.

STACKS OF CASH

KNOW:
Adding pattern and shading to an object gives it form and dimension.

UNDERSTAND:
• Using a cube's principles to create a three-dimensional rectangle.
• Employing receding lines to illustrate perspective.

DO:
Create an original artwork of "Stacks of Cash" showcasing perspective. Incorporate at least three stacks and numerous "extras." Remember to include shadows for added realism.

VOCABULARY:

Cube: A solid figure with six square faces, each side equal in size, presenting a 3D appearance.

Perspective: The point from which an object or scene is viewed.

Receding Lines: Lines that appear to diminish or move backward from the foreground, contributing to the illusion of depth.

Rectangular Prism: A three-dimensional solid shape with six faces that including rectangular bases. A cuboid is also called a rectangular prism.

Stacks of Cash

1.

Start with 2 parallel lines drawn at an angle

2.

Connect on the sides to create a slanted rectangle

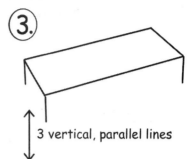

3.

3 vertical, parallel lines

4.

Connect with 2 angled lines

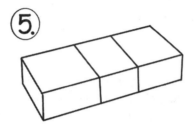

5.

"Wrap" the 3-D rectangle in the center

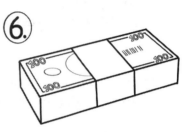

6.

Add design details

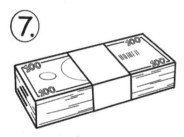

7.

Add random parallel dashed lines to show lots of stacked bills

8.

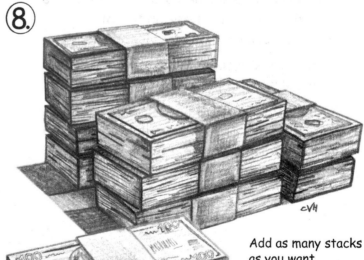

Add as many stacks as you want. Shade.

MO MONEY MO PROBLEMS

EASY SPIDER WEB

KNOW:
Symmetry, Asymmetry, Radial Balance.

UNDERSTAND:
A spider web's structure is circular, with its pattern radiating from the center.

DO:
• Create an original spider web design emphasizing radial balance.
• Add a spider and other "extras" to enhance your design.

VOCABULARY:

Symmetry (Symmetrical Balance): A design principle where elements on one side of a composition mirror those on the other side, creating a balanced appearance.

Symmetry is recognized as one of the ten principal types of patterns.

Radial (Rotational) Balance: A form of balance achieved through a circular composition where elements radiate from or are arranged around a central point.

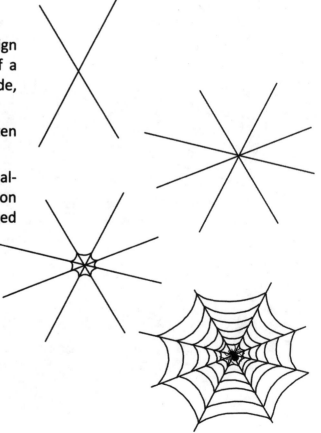

90° 45°

Easy Spider Web

①.

Start with a 90 degree angle. This will be the corner the spider web will be "spun" in.

②.

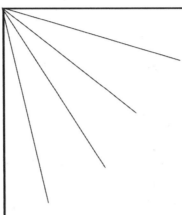

Draw 4 or 5 equally spaced lines radiating from the corner. (Like spokes of a bicycle wheel)

③.

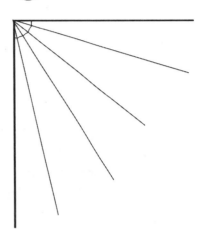

Create a layer of lines that curve around the upper corner. They should look like upside-down waves

④.

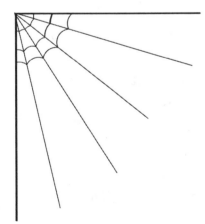

Add a few more layers of the web.

⑤.

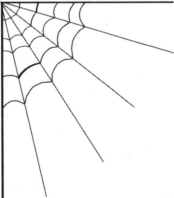

Continue to add web lines, each layer further apart from the last.

⑥.

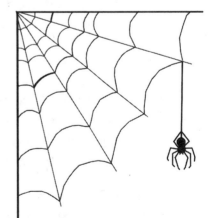

Finish the web.
Add a dangling spider.
Remember: Spiders have 8 legs!

EPILOGUE

As we close the pages of the latest edition of "How to Draw Cool Stuff," I find myself reflecting on the incredible journey we've embarked upon together. This book has traveled through classrooms, studios, and cozy corners of homes across the United States and the world, igniting the spark of creativity in the hearts of many. The stories shared by artists and educators, the artwork that has filled our community's galleries, and the personal milestones achieved through the guidance of these pages are a testament to the power of artistic expression.

Our collective journey through the world of drawing has not only enhanced technical skills but has also opened doors to new perspectives, fostering a deeper appreciation for the world around us. The challenges faced along the way have become stepping stones, leading to growth and newfound confidence in our abilities to create and convey meaningful stories through art.

As we look towards the horizon, the future of "How to Draw Cool Stuff" and its community is bright with possibility. The canvas of tomorrow awaits, ready to be adorned with the visions of new artists and the continued contributions of those who have walked this path alongside us. The legacy of this book will be carried forward not just in the drawings it has helped create but in the lives it has touched and the connections it has fostered.

In the spirit of continuous growth and exploration, I invite you to keep this book close as both a reference and an inspiration.

The journey, however, does not end here. The "How to Draw Cool Stuff" series is a growing universe of creativity, with each book designed to explore new horizons in the world of drawing:

"How to Draw Cool Stuff: Shading, Textures and Optical Illusions" and **"Drawing Dimension - Shading Techniques"** delve deeper into the nuances of light and shadow, bringing your drawings to life with a sense of realism and depth.

"How to Draw Cool Stuff: Holidays, Seasons and Events" celebrates the joy and spirit of various festive seasons through art, offering you a chance to explore thematic drawing.

"The 5 Minute Workbook" is a perfect companion for honing your skills, focusing on quick, effective exercises to improve your shading and observational drawing.

"How to Draw Awesome Stuff" and **"How to Draw Cute Stuff"** cater to diverse tastes, whether you're inclined towards the spooky and surreal or the adorable and endearing.

These books, and the many more to come, are invitations to continue your exploration of drawing, to push the boundaries of your creativity, and to express your unique vision through art.

I encourage you to explore the entire series, to find new challenges, and to discover new joys in drawing.

Thank you for allowing me to be a part of your creative journey. May your pencils stay sharp, your erasers stay soft, and your pages be filled with the cool stuff you love to draw!

CATHERINE V. HOLMES
Author
How to Draw Cool Stuff
www.HowToDrawCoolStuff.com